A Portrait of the Visual Arts

Meeting the Challenges of a New Era

Kevin F. McCarthy | Elizabeth H. Ondaatje

Arthur Brooks | András Szántó

RAND RESEARCH IN THE ARTS

Supported by The Pew Charitable Trusts

The research in this report was supported by The Pew Charitable Trusts.

Library of Congress Cataloging-in-Publication Data

A portrait of the visual arts : meeting the challenges of a new era / Kevin F. McCarthy ...
 [et al.].
 p. cm.
 "MG-290."
 Includes bibliographical references.
 ISBN 0-8330-3793-5 (pbk. : alk. paper)
 1. Art—United States—Marketing. 2. Art—Economic aspects—United States.
 3. Art—Forecasting. I. McCarthy, Kevin F., 1945–

 N8600.P67 2005
 338.4'77'09045—dc22

 2005008592

Cover design by Eileen Delson La Russo

Published 2005 by the RAND Corporation
1776 Main Street, P.O. Box 2138, Santa Monica, CA 90407-2138
1200 South Hayes Street, Arlington, VA 22202-5050
201 North Craig Street, Suite 202, Pittsburgh, PA 15213-1516
RAND URL: http://www.rand.org/
To order RAND documents or to obtain additional information, contact
Distribution Services: Telephone: (310) 451-7002;
Fax: (310) 451-6915; Email: order@rand.org

Preface

This is the third in a series of books that examines the state of the arts in America. It uses a systemwide approach to examine the visual arts in the context of the broader arts environment and to identify the major challenges they face. We developed this approach in our earlier book on the performing arts, *The Performing Arts in a New Era* (MR-1367-PCT, 2001), and employed it again in our book on the media arts, *From Celluloid to Cyberspace: The Media Arts and the Changing Arts World* (MR-1552-RF, 2002). This approach focuses on the organizational features of the visual arts by describing the characteristics of their consumers (collectors and appreciators), artists, finances, and organizations. Our focus is primarily on the fine arts—visual arts objects that are produced by professional visual artists; distributed in the fine arts market of galleries, art fairs, and auction houses; and displayed in fine arts institutions, especially museums. Our focus includes but is not limited to a variety of art objects, such as paintings, sculpture, and photographs, as well as some types of media art and performance art.

This book should be of interest both to the visual arts community (artists, organizations, market intermediaries, and funders) and to individuals interested in arts policy and the future of the arts in America.

The study was supported by a grant from The Pew Charitable Trusts as part of its cultural initiative "Optimizing America's Cultural Resources." One of the objectives of the program was to help build research capability in the arts to foster discussion and communication among cultural leaders, policymakers, journalists, artists, the philanthropic funding community, and the American public. We hope this book not only provides useful information about developments in the visual arts, but also promotes analysis of the arts sector more generally.

This publication was produced under the auspices of RAND Education, a unit of the RAND Corporation. Inquiries regarding RAND Education may be directed to Dr. Susan Bodilly, Acting Director, RAND Education, at education@rand.org. Inquiries regarding this book may be directed to Kevin McCarthy at Kevin_McCarthy @rand.org.

Other RAND Books on the Arts

A New Framework for Building Participation in the Arts (2001)
Kevin F. McCarthy and Kimberly Jinnett

The Performing Arts in a New Era (2001)
Kevin F. McCarthy, Arthur Brooks, Julia Lowell, and Laura Zakaras

From Celluloid to Cyberspace: The Media Arts and the Changing Arts World (2002)
Kevin F. McCarthy and Elizabeth H. Ondaatje

Arts Education Partnerships: Lessons Learned from One School District's Experience (2004)
Melissa K. Rowe, Laura Werber Castaneda, Tessa Kaganoff, and Abby Robyn

Gifts of the Muse: Reframing the Debate About the Benefits of the Arts (2004)
Kevin F. McCarthy, Elizabeth H. Ondaatje, Laura Zakaras, and Arthur Brooks

State Arts Agencies, 1965–2003: Whose Interests to Serve? (2004)
Julia Lowell

Contents

Figures

Tables

Summary

The last 50 years have brought dramatic changes to the arts in America as public involvement, the number of arts organizations, and funding for the arts have all soared. These changes have been particularly dramatic during the last 25 years, reflecting broader changes in American society. This complex series of changes has included shifting patterns in Americans' leisure time and tastes, increasing competition from entertainment and recreation industries, a more diverse population, and new patterns of funding from both the public and private sectors. The net result of these changes has been a marked shift in the organizational ecology of the arts, by which we mean the diverse array of artists, arts organizations, funders, and consumers and the interrelationships among them that determine how the arts are produced, distributed, marketed, and consumed in the United States. The combination of these changes has engendered daunting challenges for the arts—from targeting and attracting audiences, to earning a living as an artist, to managing organizational resources, to securing funding in an increasingly competitive environment.

The key to responding to these challenges is to understand how and why they are occurring. However, our current knowledge of the operation of the arts world and its underlying dynamics is limited. The absence of systematic analysis of the arts makes it difficult to determine which of the current challenges facing the arts are due to cyclical factors and will thus subside or which reflect more fundamental changes in society to which the arts world needs to adjust permanently. Without systematic analysis of the various art forms—performing arts, media arts, visual arts, literary arts—it is difficult to determine how changes in consumer markets, organizational structures, and financing or any number of challenges will affect the different artistic disciplines.

Study Purpose and Approach

This book views the visual arts as a system, complimenting our earlier studies of the performing arts and the media arts.[1] Using a systematic and systemwide perspective, it describes the state of the visual arts today and identifies how this picture is changing, why those changes are taking place, what they imply for the future, and what policy issues are involved. Our approach is based on the observation that the visual arts system has historically reflected the broader culture and society from which it emerges. Correspondingly, we treat the visual arts as a system that responds to internal and external forces in the broader society and thus reflects such trends as growing pluralism in the artistic styles, the new technologies, and changing public expectations about the role of the visual arts in society.

We use a conceptual framework to facilitate our understanding of the different elements of the visual arts sector, identifying how those elements interact and drawing comparisons with the performing arts and media arts. This framework distinguishes among art forms (performing, media, visual, and literary); the market sectors in which the art is produced and distributed (nonprofit, commercial, and volunteer or informal); and key players and processes in the creation, distribution, and consumption of the visual arts (appreciators and collectors), artists, markets, and nonprofit organizations.

Defining the Visual Arts

As in other arts disciplines, there is an array of artists, organizations, and art forms that can be included under the rubric of the visual arts. Our focus is primarily on the fine arts, that is, visual arts objects that are produced by professional visual artists; distributed in the fine arts market of galleries, art fairs, and auction houses; and displayed in fine arts institutions, especially museums. This focus includes but is not limited to a variety of art objects, such as paintings, sculpture, and photographs, as well as some types of media art and performance art. We recognize that this focus emphasizes one part of what can be considered a continuum of visual art—from "embedded art" (e.g., design work embedded in everyday products and settings), to collectibles and crafts, to photography, to painting and sculpture that is accessible and affordable to a wide range of consumers (e.g., the work displayed and marketed at community art fairs), to what we refer to as fine art. These different categories of objects differ in their quality, in who consumes and produces them, and in the nature of the markets (size, price levels, and organizations) in which they are sold and displayed. Although the distinctions along this continuum are often blurry and where

[1] See McCarthy et al., 2001; and McCarthy and Ondaatje, 2002.

the lines should be drawn is debatable, they are still useful in improving our understanding of the current visual arts system and the importance of the fine arts to this system.

Three Distinct Institutions in the Visual Arts

There are three distinct institutions that have historically shaped the visual arts system in America—all of which have their roots in 18th and 19th century Europe. These institutions are the public art museums (which have been the dominant venues for public arts appreciation); the world of visual arts discourse (which includes the system of ideas and theories that validate art objects and links them to one another over space and time); and the visual arts market (where art works are bought and sold).

During the last three decades, each of these institutions has changed significantly. Art museums, which first appeared in the United States about 150 years ago, have multiplied in number and grown dramatically in public popularity. They manage extraordinary sums in terms of assets and revenues and have historically served a variety of missions that have often been in conflict. The world of arts discourse, once relatively circumscribed both in terms of who was included and how works of arts were evaluated, has become increasingly pluralistic and splintered, and it exerts less control than in the past over the process of determining the artistic value of emerging work. These changes have paved the way for the emergence of unprecedented artistic diversity and for the extraordinarily rapid expansion and segmentation of the arts market. Finally, the arts market has been transformed from a small and close-knit community of relatively few members into a modern, specialized, multibillion dollar marketplace.

Building on an understanding of the historical foundations of the current visual arts system, this book examines its four key features: patterns of demand (in both appreciation and collecting), characteristics of artists, the operation of the arts market, and museums and other visual arts organizations.

Demand

Demand for the visual arts takes two principal forms: appreciation and collecting. The fact that the popularity of both of these forms of demand has increased significantly in recent years is often seen as a sign of great success in the field. However, a closer look at the statistics underlying these trends suggests a less rosy story. The growth in museum attendance, for example, appears to be largely due to population growth and rising education levels, not to higher levels of attendance by those at specific education levels. Indeed, the socioeconomic status of museum audiences does not appear to have changed significantly, despite the efforts of museums to attract

more diverse audiences. Moreover, underlying societal trends—driven by changing leisure patterns, increasing population diversity, and more intense competition from the entertainment and leisure industries—suggest that new growth in demand will not come easily.

While the number of people who collect fine art is miniscule compared with the number of people who visit museums, it too has jumped markedly and become more geographically dispersed in the last two and a half decades. However, this growth appears to have been largely driven by a surge in the numbers of and the rising incomes of the most affluent segments of the population as well as by an increase in the fraction of collectors who are drawn to collecting not just as connoisseurs but also as investors.

Key questions for the future are: Will demand continue to grow and, in particular, will it expand beyond the socioeconomic groups that already participate in the visual arts; what factors will affect demand (e.g., early arts exposure and education, leisure time patterns, affluence, or technology); and, of course, how will the rest of the visual arts system respond to such growth?

Artists[2]

The number of artists in the visual arts has been increasing (as it has in the other arts disciplines), and their backgrounds have become more diverse. At the same time, however, the hierarchy among artists, always evident, appears to have become increasingly stratified, as has their earnings prospects. At the top are the few "superstar" artists whose work is sold internationally for hundreds of thousands and occasionally millions of dollars. In the next tier are the "bestsellers" whose work is represented and promoted by galleries, dealers, and auction houses and sold for substantial prices. In the third tier are the majority of visual artist who often struggle to make a living from the sale of their work. This increasing stratification is largely due to changes in the size and operation of the arts market.

At the same time, visual artists' career patterns have also been changing, as academic training has taken on greater importance as a credential for emerging artists and as artists' career progress has accelerated. Select artists, for example, may have a dealer and a solo exhibition at earlier stages in their careers than for artists in the past, possibly even while they are still in school.

Many visual artists are self-employed, but they also need to supplement their income from sales by earning a significant portion of their income from nonarts employment. Artists of all types have had to struggle to earn a living, but there are more

[2] Most of the art displayed in museums (as well as the art sold in the secondary elite arts market) has been created by artists who are no longer living and under quite different conditions, when the role of art and artist in society differed greatly and when the visual arts market did not even remotely resemble today's market. Our analysis focuses on the number, characteristics, and career paths of living artists and how the circumstances of visual artists have been changing over the last 50 years.

employment options for visual artists today in teaching (with the expansion of academic training for artists) and in the fields of design, advertising, and other commercial arts. Nevertheless, career patterns are volatile, in large part as a function of market forces. These market forces are more likely to influence career patterns than the uneven distribution of artists' earnings, which appears to be endemic to the arts.

Key issues for the future will be the availability of arts-related employment opportunities for artists who need to support themselves beyond the income they earn from the sale of their work. In addition, how might rising numbers of artists who obtain employment in related fields of design and advertising, for example, impact the organizational ecology of the visual arts? For those who rely solely on income from the sale of their work, key issues will be improving the circumstances of their self-employment with innovative programs for health or pension benefits, for regularizing their employment, or alternatively, for managing the instability of their career trajectories.

The Arts Market

The elite fine arts market, which has no direct counterpart in the other arts, has also experienced dramatic change. The arts market not only plays the dominant role in shaping the prices paid for artwork, it also shapes public perceptions of the visual arts. At the same time that prices have reached headline-grabbing heights, the structure and operation of the market itself has been transformed. It has become more efficient, transparent, liquid, and global as both prices and volume of sales have exploded. In short, it increasingly resembles other asset markets.

Another significant change has taken place in the process by which prices and values are determined. The value of an artist's work is less determined by a slowly evolving consensus among experts, critics, and curators and more by market forces of supply and demand, particularly in the contemporary arts market.

The impact of market forces in the arts market is a function of increasing demand arising from a growing number of highly affluent individuals and changes in market practices. More information is readily available via new technologies; more investors are facilitated by art advisors; and more services are provided by intermediaries. The interaction of supply and demand forces has dramatically expanded both the size and diversity of the arts market and the players operating in it.

There are several key issues to consider for the future of the arts market. First, will demand increase and, if so, will future growth in demand diversify the population of collectors? Second, how will the increasing pluralization of the arts market alter the organizational ecology of the supply of art? And lastly, will the market become regulated? Currently, it is largely unregulated even though there have been convictions on charges of price fixing benefiting intermediaries at the expense of purchasers.

Organizations

While there are many different nonprofit visual arts organizations—including non-profit galleries, artist collectives, community studios, and a host of service organizations[3]—museums dominate this portion of the organizational ecology of the visual arts. Museums have traditionally been the centers of arts appreciation and the interpreters and protectors of art objects. Moreover, as perhaps the most visible institutions in the visual arts system, they are subject to a diverse set of public expectations in an increasingly pluralistic society.

Museums, of course, have historically been forced to confront difficult choices about allocating scarce resources among their multiple missions, such as protecting and exhibiting the collection, educating the public, conducting research, and contributing to scholarship. But the tensions among competing missions appear to have intensified in the current environment, which is characterized by increasing competition for visitors, a more complex operating environment, the financial squeeze of rising costs and stable or declining revenues, and rising art prices. Symptomatic of these cross-pressures has been controversy within the visual arts community between those who value art objects and stress the museum's art-oriented missions (preservation, presentation, and scholarship) and those who stress the marketing-oriented missions (those aspects that emphasize audiences, community involvement, and doing what is necessary to respond to financial pressures).

In addition, there is increased concentration among a relatively small group of institutions within the museum world in terms of collections, revenues, donations, and visitors. With few exceptions, these superstars of the American museum world were established before the end of World War II,[4] are located in major metropolitan areas, and house world-renowned artworks and collections. They enjoy tremendous advantages over newer, smaller, regional museums in terms of access to resources, prestige, and the ability to sponsor special exhibits (e.g., "blockbusters" intended to draw large crowds to the museum) that have become a major tool in attracting visitors. In addition, the advantages of these museums appear to be growing.

In light of these challenges, museums need to understand how changes in society affect their future ability to fulfill multiple and sometimes competing missions. To navigate successfully through the challenges of the current environment, museums need to address three strategic questions for the future: What are their primary goals and missions? How will they define and measure their success? Do they have the capabilities they need to thrive?

[3] For example, service organizations such as the Association of Art Museum Directors and the National Association of Artists' Collectives provide information, contacts, conferences, and other support services to member organizations.

[4] It is notable that 75 percent of American art museums were founded *after* World War II.

Potential Roles for Public Policy

The changes that have been occurring in each of the four components of the visual arts system analyzed in this study—appreciators/collectors, artists, the arts market, and organizations—reflect the actions of the many private individuals and institutions that create, consume, market, and display the visual arts. Although government at the federal, state, and local levels provide some direct funding to the visual arts system, its primary influence on the operation of the visual arts system has been largely indirect, through regulatory, tax, enforcement, and other policies.

The future role that government might play in dealing with the challenges facing the visual arts system is uncertain. Although much of the art world has focused on direct government support for artists and arts organizations, in fact, the indirect financial support that the government provides through the tax system is an order of magnitude larger than the government's direct support. Moreover, the supply-side focus of that direct support may actually be misplaced for reasons of both equity and efficiency. Since visual arts consumers tend to be better educated and wealthier than nonconsumers, supply-side funding in essence subsidizes the activity of those who least need subsidies, thus raising equity issues. From an efficiency standpoint, the best way to stimulate public involvement in the arts may well be through programs that promote early exposure to the arts in childhood and adolescence and through work to encourage arts organizations to build public knowledge about and competence in the arts.

As we have already indicated, indirect government support for the arts through tax policies provides considerably more funding for the arts than does direct funding. Indeed, tax policies can significantly affect donors' behavior and the ultimate level of contributions to nonprofit visual arts organizations. Maintaining these tax advantages is probably the single most important policy government can use to promote the arts in the future.

Government regulations and enforcement can influence the visual arts system as well. Currently, the art market and museum world are largely self-regulating and self-policing. Individual institutions and the sector as a whole enjoy a great deal of latitude to determine best practices and appropriate codes of conduct. But the experiences of other sectors of society reveal that this situation can change quickly and dramatically in the wake of scandal or abuse, which in the case of the visual arts might involve trade in illegal art, Nazi-looted art, conflicts of interest, or public outrage over artistic content. Against the backdrop of scandals in the nonprofit sector over executive compensation, financial irregularities, and political campaign financing, such incidents bring unwelcome scrutiny to the nonprofit sector, including museums. Whether such incidents prompt efforts at greater regulation is unclear. We suspect that as long as museums, in particular, continue to respond quickly and con-

certedly to each controversy with public reprimands and new policies and guidelines, new government regulations of museums are unlikely.

A more likely candidate for regulation is the arts market, where attention drawn to shady practices and price fixing could bring calls for greater regulation. The likelihood of such calls will probably depend on continued growth in the size and diversity of the arts market.

The direct and indirect levers of government over the visual arts system principally work their effects by influencing the actions of private individuals and institutions. The future of the visual arts system will largely be determined by the multitude of nonprofits, commercial intermediaries, artists, and individuals analyzed in this book. The decisions and behaviors of these assorted actors are as likely to be influenced by broader developments in American society—in particular the increasing pluralism of society and the pressures it exerts on the visual arts system. As we have indicated, these changes have already increased the demands on the system. The key challenge the system faces is to recognize and respond to these pressures without losing sight of the art itself and how it can enrich individuals' lives.

Acknowledgments

This work was sponsored by The Pew Charitable Trusts with the guidance and encouragement of Marian Godfrey, whose interest and insights contributed greatly to the project. We would also like to thank the several individuals whose comments on earlier drafts greatly improved the final product. They include David Ross, Neil Harris, Tom Bradshaw, Michael Brenson, Claudine Brown, Agnes Gund, Joan Jeffri, Stephen Lash, Larry Rothfield, Stephen Urice, Christine Vincent, Stephen Weil, and Thomas Ybarra-Frausto. We also owe a debt of gratitude to the Los Angeles arts experts with whom we met during the conceptual phase of this project, including Adele Lander Burke (the Skirball Cultural Center), Deborah Gribbon and Barbara Whitney (the J. Paul Getty Museum), Irene Hirano (the Japanese American National Museum), Melodie Kanschat and Mary Levkoff (the Los Angeles County Museum of Art), Elsa Longhauser (the Santa Monica Museum of Art), Hal Nelson (the Long Beach Museum of Art), and Jeremy Strick (the Museum of Contemporary Art).

This work would not have been possible without the gracious assistance of our RAND colleagues Laura Zakaras, Felicia Wu, Sheila Kirby, and Sue Bodilly. Lisa Lewis and Judy Rohloff provided invaluable research support throughout the project. A strong production team—Peter Hoffman, Ron Miller, Alissa Hiraga, and Christina Pitcher—brought these pages together. Finally, we appreciate Eileen Delson La Russo's artistry on the cover of this and previous RAND books on arts policy.

Introduction

During the last 25 years, the arts world has been changing in dramatic ways. These changes have created major challenges for the arts and raised important questions about what the future holds. What are the implications of these changes and challenges for the arts in America? Our previous work addressed these issues for the performing arts and the media arts. This book focuses on the visual arts (defined below) and attempts to answer a series of questions:

- What is the state of the visual arts in America today?
- How is this picture changing?
- Why are those changes occurring?
- What might these changes imply for the future?
- What are the policy issues that arise?

Changes in the arts environment have been myriad and complex. Simply put, there have been changes on the demand side as well as changes in the supply. Changing patterns of demand for the arts have resulted from more fragmented leisure time, a more diverse population, and increasing competition from burgeoning entertainment and leisure industries. Changes in supply include new technologies that have altered the way the arts are produced, distributed and consumed; shifts in the organizational ecology of the arts[1] that are blurring the distinctions among the commercial, nonprofit, and volunteer or informal sectors; and more competition for funding. In combination, these changes have created a daunting array of challenges for the arts. Arts organizations, for example, have found it increasingly difficult to target and attract audiences, to increase their earnings and other income, to manage their resources and contain their costs, and to identify their mission and the roles they play in an increasingly complex and competitive public environment. Although some artists have prospered, most have continued to struggle to make a living at their

[1] The organizational ecology of the arts refers to the diverse array of artists, arts organizations, funders, and consumers and the interrelationships among them that determine how the arts are produced, distributed, marketed, and consumed in the United States.

chosen profession. Changes in the funding environment have increased the importance to arts organizations of earned revenue, and advocates for the arts face an ongoing challenge to convince legislators and funders of the importance of the arts.

This complex set of changes and challenges in America's arts environment has had some common consequences across performing, media, visual, and literary arts. However, because of the differences among the components in each of these fields (artists, audiences, organizations, and funders) as well as the ways they interact, the consequences have varied throughout the arts system.

For example, in an earlier work on the performing arts (McCarthy et al., 2001), we point out that in response to rising costs, the performing arts have attempted to increase their earnings by expanding their audiences. But insufficient demand has spawned increasing competition among these organizations for a larger share of existing audiences. This predicament has placed increasing stress on midsized organizations whose budgets constrain their ability to compete with the large organizations for audiences (who increasingly demand high-priced productions) at the same time that they lack the volunteer base (and reduced costs) of small community-based performing arts organizations.

The media arts, in contrast, face a different problem, identified in McCarthy and Ondaatje, 2002. As the newest and in many respects, most innovative of the various art forms, they have yet to define clearly either the parameters of their artistic genre or their potential markets. As a result, they lack the business models and marketing strategies they need to take advantage of those potential markets and the new distribution channels that technological developments have facilitated.

In contrast, the visual arts appear to be booming. Museum attendance has reached all-time highs. In addition, the prices and volume of sales in the market for fine art (as well as for virtually all classes of collectibles) have exploded over the last two and half decades. Yet, these apparent successes have raised issues that could well alter the visual arts world.

In sum, our earlier work[2] suggests that although the various artistic disciplines face an increasingly challenging environment, how those challenges manifest themselves—and thus the ways in which organizations in the various arts disciplines will react—will depend on the specific circumstances within those disciplines, their histories, and how they are affected.

Defining the Visual Arts

A variety of art forms and objects can be included under the general rubric of the visual arts. We refer here not to the aesthetic issue of what constitutes "art" but rather

[2] We have not analyzed the literary arts and thus cannot include that discipline in these comparisons.

to the diversity of forms that the visual arts can take. Several different categories of objects can be viewed along a continuum of visual arts—from "embedded art" (e.g., design work embedded in everyday products); to collectibles and crafts; to photography, painting, and sculpture that are accessible and affordable to a wide range of consumers (e.g., the work displayed and marketed at community art fairs); to what we refer to as fine art. These different categories of objects differ in their quality, in who consumes and produces them, and in the nature of the markets (size, price levels, and organizations) in which they are sold and displayed. Drawing bright lines between these different categories of visual arts objects is somewhat arbitrary, but we assert that understanding the structural differences is central to understanding the present state of the visual arts.

Our focus is primarily on the fine arts, that is, visual arts objects that are produced by "professional" visual artists, distributed in the fine arts market, and displayed in fine arts institutions, especially museums. As we will discuss, defining who is a professional artist (or what is fine art) is not straightforward. At least one central feature of professional artists is their ability to sell their work. This definition includes artists (living or dead) whose work is collected by museums, sold internationally at substantial sums, displayed in galleries and at fine arts fairs, and sold directly by the artists or through dealers and other intermediaries. Thus, the fine arts, as we define them, include a variety of art objects including but not limited to paintings, sculpture, and photographs, as well as certain categories of media art and performance art[3].

Our Approach

A central analytical challenge was to identify a set of dimensions around which to structure our analysis of the multidimensional world of the visual arts. In our earlier studies of the performing arts and media arts, we developed a conceptual framework, which we use again in this study. Parsing the visual arts using this framework has three distinct advantages. First, it facilitates our understanding of the different elements in the visual arts system. Second, it enables us to identify how these elements interact to shape the visual arts system. Finally, it facilitates comparisons of the visual arts with both the performing and media arts.

[3] Examples include such installations incorporating media as Nam June Paik's "Modulations in Sync" and Bill Viola's "Five Angels of the Millennium," as well as performance art pieces by Laurie Anderson and by Nam June Paik earlier in his career.

Conceptual Framework: Key Dimensions of the Visual Arts System

Our framework for analyzing the different art forms has three dimensions. It is designed to help us understand the different parts of the system and how they interact. First, it distinguishes among the different types of art forms (e.g., performing, media, visual, and literary). Second, it defines the market sector in which the art is produced and distributed (nonprofit, commercial, and volunteer or informal). The third and most important dimension identifies the key players and processes involved in the creating, distributing, and consumption of the visual arts—namely consumers, artists, and the various for-profit and not-for-profit organizations and intermediaries. All of these dimensions—art form, sector, and functional component—must be analyzed to paint a complete picture of the visual arts system.

Art Form

We classify the arts into four general categories: the performing arts, the media arts, the visual arts, and the literary arts. These general categories can be further subdivided by discipline, style of work, historical period, etc. For example, in our analysis of the performing arts, we examined patterns separately for theater, dance, music, and opera. In the media arts, we subdivided results for narrative, documentary, and experimental or avant-garde work. Whether and how to parse an artistic category further depends on the availability of information on subcategories and the purpose of the analysis. In our analysis of the visual arts, we have drawn several distinctions among the visual arts. First, we distinguish between fine art and the art available in the general commercial market. Second, within the fine art category, we draw distinctions between contemporary and other styles of work—e.g., modern, impressionist, and old masters. As we discuss in the chapters that follow, these distinctions capture important differences in patterns of consumption and in the nature of the market for different types of visual arts work.

Market Sector

The second dimension of our framework recognizes that art can be produced, marketed, and consumed in the three different market sectors of the art world: the nonprofit, commercial, and informal or volunteer sectors. The nonprofit sector consists of organizations that have formal nonprofit status under Section 501(c) (3) of the Internal Revenue Code. Nearly all art museums are nonprofits. Although these organizations often rely on volunteer support and may also have profit-making entities generating "earned income" for the institution, such as cafes and gifts shops, they depend heavily on philanthropic contributions and are "mission driven" as opposed to profit driven. Commercial firms in the visual arts system include such entities as galleries, auction houses, restorers, framers, transporters, insurers, and other firms

involved in the creation and distribution of the visual arts.[4] They pay taxes and depend entirely on the market for financial sustenance. Their underlying objective is profit making. The third sector—informal or volunteer—represents a large and not well-understood segment of the visual arts system and, indeed, the entire arts system.[5] This sector includes local crafts fairs, artists' collectives, amateur classes, and work produced by individuals on their own who do not expect to make a living from their work. It includes small visual arts organizations that rely primarily on volunteer efforts, as opposed to paid professional staff, as well as Sunday painters, students at sculpting studios, backyard potters, etc. We concentrate on the nonprofit and commercial sectors in this book for two reasons. First, there is very little information available about the volunteer or informal sector. Second, work produced in this sector is overwhelmingly by amateurs and is not generally regarded as fine art by experts.

Functional Components

By functional components, we are referring to individuals and organizations that serve key functions in the complex processes of creating, distributing, and consuming the visual arts. As is true of all the arts, this process begins with the artist's creation of the work and ends with the consumer, either a collector who buys the work or a viewer who sees it on display. Between these points is an array of individuals and organizations that interpret, exhibit, collect, sell, and preserve works of fine art. Supporting these entities are the individuals, foundations, government agencies, and businesses that offer financial support to nonprofit organizations. In addition, there are individuals and for-profit firms that buy, sell, transport, insure, and otherwise participate in the visual arts. Taken together, all these entities make up the visual arts system.

Methodology and Data

RAND's studies of the performing arts, media arts, and visual arts are intended to identify and assess the key trends and issues in each of these different artistic disciplines as well as to facilitate comparisons among the arts more generally. Our ultimate objective has been to build a foundation of common knowledge about the arts that would allow us to improve arts policy. Correspondingly, throughout our work, we have approached the analyses by first defining the population of interest; second, identifying the key analytic dimensions for describing it; third, using these dimensions to describe the current situation and trends; and finally, identifying the dy-

[4] Most of the "embedded" or design and architecture categories of the visual arts reside in the commercial sector.

[5] See Peters and Cherbo, 1998.

namics behind them. Building on this base, the central tasks of policy analysis can be undertaken: to examine the range of policy options that affect trends and to evaluate the costs and benefits of such options. In the arts, the knowledge base needed to identify the key policy issues, appropriate options to address these issues, and their costs and benefits has yet to be established. Consequently, this book, like the performing arts and media arts books that preceded it, necessarily focuses on the early steps in policy analysis.

We approached our task from the broadest possible perspective. We wanted to understand how existing information describes the world of the visual arts in the United States, where gaps in information exist, and how trends in one part of the visual arts system might be influencing trends in other parts. For this book, we relied on quantitative and qualitative data and analysis. We reviewed the literature, organizing existing information into our conceptual framework. Wherever possible, we used empirical evidence addressing such issues as participation rates, revenue sources for arts organizations, art market prices, and artists' earnings. We performed analysis using databases on the visual arts, such as the Survey of Public Participation in the Arts and the General Social Survey, and data from the Internal Revenue Service, the Bureau of Labor Statistics, and the Census. However, data and quantitative analyses were not available for many issues, such as trends in museum costs or matriculation rates from art schools. Moreover, many qualitative issues do not lend themselves to empirical methods, such as discussions of aesthetics (e.g., new visual art forms, new technological tools of art making, and interactivity), debates about the canon of fine arts, and the nature of the viewer's or collector's experience. Consequently, we cast our net as widely as possible to capture not only seminal works published in traditional sources (and identified by such databases as Art Abstracts, Arts & Humanities Citation Index, Business ARTS, EconLit, ERIC, Social Science Abstracts, and Sociological Abstracts), but also studies that exist only "in the field," such as papers at conferences, dissertations, newsletters, and unpublished works.[6] Moreover, we looked even farther afield at sources outside the usual bounds of policy research. We consulted a wide range of essays, editorials, interviews, online discussions, blogs, and journalistic coverage of attitudes, opinions, trends, and norms of behavior in the art market. Though more subjective in nature, the issues identified in such qualitative sources provided an additional and essential lens through which the more quantitative findings are filtered.

The conceptual framework outlined above—art form, market sector, and functional component—organizes both the quantitative and qualitative information we used. It has facilitated our analyses of the characteristics of the performing, media, and visual arts sectors that make them similar to and different from each other as well

[6] We were aided by a compendium of information on the arts at the RAND Corporation, containing over 3,000 books, articles, datasets, and other studies.

as other industries. In addition, this conceptual framework enables us to compare arts activities within art form, market sector, and functional domains over time, and to consider how activities across the various domains may be related.[7] Moreover, by looking at specific issues or questions from several different dimensions, we can begin to understand how the different parts of the system interact. For example, to answer the question "how has demand for the fine arts changed over the last 20 years?" one might look at attendance figures at fine arts museums or prices at art auctions. However, this approach would miss activity among art dealers or commissioned work by artists, which also reflect changes in demand. Moreover, structural changes in the way the fine arts are bought, sold, and perceived might only be identified by looking across sectors.

Organization of the Book

Of central concern in this study is recognizing how the various dimensions in the visual arts system affect how the visual arts are created, marketed, distributed, and consumed (along with the implications of those activities for the visual arts more generally). The next chapter provides additional background on the visual arts and a discussion of the major institutional roots of the current system (art museums, the world of discourse, and the art market). It discusses how these institutions have historically operated and how they have been changing in recent years. Chapter Three then describes the demand side of the visual arts, its major features, and how they have been changing. Chapter Four provides a similar description of visual artists and the key trends affecting them. Chapter Five analyzes the organization and financing of the commercial visual arts market, how it has been changing, and the implications of these changes. Chapter Six examines the organization and financing of the non-profit sector, the role that museums play in providing art to the public, how this sector has been changing, and the implications of these changes. Finally, Chapter Seven summarizes our key findings and their implications for the visual arts world.

[7] For example, artists in the performing arts can be either creators (composers, playwrights, choreographers) or re-creators (orchestral musicians, singers, dancers) whose artistry consists of their technical and interpretive skills in executing the work of the creator. In the visual arts, there is no such distinction: Visual artists are principally creators of the art. In media and performance arts, these differences are often intentionally blurred.

The Evolution of the Visual Arts System

With their origins in early cave drawing in the Neolithic era, the visual arts are in all likelihood the oldest of the arts. Every major civilization has had a visual arts tradition that reflected the broader culture from which it stemmed.[1] As those cultures have changed, so too have the purposes, styles, and organizational features of their visual arts systems. The institutions that dominate the organizational ecology of the visual arts in America today have their roots in 18th and 19th century Europe, especially France—although these institutions have evolved with a distinctive American style. These institutions are public museums, the world of visual arts discourse, and the visual arts market.

This chapter places the art world's current organizational structure in its historical context using broad brushstrokes. We make no attempt at a comprehensive historical summary. The sketch of key components of the current system is intended to set the stage for the analysis of current art world structures and dynamics that is set forth in the ensuing chapters. We begin by briefly describing the major institutional roots of today's visual arts system: art museums, arts discourse, and the arts market. We then discuss how these elements/institutions have created the distinctive features of today's visual arts system.

The Development of the Public Art Museum

As Lee and Henning (1975) have pointed out, the cave, the temple, the palace, and the cathedral have all served as the principal venues for displaying art in different eras. In today's art world, the dominant venue for arts appreciation is the public art museum. The museum began to assume this central role in the 19th century. Prior to that time, art appreciation and art patronage were often tightly linked. Wealthy patrons commissioned works of art largely for their own pleasure or to be shared in private viewing galleries. Art appreciation as a public pastime began to emerge with the

[1] See, for example, Janson, 1964.

rise of a bourgeois audience in 18th century France, who helped shape artists' reputations by choosing to attend exhibitions. The circle of public appreciation widened in the late 19th century as museums began to proliferate and art criticism emerged (Sherman Lee, 1975). Since then, art museums—where art is exposed to a wide public audience—have been central to framing the public's awareness and experience of art.

Significantly, American museums, unencumbered by ties to aristocratic households, anchored their missions from the beginning in the edification of the public. As Taylor (1975, pp. 34–35) points out, the earliest permanent museums were established in the mid- to late-19th century and were founded by associations with the dual aim of fostering the creation of art and the elevation of public taste. The fine arts were often mixed with other collectibles in the early museums and in art exhibitions. During the 1870s, major museums were founded in New York (The Metropolitan Museum of Art), Boston (the Museum of Fine Arts), Philadelphia (the Philadelphia Museum of Art), and Chicago (the Art Institute) that were dedicated exclusively to the fine arts. As Taylor (1975, p. 37) puts it, "Art was accepted as having its own history and as demanding it own special range of sensibilities."

By the turn of the century, the art museum's initial educational focus began to be superseded by a growing concern for aesthetic purity that "values art as an end in itself, but not because it fulfills some other purpose" (Weil, 2002a, p. 160). As evidence of this shift, Weil describes the decision by The Metropolitan Museum of Art in New York and the Museum of Fine Arts in Boston to do away with the plaster cast reproductions of famous works that they had previously collected assiduously in favor of original works. This concern for aesthetic purity created a hierarchy of value within the fine arts, based on the evaluation of objects in terms of both their utility and their uniqueness. Weil describes a hierarchy at the bottom of which are objects that are both useful and can exist in limitless quantities (e.g., the decorative arts); in the middle are objects that are unique but are also useful (e.g., crafts); at the top are objects that are both unique and useless (e.g., painting and sculpture). Weil (2002a, p. 167) goes on to assert that this hierarchy is reflected in "the different amounts and kinds of gallery space, acquisition budgets, staff salaries, and even the prestige attached to each category." The net effect of this emphasis on aesthetic purity was that the art museum began to increasingly be viewed as a palace of high culture (as opposed to popular culture) and to be associated with the elite, both as visitors and as patrons.[2]

[2] Indeed, Weil notes that about the same time, the boards of The Metropolitan Museum of Art and the Museum of Fine Arts (as well as those of other museums) began to shift from representatives of "old families," landed gentry, and professional men to representatives of great wealth.

Although occasional efforts were made to make art museums more accessible to more varied audiences,[3] the aesthetic focus described above continued to dominate the museum world for several decades. In the meantime, particularly after World War II and the improvement of America's economic fortunes, museums sprouted up around the country, drawing on a combination of public and private support. The creation of tax incentives for philanthropy as part of the new federal income tax in 1913 and 1918 was a boon for museums and other arts organizations thereafter (Jeffri, 1997). The visual arts also received a boost from the collapse of the art world in war-ravaged Europe and the emigration to America of many leading artists, collectors, dealers, and experts.[4] Increasing education levels and expanded leisure time further stimulated a wider public appreciation for art. As a result, the art museum developed into an indispensable civic institution that no self-respecting city could do without. Indeed, museums—often designed by brand name architects—have become a strategic weapon in the arsenal of urban development and the revitalization of blighted downtowns. Easily accessible and frequented by relatively diverse audiences, the concept of the museum for some has evolved into a "public square"—a fulcrum of civic life alongside places of worship and shopping malls.

During the late 1970s and early 1980s, a series of developments led museums to pursue broader public involvement and a more active role in society. Neil Harris (1999) cites three specific developments as driving this change: First, rising costs and the declining real value of endowments drove museums to dramatically expand their efforts to cultivate public support; second, public protests about the limited scope of museums' audiences and the nature of the art that they collected and exhibited provided an ideological imperative for museums to concern themselves with social equity; and, finally, the development of ideas and approaches in the international museum community provided a theoretical underpinning and an example for changing the way American museums operate. As a result, art museums today pursue a wide array of programs to expand and diversify their audiences, have adopted a more pluralistic approach to the art they collect and exhibit, and have undertaken a variety of efforts to become more involved in their communities. In sum, they have in Weil's terms attempted to transform themselves "from being *about* something to being *for* somebody" (Weil, 2002a, pp. 28–52).

[3] See Harris, 1999.

[4] Sandler, 1979. More details on the sociohistory of the New York art world can be found in Sandler's subsequent works and in Guilbaut, 1983.

The World of Arts Discourse

More than any other artistic domain, the visual arts are heavily dependent on a system of ideas and theories that validate art objects and link them to one another over space and time. This discourse is objectified in the works of art themselves, and it is manifested in a dialogue about the value of art that evolves from the linked practices of criticism, curatorship, patronage, and scholarship. Indeed, contingent on the rise of the mass media (originating in published evaluation of the salons in the late 1700s), art criticism had begun to emerge as a professional activity in the second half of the 19th century. Since then, art criticism or "discourse" has been the vehicle for expressing and refining art's ideational underpinnings. It has also played a central role in shaping what museums collect and exhibit and how the arts market values works of art.

Two ideas have played a central role in framing that discourse. The first, aestheticism, emerged in the second half of the 19th century and is sometimes associated with the rise of Impressionism.[5] Unlike academicism, which preceded it and which stressed the importance of art's subject matter, aestheticism was primarily focused on the "intrinsic perceptual value" of the object under scrutiny.[6] As Weil (2002a, pp. 170–187) notes, three ideas were at the core of the aesthetic approach: "Foremost is the notion that the true aesthetic experience must be a disinterested one, an end in itself and not instrumental toward the fulfillment of some further purpose"—in other words, art for art's sake. "A second idea . . . is that the intrinsic perceptual value of a work of fine art is determined by characteristics that are timeless and universal"—thus all art work, regardless of its origins and cultural context, shares something in common and can be evaluated with a common standard. The third characteristic of aestheticism is that "the ideal aesthetic response . . . ought also be autonomous"—that is, separate from everyday life.

As Weil sees it, aestheticism has had two major effects on the visual arts world. First, it promoted the hierarchy of value discussed in the prior section. This hierarchy values certain kinds of visual art more than others based on their aesthetic purity—a principle that has influenced what museums collect and exhibit. Second, because judgments of aesthetic quality are increasingly esoteric, aestheticism has dramatically limited the fraction of the population that takes part in the arts discourse.

The second idea, which encompasses a set known collectively as modernism, was originally developed in Europe in the late 19th century. Modernism began to gain ascendancy in American art in the aftermath of World War I. Successive formulations of modernism, which was seen as an avant-garde progression of ideas about the nature of art itself, took shape in various styles and movements. Art world

[5] See Bourdieu, 1984.

[6] This description of aestheticism relies heavily on Stephen Weil's work (2002a, pp. 170–187).

participants understood that these styles and movements fashioned a larger, forward-moving arc of art history. For much of the 20th century, this cumulative, canonical notion of art—never entirely clear or linear in the present, but framed over time as such by critics, curators, and art historians—powerfully shaped the styles of art and the value assigned to them by critics and dealers.[7]

By the 1970s, however, the supremacy of the modernist approach gave way to a more segmented and multidimensional discourse, in which a multitude of genres and aesthetic approaches began to enjoy parallel critical and commercial acceptance.[8] Since then, no single movement has claimed supremacy. Instead, as the visual arts world has expanded dramatically both nationally and internationally, new waves of arts criticism and scholarship have vied for their share of legitimacy (Szántó, 1997). In addition, art forms hitherto secondary in status to painting and sculpture—foremost, photography as well as video art, installations, and, more recently, new forms of digital art—have gained in critical and commercial acceptance. Indeed, the postmodern resistance to a linear or hierarchical arts discourse has made it possible for an unprecedented range of creative practices to compete simultaneously on the visual art world's stage. As a result, abstraction and figuration, material and conceptual art, traditional genres and new media, domestic and foreign-born artists, ivory-tower experimentation and socially engaged artistic activism all coexist in a contemporary art world with few strictures about what art ought to look like.

Likewise, historical "rediscoveries" and the search for new marketable materials beyond the exhausted supply of the old masters inventory has led to new critical and commercial interest in the forgotten artists of yesterday and in forms of decorative or "outsider" art that were earlier excluded from the mainstream. The art world has absorbed this pluralism by segmenting into a series of sub-art worlds or submarkets, each serviced by a particular network of critics and publications, collectors and galleries.[9] Growth, in other words, has not led to a larger pyramid of arts discourse, but rather to an archipelago of smaller and larger circles around a multiplicity of coexisting visual arts practices.

The Visual Arts Market

The pluralization of arts discourse has also paved the way for the emergence of an unprecedented artistic diversity, and along with it, the extraordinarily rapid expan-

[7] Wolfe (1976) discusses the role of critics in this process.

[8] A voluminous literature exists on the pluralization of arts discourse, a topic critically assessed in Arthur Danto's writings in *The Nation* and numerous books by the author, for example, Danto, 1998. Also see Levin, 1988, and Robins, 1984.

[9] For further discussion of these issues see Kramer, 1973.

sion and segmentation of the arts market. The arts market as we know it today is a relatively recent phenomenon. Although full-time art dealers emerged in Paris by the mid-18th century, and Christie's and Sotheby's saw their beginnings in the mid- to late 1700s (Watson, 1992), the system of guilds and academies gave way to a market-based arts distribution system—centered around artists, dealers, and critics—only in the late 19th century. Coincidentally, this was the time when the foundations of modernism were being laid down by painters and sculptors (White and White, 1965).

The arts market in America began to prosper around the turn of the century as several of the nation's very wealthy titans of industry became interested in art and were willing and able to spend their wealth acquiring it (Weil, 2002a, pp. 159–169). Moreover, as Weil (2002a, p. 165) points out, as some of them joined museum boards, they began

> to apply the same standards to the museum's new acquisitions that they had hith-
> erto applied to their own. What an object looked like was, of course, important.
> But so too was a firm attribution to a highly regarded artist, preferably one who
> might be considered a genius. So too was an impressive provenance, preferably
> one studded with aristocratic names. Finally, it was important that the acquired
> object be something of which nobody else might have a duplicate.

In the years that followed, the arts market both here and abroad grew in volume to supply this acquisitive urge. In the process, it swelled both individual and museums' collections and underscored the importance of what Weil has termed the "commodity value" of art.

Like any other marketplace, the arts market has developed in fits and starts, re-sponding to cycles in the accumulation of wealth, political circumstances, and phases of discovery and innovation in art itself. Booms give way to downturns and occa-sional periods of tranquility. The overall pattern of development in the post–World War II era is best likened to an upward spiral: To date, every bout of arts-market euphoria has widened the circle of patronage and produced higher prices.

Perhaps the most notable development of recent decades has been the dramatic increase in the value of the work of living masters and contemporary artists—and the related inflation in the prices of photography, media arts such as video and digital art, and serially reproduced works and reproductions. The Pop Art boom in the late-1960s already saw high values assigned to the work of young artists (Mamiya, 1992), but during the 1980s, six-figure auction prices for painters only a few years out of art school became commonplace (Tomkins, 1988).[10] The prices of the work of the top living artists quickly began to approach old master levels. The first $1 million sale of

[10] See also Hughes, 1984.

a work by a living painter, Jasper Johns' *Three Flags,* occurred in 1980. Twenty years later, another work by Johns reportedly sold for $40 million—a forty-fold increase.

These soaring prices have accompanied an expansion of the art world since World War II that has been nothing short of dramatic. Around 1946, there were about 150 art galleries in New York, and in 1961, around 300. According to recent estimates, there are 700 to 800 galleries and museums in the city today. During the early La Cienega gallery scene, after 1957, Los Angeles galleries numbered a mere handful of dealerships; today, there are at least 400 galleries in greater Los Angeles (Szántó, 2003, p. 393). Smaller cities have logged equally dramatic gains; indeed, the emergence of active gallery scenes in such cities as Portland, Denver, and Providence has constituted some of the most dramatic aspects of the expansion of the national visual arts world.

It should be noted that although the recent expansion and inflation of the arts market is unprecedented, intense competition for "stars" is in itself nothing new. Favored court painters of past centuries often lived in a regal style and, in some cases, operated industrial-scale studios. During the industrial revolution in London, then the world's visual arts capital, some painters enjoyed commissions worth millions in today's dollars. And for all the talk about "supercollectors" like Charles Saatchi, who can shape entire arts market segments, no collector today comes close to the spending power of royal patrons and early capitalist tycoons.

What is new is the rapid proliferation and specialization of actors on the art world stage. The escalation of market prices has given rise to a cast of characters befitting a modern-day cultural industry. The changes are particularly noteworthy in the contemporary market where, until relatively recently, low prices have allowed transactions to be conducted informally, via gentlemen's agreements and in the absence of the kind of complex legal and bureaucratic apparatus required to conduct a high-volume, high-value business. The last quarter century has seen, in addition to the emergence of a global pool of collectors and artists, the advent of new professional specializations. A new service economy orbits the visual arts—specialized art banking services, collectors' investment consortia, art shipping and insurance experts, art lawyers, corporate art collections and consultants, independent curators who double as dealers, public relations companies specializing in managing the reputations of artists and museums, and online inventory management and art trading services.

Distinctive Characteristics of the Visual Arts System

As this discussion suggests, the development of art museums, arts discourse, and the arts market has proceeded somewhat in parallel. Developments in the world of arts discourse have, for example, helped determine what art museums collect as well as

how they exhibit and value that work. They have also helped determine how the market evaluates different art works and correspondingly the prices for which that art is sold. Similarly, changes in the arts market have helped shape public perceptions of art and, as we will demonstrate, how museums go about attracting audiences. Perhaps most important, these three institutions have shaped the operation of the visual arts world in a way that clearly differentiates it from the other arts. These differences are manifest in how individual art works are evaluated and consumed, the skills that determine artists' prestige and earnings, and how the visual arts system is organized.

The visual arts consist primarily (although increasingly not exclusively) of physical objects; whereas the performing arts typically consist of ephemeral experiences.[11] The qualities used to evaluate individual art works in these two art forms differ markedly. Authenticity, originality, and uniqueness are key features of visual art works.[12] By contrast, key features of performing art works are the interpretation the performing artist brings to the art, the quality of that performance, and its reproducibility. In addition, given the importance attached to the authenticity of visual art works, institutions in this field, especially museums, bear a central responsibility for the preservation of the art object as well as the presentation of those objects, whereas the overwhelming responsibility of performing arts institutions is the performance of that art.

In addition, there are important differences in the ways these two art forms are consumed and distributed. In the performing arts, for example, individuals can consume the art in one of three ways: They can attend live performances; they can view or listen to recorded performances; and they can perform themselves.[13] Consumption in the visual arts, however, differs from this pattern in important ways. First, because authenticity is a central feature of the visual arts experience, reproductions of visual art works are viewed as distinctly inferior substitutes for viewing the original work. Thus, appreciating visual arts in an intermediated form—e.g., viewing art on televi-

[11] We recognize, of course, that this distinction is not always as clear as we have drawn here. Performance art, for example, is typically included within the visual arts and is often explicitly designed to be ephemeral. However, as the name suggests, performance art usually has more in common with the performing arts than with most of the visual arts. The media arts are also often ephemeral and, like some performance art, intentionally blur the boundaries among the various disciplines.

[12] Despite recent debates about the "dematerialization" of the art object and the appropriation of work from the media arts as well as widely reproducible art—e.g., photography—the emphasis on originality and uniqueness is still an important consideration for fine art in the overwhelming majority of cases. Glenn Lowry (2004), director of the Museum of Modern Art, underscores the importance of authenticity to the museum's meriting the public trust.

[13] Indeed, our study of the performing arts suggests that "hands-on" participation plays an important role in providing the performing arts to the public since "amateur" artists (that is, those who are not paid for their performance) are a major source of artists in the volunteer sector. See McCarthy et al., 2001.

sion or video—is much less prevalent.[14] Second, because visual art works are objects, individuals can collect or buy the work itself. This is not true in the same sense in the performing arts.[15] Finally, although individuals can certainly enjoy the visual arts in a "hands-on" way by painting, sculpting, etc., there is a much sharper distinction drawn in the visual arts than in the performing arts between the work of amateur versus professional artists: Amateurs' work is rarely, if ever, considered "fine art."

The nature of the artistic process also differs between these two art forms. On the one hand, visual artists are principally creators of the art. In the performing arts, on the other hand, artists can be either creators (e.g., playwrights, composers, and choreographers) or performers, whose artistry consists of their technical and interpretive skills in executing the work of the creator. This distinction is reflected in the prestige and remuneration that visual and performing artists receive. In the visual arts, these benefits accrue to the creator; in the performing arts (as we demonstrated in our book on the performing arts), they accrue primarily to the performers. Given this fact, it is not surprising that in the performing arts, the performers vastly outnumber the creators.[16]

The difference between visual art works as objects and performing art works as performances also affects the organizational structure of the visual arts system as well as the missions of visual arts organizations. Since consumption in the performing arts involves the consumer's experience of the performance (either in live or recorded form), the central missions of performing arts organizations revolve around the production and presentation of the performance. Consumption in the visual arts, in contrast, can take the form of either buying and collecting or viewing the art object. As we have discussed, these two tasks are generally performed by two very different sets of organizations: art appreciation by museums and purchasing and collecting art by the arts market. In both cases, the preservation of the original object is an essential component of the organization's mission. Organizations involved in exhibiting visual art objects have, in addition, a variety of other missions, including collection, display,

[14] We recognize of course, that reproductions of visual art works in the form of slides, books, etc. are abundant. But unlike the performing arts—where reproductions of original works, e.g. recordings, are often the principal form in which the public appreciates the work—in the visual arts, reproductions are principally used by scholars, students, and others directly involved in the visual arts system. To the extent that the general public buys "art books," we suspect that these consumers develop their taste through in-person visual art experiences. Even then the art books may often serve primarily as coffee table displays.

[15] Of course, a script or an original composition can be purchased, but in that case, the work of art as a performance is not being consumed but rather collected.

[16] Moreover, if considered artistically rather than economically, performance artwork is usually designed to require more people to perform it (actors, dancers, musicians, singers, etc.) than to create it. Some would argue that composing or choreographing, for example, is a far more difficult endeavor, achieved by relatively few; so the difference in numbers is more a function of artistic skill rather than economic rewards.

education, and interpretation;[17] while organizations involved in buying and collecting are principally dedicated to facilitating the sale of the artwork. Similarly, the principal asset of visual arts organizations is their collection of art objects. By contrast, the principal asset for most performing arts organizations lies primarily in the artists affiliated with the organization. Put in economic terms, visual arts organizations' principal assets are physical capital, while performing arts principal assets are human capital.[18]

Given the importance of the visual arts object, it is not surprising that the relative attraction of museums depends on the size and quality of their collections; in contrast, the relative attraction of performing arts organizations depends on the quality and renown of their performers. Indeed, because visual arts objects are not ephemeral, there is an ongoing discourse in the visual arts about art objects and how they compare with what has preceded them. These connections are constantly reinforced by art history, theory, and criticism. The role of critics in these two art forms differs markedly as a result. Criticism in the performing arts, at least in terms of evaluations of specific productions, can often be the decisive factor in determining whether the production enjoys success. In the visual arts, critics do not have this sort of power (no art critic can close down a show), but they have traditionally played a longer-term role in shaping the discourse about the relative merits of different artists and their work.[19]

In the balance of this book, we build on these insights to examine four key features of the visual arts system: first, patterns of demand (both appreciation and collecting); second, the characteristics of artists; third, the operation of the arts market; and finally, museums and other visual arts organizations.

[17] To a much greater degree than in the performing arts, a background in the visual arts is important to the appreciation process. As Arthur Danto (1986) has stated, art requires an understanding of an "atmosphere of theory" to comprehend what the viewer is looking at, indeed, even to answer if the object in question is "art." The performing arts, by contrast, do not require this level of background to gain a basic appreciation for the work.

[18] Museum curators, of course, often develop considerable human capital, but that capital is applied to the education and interpretation function, not to the creation function.

[19] In *The Painted Word,* Tom Wolfe (1976) provides an amusing survey of 20th century art criticism through the early 1970s.

Demand for the Visual Arts

As discussed in the last chapter, demand for the visual arts has increased dramatically over the last century as the number of consumers—both those who attend museums and those who purchase fine art—has soared and their characteristics and behavior have shifted. As we also indicated, the organizational structure and operation of both museums and the arts market have changed in conjunction with these shifts in demand. Thus, we might reasonably expect that future changes in public demand will, correspondingly, shape the organizational ecology of the visual arts in the future.

This chapter focuses on patterns of demand for the visual arts. After a brief discussion of concepts used to define and measure demand, we address three questions: What do patterns of demand look like today? How has that demand been changing? What issues are these changes likely to raise for the future?

Key Concepts

Forms of Participation

Public involvement in the arts can take several different forms. Individuals may be involved as producers (at a professional or amateur level), as consumers (by visiting a museum, watching a television program on the visual arts, or purchasing and collecting art works), and as supporters (by donating time or money to art organizations) (Balfe, and Peters, 2000). Although individuals who are involved in one form may also be involved in another, demand for the arts is typically gauged by examining patterns of consumption—which are typically measured in terms of the form and levels of consumption and the characteristics of the consumers.

As we discussed above, the principal forms of consumption in the visual arts differ somewhat from those in the performing arts. First, because visual art works are principally objects whose authenticity and originality are highly valued,[1] visual art

[1] See, for example, Moulin, 1987.

works can be bought and collected in a manner that is not true of the other arts.[2] Indeed, as we will discuss in greater detail later, the role the market plays in the visual arts has no direct parallels in the other arts.

Second, the visual arts, like the performing arts, can be appreciated either by viewing them in person or in reproduced form. Although appreciation in person is generally preferred in either case, this preference appears stronger in the visual arts. Indeed, firsthand encounters with works of art in traditional art venues have remained the primary mode of appreciating visual art works—with the exception of web-based art.[3] This preference is largely a result of the importance the visual arts place on the authenticity of the original work of art itself—something that is not true of the performing arts, where the vast majority of performances are interpretations of the original work.

A third distinctive feature of visual arts consumption is the role played by what is sometimes referred to as "hands-on" participation. As we noted in our analysis of the performing arts, performers who are unpaid (or willing to work for reduced pay) often play a significant role in the production of the performing arts, especially in smaller performing arts organizations. Although a small fraction of the American public states that they have "hands-on" involvement with the visual arts, this involvement is more likely to be regarded as a source of individual enrichment and enjoyment than as part of the professional visual arts environment. As noted in the Introduction, objects produced by amateurs are not typically considered fine art works.

Thus, there are two principal forms of consumption of the visual arts: (1) viewing original works of art primarily (but not exclusively) in museums and galleries and (2) buying and collecting art.

Levels of Participation

Three different metrics are used to measure levels of participation:

- Absolute level of consumption—typically measured in terms of the total amount of participation, e.g., total numbers of museum attendees or art purchasers
- Rate of participation during a given period, typically reported as a percentage of the population (or subpopulations) who participate

[2] We recognize, of course, that original scripts and scores are often highly valued by collectors, but that value derives from their historical rather than their artistic significance.

[3] Arts books sold in conjunction with an exhibit or in bookstores are another form of consumption that may serve scholars, museum visitors purchasing a souvenir, or art lovers who enjoy browsing the photographic reproductions from their coffee tables. However, such consumption is a small subset of participation through appreciation.

• Frequency of participation among those who actually participate, such as the average number of visits attendees made to museums in the last year.

These different measures are related because changes in the overall level of consumption can be expressed as the product of the number of participants and the average frequency of participation. Moreover, changes in the number of participants, when expressed as a participation rate, may be due either to a change in behavior (a higher participation rate) or to a change in the size or composition of the population.

In fact, changes in total consumption levels may be due to any one of four different factors: changes in the size of the population, changes in the composition of the population, changes in the rate of participation among specific subpopulations, and changes in the frequency of participation for a subgroup. Understanding these distinctions is important because the conclusions drawn about how and why consumption patterns may be changing will differ depending on the mechanism that is driving the change.

Changes due to growth in the size or composition of the population do not represent behavioral change but are the by-products of broader population shifts. However, changes due to participation rates indicate that the fraction of the population participating in the arts has itself changed. Changes due to increasing frequency of participation suggest not that more people have become involved in the arts but that current participants have changed their behavior. Because all these factors are likely to come into play, it is useful to understand these distinctions when attempting to understand changes in participation patterns.

Characteristics of Participants

In addition to understanding how levels of demand vary across forms of participation, it is also important to identify the sociodemographic and other characteristics associated with participation. Historically, education has proven to be the single best predictor of participation in the fine arts, but studies have demonstrated that a variety of other attributes are also correlated with arts involvement, including income, race, age, and family characteristics.[4]

Factors That Influence Participation

Finally, a number of factors influence patterns of demand in the aggregate. Although most empirical studies focus on who participates rather than why they participate, the following factors have been used to explain changes in participation patterns:

[4] See McCarthy, Ondaatje, and Zakaras, 2001.

- Sociodemographic changes, e.g., changes in the size and composition of the population
- Changes in taste, e.g., preferences for the arts and specific styles of art
- Changes in such practical considerations as the supply of the arts (e.g., the hours and locations of museums and galleries and the cost of attendance), the availability of leisure time, income levels, and the dissemination of information about the arts.
- Changes in the stock of individual experience with the arts (arts education, prior experience, and knowledge).

Because available information about these measures varies considerably, our description of demand patterns focuses on the two primary forms of visual arts participation—appreciation, as measured by museum attendance, and art collecting; levels of participation (particularly rates and frequency of participation); and the characteristics of visual arts consumers (museum attendees and art purchasers). Moreover, because there is much more systematic empirical data available on museum attendance than on art collecting, our analysis of the former relies more extensively on such quantitative data sources as the *Survey of Public Participation in the Arts* (SPPA) (National Endowment for the Arts [NEA], 2003)[5], while our analysis of art purchasers and collectors relies primarily on journalistic sources.

The Current Picture

Many More People Are Involved in Appreciating Than in Collecting

Attending museums, art fairs, and galleries is the most typical form of public involvement with the visual arts. Fully 43 percent of American adults attended visual arts events at least once in 2002, the last year for which data are available.[6] As shown in Figure 3.1, nearly one-third more Americans attended a visual arts event than a performance. The fraction of Americans who attended a visual arts event is also substantially higher than those who watched at least one television program about the visual arts (25 percent), the next most frequent visual arts activity. We note that this apparent preference for viewing exhibitions of art in person differs sharply from the pattern of participation in the performing arts, where almost twice as many individuals listen to or watch a recorded performance as attend in person.[7]

[5] The NEA began sponsoring the SPPA in 1982 in response to the acknowledged need for a systematic national survey of public participation in the arts. It has been fielded every five years since that time. For a review of this and other arts participation sources, see McCarthy, Ondaatje, and Zakaras, 2001.

[6] SPPA data are based on a representative sample of the national adult population (over 18 years of age).

[7] See McCarthy et al., 2001.

Figure 3.1
Percentage of the U.S. Adult Population Attending Performing and Visual Arts Events

NOTE: Calculations are based on data from SPPA, 2002 (NEA, 2003).
RAND *MG290-3.1*

Americans are also three to five times more likely to engage in both of these forms of appreciation, however, than they are to become involved in a "hands-on" way (painting, sculpting, or drawing).[8] Finally, about 21 percent of all Americans own "an original piece of art." However, it is not clear what the respondents to the Survey of Public Participation in the Arts had in mind when they referred to an "original piece" of art. It is likely that this figure is far in excess of the proportion of Americans who participate in the "elite" fine arts market.[9] As Halle (1993) has demonstrated, Americans own a diverse collection of prints, photographs, landscapes, and

[8] In addition to the 9 percent who at least occasionally paint, sculpt, or draw, 12 percent take photographs, and an even larger percentage are involved with the crafts of pottery (7 percent) or sewing (18 percent), according to the 2002 SPPA (NEA, 2003).

[9] We use the phrase "elite" here not in a class-based sense but rather to denote inclusion within the narrowly defined world of the art specialist. This is the world of arts discourse that we described above. The elite market is connected with the prevailing aesthetic dialogue, in which the art world's validators—critics, curators, and certain dealers and collectors—play a role. It is elite insofar as it is much narrower than the general arts market. However, we also acknowledge, as Bourdieu and others have noted, that there are also significant differences in art appreciation and art purchasing patterns among different socioeconomic groups. Bourdieu, 1984; see also DiMaggio, 1986.

other materials—very few of which could be considered fine art.[10] As we will discuss later, the fraction of Americans who are involved in the arts market is likely to be a tiny fraction of this figure.[11] Indeed, for the vast majority of Americans who are involved in any way with the visual arts, it seems fair to say that this involvement entails occasionally attending a museum or art fair and, perhaps, watching a television program about the visual arts.

However, the range in variation of participation in the visual arts is not captured by a tally of the proportion of the population who attends a museum once a year. As we have noted in previous studies, Americans can be sorted into three categories based on the frequency with which they participate in the arts: those who rarely if ever participate, those who participate occasionally, and those who are frequent participants.[12] The sum of these latter two categories accounts for the 43 percent who attended at least one art exhibit a year—a percentage that exceeds the comparable figure for attending a live performing arts event (32 percent). Figure 3.2 indicates that, among those who do participate in both art forms, the average frequency of attendance is higher in the performing than in the visual arts (5.0 visits per year versus 4.1).

To the extent that we can generalize from this comparison, it suggests that occasional participation is more common in the visual than the performing arts. Although we know of no definitive studies of this phenomenon, there are several reasons why the visual arts may be more accessible to casual participants. First, "blockbuster" exhibits, which have been an increasingly important part of art museums' programming, appear to have considerable appeal to casual attendees.[13] Second, American consumers appear to place a premium on flexibility in their consumption of the arts.[14] That is, they tend to choose art forms and modes of participation that allow them to determine what they consume, when they consume it, and how they

[10] Halle's work also indicates that there are clear differences, by household socioeconomic status, between the types of art that are collected.

[11] Watson (1992), for example, has quoted Michael Ainslie as stating that there were roughly 400,000 serious collectors worldwide in 1992. He defines serious collectors as those who have spent at least $10,000 dollars on art. Although Watson's estimate is for the world as a whole, even if all these collectors were located in the United States, this would be equivalent to less than 3 percent of the population.

[12] See McCarthy and Jinnett, 2001; and McCarthy et al., 2001.

[13] "Blockbuster" exhibits are defined more by intent than by actual number of visitors. For example, a small museum's blockbuster might constitute the weekly attendance of a museum like the Metropolitan Museum of Art in New York. Blockbusters are noteworthy for works of widespread appeal (Impressionists or Egyptian antiquities). Often most, if not all, the works in the exhibit are borrowed, unless a museum already has an outstanding collection in a popular area; in some cases, the entire exhibit might come from another museum, a single collector, or even a private company (e.g., Clear Channel's Vatican exhibit). Blockbusters involve marketing campaigns to attract visitors and often involve a separate admission ticket and price.

[14] See Robinson and Godbey, 1997.

Figure 3.2
Frequency of Attendance for the Performing Arts and the Visual Arts

NOTE: Calculations are based on data from SPPA, 2002 (NEA, 2003).
RAND *MG290-3.2*

consume it. This preference is likely to be especially true for occasional arts partici-
pants, which would lead them to select museum attendance over the performing arts
since museum attendance involves less scheduling, requires less time, and allows
them to choose among a variety of works of art. Finally, price may be a factor in a
preference for attending visual arts events. Admissions to museums, while rising in
recent years, are still substantially lower than tickets to the ballet, opera, or theatre.
Only rarely will museum admissions cost more than $15 or $20 for a special exhibit,
and many museums still offer free admission or unlimited free admission with mem-
bership. Moreover, visiting a gallery or browsing through most art fairs has typically
been free of charge.[15]

[15] This pattern may be changing as museums, faced with increasing costs, have begun to charge admission fees
not only for special exhibits but also for general admission. The Museum of Modern Art in New York, for exam-
ple, has instituted a $20 general admission fee for its recently remodeled building.

In the Sociodemographics of Appreciation, Education Appears to Be the Key
Previous research suggests that education tends to be the most important correlate of arts participation.[16] Our own research on the performing arts (McCarthy et al., 2001) supports this finding, as does Schuster's research (1991) on museum attendance. Furthermore, our analysis of the most recent SPPA data on museum attendees confirms this pattern (see Table 3.1). These data show that although museum attendees look a lot like the total population in most respects, they do differ in two important ways: they are better educated and have higher incomes.

Although income and education tend to be closely related, our multivariate analysis indicates that of these two variables, education is the most important.[17] Indeed, the effects of education become progressively stronger the higher the level of education attained. For example, compared with those who have less than a high school degree, those with a high school diploma are 10 percent more likely to have visited a museum in the past year, those with some college 25 percent more likely, those with a college degree 38 percent more likely, and those with some graduate education 45 percent more likely.[18]

It is not entirely clear what drives this education effect. More highly educated individuals are more likely than others to have been exposed to the arts by family

Table 3.1
Demographics of Visual Arts Appreciation: Art Museum Attendance

	Total SPPA Population	All Art Museum Attendees[a]	Frequent Attendees[b]
Male	45%	42%	41%
White	86%	90%	91%
Married	58%	61%	59%
Age (median)	47 years	46 years	45 years
Income (median)	$44,140	$53,695	$55,395
College graduate	26%	49%	55%
Total	100%	27%	17%

NOTE: Calculations are based on data from 2002 SPPA (NEA, 2003).
[a] Attended at least once in the past year.
[b] Attended more than once in the past year.

[16] See, for example, the 1997 SPPA (NEA, 1998). For the relationship between education and the various performing arts, see Deveraux, 1994; Holak, Havlena, and Kennedy, 1986; Keegan, 1987; and Lemmons, 1996.

[17] This analysis is based on probit regression. The model regresses visual arts attendance on a vector of sociodemographic variables including income, education, race, gender, age, and marital status.

[18] These effects are essentially the same for frequent attendees and all attendees. That is, education appears to distinguish those who attend museums from those who do not but does not appear to be more strongly related to the number of visits made per year.

members during their childhood and to have taken courses in the arts during their schooling. This early exposure to the arts is important because familiarity and knowledge of the arts are directly related to participation rates, as they are for most other forms of leisure activity.[19] Indeed, Orend and Keegan (1996) find that arts appreciation classes taken during college have an even stronger effect on subsequent participation than those taken earlier—a finding that we confirm in our analysis of museum attendance using the 2002 SPPA (NEA, 2003) data.

At least two different factors may be operating here. First, the more knowledgeable people are about the arts, the more likely they are to participate, because they gain more satisfaction from a given level of consumption than do people who are less knowledgeable.[20] This argument suggests that knowledge and taste are related and that education shapes knowledge and thus tastes. A second argument focuses more on social standing and background and the role that knowledge of the arts can play as a sign of cultural capital and social distinction.[21]

Two studies that examine how tastes change with education and across backgrounds are relevant to these issues. In the first study, Winston and Cupchink (1992) find that the tastes of inexperienced and experienced viewers differ notably. Experienced viewers value the complexity of art objects, believe that visual art should provide a challenge to viewers rather than providing "warm feelings," and prefer "high art." Inexperienced viewers value the emotional response they get from looking at art ("warm feelings"), and they prefer sentimental and wildlife paintings. Perhaps most important, Winston and Cupchink found that after just a few hours of college-level arts appreciation classes, inexperienced viewers' tastes tended to transform into those resembling experienced viewers.

A second study by Pierre Bourdieu (1984) compares the extent to which viewers' focus on the literal versus the abstract aspects of art. Bourdieu found that viewers with cultural capital, that is those who have a familiarity with arts appreciation from an early age, tend to focus on the abstract aesthetic quality of the art; while those who lack this background are much more likely to focus on the literal. Thus, for example, when presented with a black and white photo of an old woman's thickly veined hands, respondents who lack a background in the visual arts are much more likely to relate the picture to their prior experience ("It reminds me of my grandmother's hands"); while those with a more extensive background in the visual arts are more likely to describe the picture in terms of its aesthetic qualities ("It's a study in form, light, and shadow").

[19] See Orend and Keegan, 1996, for the relationship between education and arts participation and Kelly and Freysinger, 2000, for the relationship between knowledge and leisure activity.

[20] See Stigler and Becker, 1977.

[21] See Bourdieu, 1984.

There Are Many Different Types of Collectors

As we noted above, 21 percent of the population surveyed in the 2002 SPPA (NEA, 2003) (or roughly 42 million Americans) reported that they own an original piece of art. This figure, as we have already suggested, is far in excess even of the most generous estimate of 400,000 serious collectors worldwide.[22]

The existence of not one arts market but several explains this apparent discrepancy. Precisely defining these various markets is probably impossible. However, at the most basic level, we can distinguish between the broad commercial arts market and the market for "fine art"[23] (or what is also called the "elite" market). As we will discuss in greater detail in Chapter Five, these markets can be distinguished by the styles of work, the artists whose work is sold, the intermediaries who deal in these different works, and, most important from the art world's perspective, whether they are recognized and reviewed by "qualified judges".[24] These qualified judges are at the center of the discourse about art that we described in Chapter Two. Their validation of objects as "art" places them in the context of art history. Although objects in the general commercial market may emulate fine art objects, they are not part of this narrower world of discourse.

Each of these arts markets can, in turn, be disaggregated into assorted submarkets by the styles of work. For example, the fine arts market can be sorted into submarkets for contemporary, modern, Impressionist, old masters, etc. Similarly, the general commercial market might be distinguished in terms of particular themes—e.g., landscapes, still lifes, and Western art.

From a demand perspective, there is another major distinction between these two markets: the prices they command. Although there is variation in both of these markets, the prices paid in the general commercial market are typically quite modest; whereas the prices paid in the fine arts market are typically quite high.[25] Given this price differential, we surmise that the 21 percent figure mentioned above refers to individuals who at one time or another purchased or obtained an original work of art from the general commercial market.[26] However, since the SPPA data refer to owner-

[22] Watson estimates that there are roughly 400,000 collectors worldwide who spend at least $10,000 a year on art. See Watson, 1992.

[23] Moulin, for example, distinguishes between what she refers to as the "nonart" and the fine arts markets. See Moulin, 1987.

[24] This phrase "qualified judges" is borrowed from Moulin (1987). Szántó (1997) refers to work in the "high art" market as "legitimate," meaning artwork that "is deemed fit to be appraised in terms of the prevailing aesthetic. Legitimacy, in short, is the privilege of being judged."

[25] This general point is made in Moulin (1987). However, systematic data on art prices are generally unavailable in the general commercial market, but impressionistic evidence suggests that the price range varies from under $100 to $5,000 or $10,000. Prices in the fine arts market can vary from a few thousand dollars to over $100 million dollars. For prices in the fine arts market see, for example, Dobrzynski, 1999; and Vogel, 2000 and 2002.

[26] Halle's (1993) description of the art owned by the families in his samples seems to confirm this point.

ship rather than purchasing or collecting, the actual number of individuals who regularly purchase or collect from the general market is, no doubt, only a fraction of this figure.

Whatever the size of the general market, the number of collectors and regular buyers in the fine arts market is much more circumscribed. Moreover, as prices rise, the number of potential buyers dwindles. After citing Ainslie's estimate of 400,000 buyers worldwide who spend $10,000 a year as an upper limit, Watson (1992, p. 419) continues:

> This is too large and too disparate a group to be studied systematically; the best one can do is to fall back on the lists of collectors published by the art magazines. Allowing for overlap and changes from year to year, these lists provide a microcosm of between 250 and 350 very serious collectors, whose collections are worth millions.

Sandler (1996, p. 426) also suggests the select nature of the buyers in the elite market by quoting Diana Brooks, former president and chief executive officer of Sotheby's, who estimated that there were roughly 100,000 serious private clients in the auction market in the mid-1980s. Brooks was also quoted by Decker (1998a, p. 116) as saying that there are only 20 to 30 people in the market for paintings worth $5 million and 10 to 15 for those over $10 million.

Wealth Is the Key Characteristic of Collectors

Not only does the number of individuals in these two markets differ but so do their characteristics. An analysis of the SPPA data suggests that the 21 percent of the population who own original art are older, better educated, have higher incomes, and are more likely to be white than the general population. Although there is no systematic information on the characteristics of buyers and collectors in the fine arts market, the journalistic evidence indicates that they are even more distinctive than the former group in several ways.

The most obvious characteristic of these high-end art collectors and buyers is their wealth. They clearly have incomes and assets that place them in the upper reaches of Americans' income and asset distributions.[27] A second key feature of the high-end collectors is their international backgrounds. Unlike the general commercial market, which as Moulin notes has a distinctly regional character, the elite market is truly international in scope.[28] Third, institutions—especially corporations—are important players in the elite market. Watson, for example, asserts that in the early

[27] See, for example, Smith, 1987.

[28] Watson, 1992, demonstrates this point, noting that the three largest collectors of American contemporary art in 1990 were all non-Americans: Charles Saatchi in London, Peter Ludwig in Germany, and Count Giuseppe Panza di Biumo in Italy. See also Finn and Katayama, 1986 and 2004.

1990s, corporations accounted for 20 to 30 percent of the business in New York galleries and as much as 40 percent elsewhere.[29]

The elite market can also be described in term of the tastes and motivations of collectors. Watson (1992, p. 420), for example, describes three different groups of collectors in terms of their tastes:

> Collectors of contemporary art being the first and largest. Collectors . . . who are not at all interested in contemporary art and have the funds and the appetite to acquire the very best in their chosen field. . . . And a third group, characterized by the idiosyncratic nature of their collections.

Watson (1992, p. 419) further states that

> collecting contemporary art is twice as popular as collecting Modern—that is twentieth century—art; three times as popular as collecting Impressionists and four times as popular as collecting Old Masters. Good Old Masters are much harder to come by these days, of course, and the religious content of many Old Masters is unappealing to many buyers. The high price of Impressionist and Modern works probably accounts for some but by no means all of the appeal of contemporary art.

In addition to tastes, the motivations of collectors in the elite market appear to differ. Moulin (1987), for example, describes several different groups of collectors in her analysis of the French arts market—including prestige purchasers, fashion imitators, scholar collectors, discoverers of the avant-garde, snobs, and speculators. Sandler and Watson also distinguish among different classes of collectors, emphasizing distinctions among connoisseur collectors, status collectors, and investors. Connoisseur collectors are those who have been collecting for a long time, are reasonably knowledgeable about art, and generally avoid notoriety. Status collectors tend to be more recent collectors and are more attuned to trends in the market. Investors are those whose interests are tied less to the art and more to the possibility of making money by buying and later selling their art. Of course, an individual may start out as one type of collector and later shift to another category. Indeed, as collectors become more experienced in the market and their level of knowledge and appreciation grows, they are likely to move toward the connoisseur category.

We now turn from an examination of the characteristics of current demand to a description of how current patterns have been changing. In addition to describing these changes, we also attempt to identify why those changes have been occurring.

[29]Watson, 1992, p. 422. See also D'Arcy, 1997, and Gimelson, 1994.

Key Trends

Museum Attendance Has Been Rising

There are two ways to compare changes in visual arts appreciation. The first is to examine growth in the total number of people who visit museums; the second is to examine changes in the rate or proportion of the population who visit museums. Both comparisons are useful, but they describe different phenomena. Changes in total attendance address the issue: how many people participate in the visual arts and how is this number changing? Changes in the rate of attendance indicate that the relative attraction of visiting museums has been changing.

Total attendance can increase for several reasons including overall population growth, changes in the composition of the population, or an increase in the rate at which the population attends museums. Changes due to the first two of these factors have less to do with the increasing popularity of museums and the visual arts but reflect broader sociodemographic changes in the population. Changes due to an increase in the rate at which people attend museums reflect a direct change in behavior, specifically an increase in the population's propensity to visit museums.

Figure 3.3 shows how both of these measures of museum attendance have changed during the last 20 years. As this comparison makes clear, the total number of art museum attendees has risen by almost half between 1982 and 2002 (from approximately 38 million visitors to close to 56 million). This increase is substantially greater than the increase for all of the performing arts and helps contribute to the perception that appreciation of the visual arts has been booming. However, despite this increase in total visitors, the rate of attendance has only increased by 20 percent over this period (from 22.4 to 26.9), and almost all of this change in rates occurred between 1982 and 1992. Over the last decade, the rate of museum attendance appears to have largely stabilized. Indeed, almost two-thirds of the total increase in the number of attendees occurred between 1982 and 1992 (11.5 of the 17.8 million total increase).

Blockbuster Exhibits Appear to Have Increased Museum Attendance[30]

Blockbuster exhibits, of course, have become increasingly popular during the last decade (the number of blockbuster exhibits drawing over 200,000 visitors increased

[30] In several respects, blockbuster exhibits are the visual arts' equivalent to the star-studded spectacular of the performing arts.

Figure 3.3
Rate and Number of Visitors to Museums

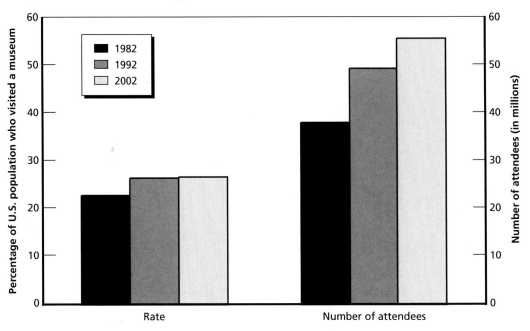

NOTE: Calculations are based on data from SPPA, 1982, 1992, and 2002 (NEA, 1983, 1993, and 2003).
RAND *MG290-3.3*

from 14 to 31 between 1996 and 1999).[31] Although the museum attendance numbers collected annually by *The Art Newspaper* from the museums themselves are not directly comparable to SPPA attendance figures, it appears that a substantial share of the total attendance increase at museums between 1992 and 2002 was due to the popularity of blockbuster exhibits.[32] Indeed, since the total fraction of the population attending museums hardly increased during this period, these data suggest that a large share of those visiting blockbuster exhibits were, in fact, return attendees. This possibility is also suggested by the fact that the average number of visits by those who

[31] Dobrzynski (2000) reports that the number of special museum exhibits that drew more than 200,000 attendees "has grown from 14 in 1996, to 18 in 1997, to 21 in 1998, to 31 in 1999." Also see Dobrzynski, 1998, and Jones, 2003. Dobrzynski finds that the largest single blockbuster was the Los Angeles County Museum of Arts van Gogh exhibit, which drew over 800,000 attendees. At least a dozen others have drawn over 300,000 visitors. Attendance is tracked for the duration of the exhibit, whether it is several months or more than a year. Some care must be taken in relying too heavily on museum attendance statistics, both in general and for blockbuster exhibits since, as Anderson (2004) has pointed out, museums rely on a variety of techniques for measuring attendance, and the numbers reported may not always be reliable.

[32] Assuming that the average attendance at blockbuster exhibits (defined as those that attracted at least 200,000 visitors) was 250,000 (likely a conservative assumption), then the increase in the number of such exhibits between 1996 and 1999 would have added approximately 4 million to museum attendance.

visited museums between 1992 and 2002 increased from 3.3 visits to 4.1 visits per year.[33] The combination of more frequent blockbuster exhibits and a higher number of average visits per attendee suggests that the strategy of increasing blockbusters may well be increasing the number of return visits among museum attendees. However, this conclusion also raises questions about just how broad based the increase in museum attendance over the last decade has actually been.

The Increase in Total Museum Attendance Appears to Be Due More to Population Growth and Rising Education Levels Than to a Higher Rate of Attendance

As we noted above, the increase in total museum attendance could be a product of any combination of three factors: first, growth in the total population; second, increasing education levels among the population; and/or third, higher rates of attendance among the various education groups. Because each of these three factors depends on different dynamics, their relative importance not only gives us a clearer picture of why attendance rates have been increasing but also of how they might change in the future. Attendance growth due to growth in the overall population, for example, would indicate that the rise in museum attendance is driven more by an expanding population than the increasing attraction of museums. Attendance growth due to higher levels of education, however, underscores the importance of education to visual arts consumption and suggests that as long as education levels in the population continue to rise, so will museum attendance. Lastly, attendance growth due to higher rates of attendance suggests that more people are attending museums at all levels of education and thus, that museums are becoming a more attractive alternative relative to other activities across the population.

Table 3.2 compares the importance between 1982 and 2002 of each of these factors in the growth of total museum attendance and attendance levels for five different performing arts' live performances.[34] These data indicate that about 60 percent of the total increase can be attributed to the growth of the population during this period,[35] and the rest are the result of increasing levels of education. In contrast, the actual rates of attendance among the various education groups actually declined slightly in the aggregate over this period. In other words, the growth in museum at-

[33] These estimates are based on comparisons of the average frequency of attendance reported in the 1992 and 2002 SPPA data (NEA, 1993 and 2003).

[34] These computations are made by disaggregating the total change in attendance between 1982 and 2002 into three components: first, the amount of the change due to growth in the total population; second, the amount due to increases in the proportion of the population in each of the different education categories (less than high school graduate, high school graduate, some college, college graduate, and more than 16 years of schooling); and third, the amount due to changes in attendance rates for each of these education categories.

[35] Between 1982 and 2002, both the total resident and total adult population of the United States increased by about 26 percent. Calculations are based on data available at www.census.gov/statab/hist/HS-03.

Table 3.2
Decomposition of Change in Total Attendance
(in millions)

	Total Visitors, 2002	Change from 1982–2002	Controlling for Population Growth, Total Increase in Visitors	Controlling for Growth in Education Levels, Total Increase in Visitors	Controlling for Both,[a] Changing Rate of Participation
Museum	55.9	16.9	10.2	8.1	−1.4
Classical music	24.3	2.2	4.4	4.2	−6.4
Opera	5.6	0.5	1.0	1.2	−1.7
Theater	25.8	5.7	4.7	4.1	−3.1
Ballet	7.8	0.7	1.4	1.3	−2.1
Jazz	21.6	5.8	3.9	3.5	−1.6

NOTE: Calculations are based on data from SPPA, 1982, 1992, and 2002 (NEA, 1983, 1993, and 2003).
[a] Population growth and growth in education levels are controlled for.

tendance between 1982 and 2002 was due entirely to population growth and rising education levels among the population. In fact, holding education and population constant, the overall rate at which individuals of different education levels attended museums actually declined—primarily because of slightly lower rates of attendance among the less educated.

These findings provide a somewhat less rosy base for projecting future growth in museum attendance than that suggested by the increase in total attendance alone. Instead, they indicate that museums have had less success in raising interest levels among the various educational groups, especially those with less education, than the overall numbers might indicate. Indeed, as Weil has pointed out, the better educated remain the core audience for museums—despite the various efforts museums have taken in recent year to diversify their audiences and increase attendance among lower-income and minority segments of the population.[36] One factor that may help account for this apparent lack of success is that large segments of the population feel uncomfortable with the atmosphere of museums and believe that museums are not welcoming to those who are not knowledgeable about the arts.[37] In addition, as Toffler (1964) has suggested, the rise in college attendance and exposure to visual arts appreciation courses among the American population have increased the exposure to and subsequent appreciation of the visual arts among the better educated segments of the population.

Changes in leisure time and leisure options are other factors that may help explain museums' failure to expand their reach among the less well-educated and mi-

[36] For a discussion of the continued socioeconomic selectivity for museum attendance, see Weil, 2002a, pp. 170—187; for a discussion of museum efforts to diversify their audiences, see Neil Harris, 1999.

[37] For an example of this phenomenon, see Getty Center for Education in the Arts, 1991.

nority segments of the population. Although the growth in leisure time that Americans have enjoyed for much of the 20th century has reversed for some segments of the population, it is unclear whether this is true for Americans in general.[38] Most observers agree, however, that as a result of irregular working schedules, the structure of free time has become increasingly fragmented—especially for the more highly educated, who are the heaviest consumers of the arts (Robinson and Godbey, 1997; Schor, 1991). The perception of reduced leisure time and the increasingly home-centered focus of leisure activities have no doubt increased the competition that the arts face from other leisure time pursuits.[39] In addition, the entertainment and leisure industries have dramatically expanded the options that Americans have for using their leisure time.

A key issue for the future may well be the incompatibility between the importance of in-person visits to see original art works and Americans' increasing propensity to entertain themselves with electronic media at home. Although audiences stretched for time can more easily fit in a museum visit than a theater performance, it is also true that unlike a performing arts experience, people do not tend to substitute an electronic for an in-person visual arts experience. However, technology could provide a gateway to the museum experience by allowing potentially interested consumers to obtain an inside view of a museum's collection and/or educational information about the visual arts to overcome the perceptual barriers some people might have. Nevertheless, unless the visual arts can expand their attraction to a broader educational cross-section or enhance the substitutability between personal and intermediated visual arts experiences, there may well be a ceiling on the potential growth of museum attendance.

Of course, improvements in technology could expand the reach of the visual arts. Such changes as expanded broadband capacity and improved transmission quality may improve the quality of reproductions and thus reduce the difference between the original and the reproduction—just as such improvements have reduced the difference in quality between live and recorded performances. Indeed, the arts market appears to already be using the Internet to show works for sale to potential buyers. However, such developments seem more likely to be used by those who have already developed a taste for "fine art" than they are by those who are less knowledgeable. Moreover, given the differential access to computers by income and education level, it seems unlikely that technology alone will increase the fine arts appeal to the less well-educated and lower-income segments of the population.

[38] For opposing views on this issue, see Robinson and Godbey, 1997, and Schor, 1991. Robinson and Godbey argue that with a few notable exceptions, Americans have as much leisure time as in the past. Schor argues that Americans have less.

[39] See Putnam, 2000.

As Table 3.2 also demonstrates, however, museums have fared better in this respect than the performing arts. Not only has the increase in the number of museum attendees been larger than the number of attendees at live performances, but the decline in rates of participation has also been less steep. As we suggested above, this apparent advantage for the visual arts is largely a result of the greater flexibility museums offer consumers in terms of scheduling, the amount of time spent, the range of options available, and the cost of admission. Thus, although the future museum attendance picture may not be as rosy as the total attendance figures suggest, demand for the visual arts and museums appears to be more resilient than for the performing arts. Nevertheless, if past trends are an indication of the future and in the absence of efforts to change tastes and enhance demand among less educated segments of the population, future growth in visual arts appreciation and museum attendance appears to depend on continued population growth and increasing education levels.

Demand in the Arts Market Has Grown Dramatically over the Last Three Decades
Although comprehensive statistics on the size and growth of both the general commercial and elite arts markets are not available, journalistic accounts of how the market has changed since the early 1980s, particularly the elite market, are abundant.[40] The picture that these accounts paint is of a market exploding throughout the 1980s, plunging during the early 1990s, and then surging ahead more steadily but just as assuredly into the new century. The chief indicators of these changes are the increasing volume of sales, the growing number and diversity of collectors/buyers, and, most particularly, the explosion of prices.[41]

Figure 3.4 tracks the rise in art prices and compares them to the changes in equity prices from the early 1950s to 2002. These data document the 1980s boom, early 1990s bust, and subsequent rise in the late 1990s and into 2000. Between 1982 and 1989, for example, the Mei and Moses art price index increased six-fold (from an index value of 50 to a value of 300). It subsequently fell close to 40 percent during the early 1990s (from a value of 300 to a value of 180), and then rose over 90 percent from the mid-1990s to 2001. As Figure 3.4 also shows, this rise was greater than the increase in stock prices over this period, although art prices were generally more volatile.

Hughes (1984, p. 2) has pointed out that arts markets have flourished in the past: "some modern art prices are by no means as fantastic when compared to the prices of the past, as we might casually think." However, he also acknowledges that

[40] See, for example, "Yesterday's Blooms," 1990; "Inside the Art Market," 1998; "Special," 1997; and Hughes, 1989a and 1984.

[41] See, for example, McGuigan, 1985; Walker, 1987; Wechsler, 1989; Graeber, 1989; Hughes, 1990a and b; Tomkins, 1992; Vogel, 1994, 1996b, 1997a, and 2000; Dobrzynski, 1999; and Gleadell, 2003.

Figure 3.4
Comparison of Art and Equity Prices, 1952–2002

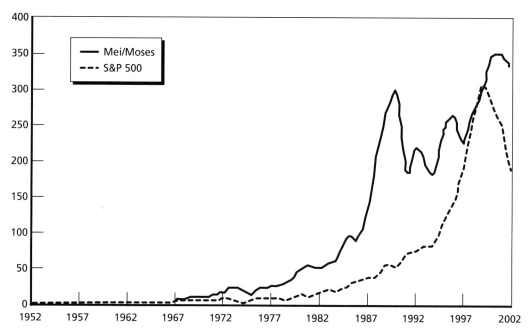

NOTES: S&P 500 = Standard & Poor's 500 stock index. Mei/Moses = the Jianping Mei and Michael Moses fine art index.

RAND *MG290-3.4*

the scope and extent of the explosion of the arts market during the last 30 years are truly unprecedented. One measure of the special nature of this phenomenon is the scope of the increase in prices and volume. As Figure 3.5 indicates, the recent dramatic increase in prices has not been limited to specific artists or styles of art but has occurred across a diverse array of submarkets or styles of visual art. Indeed, Sotheby's *Art Market Trends* reported that over the five-year period 1985 to 1989, all six of the submarkets for which they compiled major price indices (old masters, Impressionists and post-Impressionists, modern paintings [1900 to 1950], American paintings from 1800 to World War II, and contemporary [post-1945] paintings) posted price increases of at least 14 percent per year.[42] This increase was not limited to the elite sector of the arts market—judging by similar, if somewhat more modest, price increases—but also occurred in the market for collectibles as well.

[42] See *Forbes*, March 6, 1989, p. 76. *Forbes* also reported indices for various types of collectibles—e.g., jewelry, furniture, and ceramics—and found similar increases.

Figure 3.5
Comparison of Price Increases in Arts Submarkets, 1952–2002

SOURCES: Mei and Moses fine art index and Standard & Poor's 500 stock index.

RAND *MG290-3.5*

It is particularly noteworthy that the demand for contemporary art is substantially greater than the demand for other types of art. As a host of observers have noted, prices in the contemporary market are especially volatile since neither contemporary artists nor their art works have passed the test of time, which appears to be paramount in setting and stabilizing market prices.[43]

This transformation of the arts market has been driven by a combination of changes in the operation of that market and changes in the demand for collectible art. We will discuss how the market has changed and the consequences of those changes in Chapter Five. Here, we focus on how changes in the nature of demand have contributed to market changes.

One key factor behind the growth of demand has been the rising incomes of the population—especially the most affluent segments of the population who are the most likely to be involved in the arts market. While the average American household experienced an 18 percent increase in real income between 1980 and 2000, for example, households in the upper five percent of the income distribution saw their av-

[43] See Hughes, 1989a and 1990a; and Decker, 1998b, pp. 114–115.

erage incomes almost double (93 percent).[44] Indeed, the combination of a surging stock market and the proliferation of digital millionaires, real estate tycoons, and entertainment stars (whose incomes are in the top one percent of all households) created an unprecedented increase in the number of potential art buyers.[45]

More education and a greater familiarity with contemporary art among the populations coming into their peak earning years are also playing a role. Many of these newly affluent individuals were part of

> the first wave of the postwar baby boomers entering their 40s. They were better educated than their parents (or anyway had spent more time in schools). Many were more comfortable with art, especially with contemporary works, which no longer required a knowledge of the Bible, the classics, or even history to understand ("Yesterday's Blooms," 1990, p. 8).

In addition to the buying power of these newly affluent potential consumers were two other groups who became directly involved in the arts market during this period: first, foreign buyers (initially Europeans and later Japanese and other Asians, and more recently Middle Easterners) who joined the market as it globalized[46]; and second, corporations, which had the money and the hired expertise to become major players in the market.[47]

If these developments help explain where the new buyers and money came from, they do not fully explain why these two sets of resources were targeted at the arts market and most particularly at the contemporary market. The missing link here appears to be the dramatic expansion of the idea of art as a good investment. Although, as Hughes points out, the idea that art should be considered a form of investment did not originate during the 1980s, it certainly proliferated during that period. Indicative of the growth of this attitude was the following statement about the advisability of art as an investment: "In these days of the weakening dollar, art is a surer investment than gold. One study shows that in 1986, only diamonds appreciated faster than collectibles. Art has the potential to turn a better profit than soybeans—and, of course, it's more beautiful" (Dinitia Smith, 1987, p. 36). In fact, art

[44] Moreover, the share of aggregate income going to the top 5 percent of households rose from 16 to 22 percent during this period. Calculations are based on data available at http://www.census.gov/hhes/income/histinc/h01ar.html.

[45] See Brown, 1997; and "Yesterday's Blooms," 1990.

[46] Descriptions of the international flavor of the market can be found in "Yesterday's Blooms," 1990; Watson, 1992; and Sandler, 1996 and 1979. For an example of the Middle Eastern influence, see Adams and Harris, 2004.

[47] An institutional change that contributed to the pattern of collecting throughout this period—and has been cited as improving the pattern of purchases during the late 1990s—has been the entry of art advisors who help individuals and institutions in making their art purchases and building their collections. See Bahrampour, 2000.

is not only more beautiful, it is more volatile, as the plunging market, particularly the contemporary arts market, at the end of the 1980s proved.

Although some observers claim that the lessons learned from the sharp rise and fall of the arts market in the 1980s contributed to a more orderly climb in the late 1990s, the market (and demand for fine art works) had already changed significantly. Change has been particularly pronounced in the market for contemporary work, where many buyers appear to focus more on responding to trends and identifying new artists—in much the same fashion as investors in the stock market have eagerly sought out initial public offerings.

Future Issues

The key issue for the future is, How will demand for the visual arts change? Whether gauged by increases in museum attendance or the growth and escalation of prices in the arts market, demand for the visual arts appears to be booming. As our analysis has indicated, however, the increase in museum attendance has not been quite as robust as suggested by headlines proclaiming a boom in museum visits. Although total attendance has indeed increased (particularly in contrast with attendance at the live performing arts), this growth appears to have been largely caused by population growth and rising education levels rather than an increase in the rate of attendance per se.

From the perspective of museums, the most positive aspects of the increase in total attendance have been the increasing frequency of visits among regular museum-goers and the success of blockbuster exhibits in increasing attendance. By and large, this increase in attendance appears to have been largely concentrated among the better-educated segments of the population. Thus, we might expect that continued growth in total museum attendance might well be predicated on increasing education levels of the population. Education levels in America may be expected to continue to rise. But the increasing diversity of the population—due to influxes of immigrants and declining fertility among the native born—suggests that the rate at which education levels increase in the future might not be as rapid as in the recent past.

However, even if education levels continue to rise, museums' ability to attract succeeding generations of college graduates to visual arts appreciation will be challenged by changing patterns of leisure time, which have increased the demand for home-centered leisure activities and growing competition from expanding and increasingly market-savvy entertainment and leisure industries. Indeed, our analysis of changes in museum attendance over the last decade suggests that the rate at which the better educated segments of the population have been visiting museums has stabilized.

In all likelihood, an even greater challenge for museums will be broadening their appeal to underrepresented groups, such as the less well-educated and minority segments of the population. Despite a variety of efforts, museums on the whole have had little success in diversifying their audiences. Instead, museum attendance remains highly correlated with education levels, which in part reflects the aesthetic focus of their past, but this focus presents a perceptual barrier to the more diverse audiences they are attempting to reach.

To date, museums have attempted to broaden their outreach and marketing efforts with special exhibits, blockbusters, and attempts to make museums the center of social activity and general entertainment. However, is an outreach strategy based on blockbuster exhibits feasible, considering that the costs of putting on these exhibits may place them beyond the reach of all but the largest museums? Moreover, attempts to make museums an entertainment attraction have led some to question what the longer term effects of such efforts will be on museums' ability to fulfill their traditional missions.[48]

Technology could have an effect on future patterns of demand just as it seems to have increased the demand for the performing arts. To date, technology's effects on the visual arts seem to have been concentrated in the visual arts market, where, as we will discuss, it appears to have increased the flow of information about the availability and pricing of visual arts works. Technology has been applied to a lesser extent among museums, where it has facilitated the management of museums' collections. In principle, however, it could expand access to the visual arts, particularly if continued improvements in computer technology reduce the differential between the original work and the reproduction. Although such improvements might increase access to art, they seem unlikely to diversify demand, since those groups who are least inclined to attend museums today are also likely to have less access to the new technology.

Instead, probably the most important issue for the future is how to increase demand for the visual arts, particularly among those segments of the population who are not currently inclined to visit museums. The traditional focus of arts advocates has been on policies designed to increase the supply of the arts in the belief that "if we build it, they will come." However, as we have argued elsewhere, we believe too little emphasis has been placed on strategies designed to build demand and, in particular, to provide gateway experiences to the arts (especially arts education) for the young.[49] Such experiences can have an enduring effect on future arts participation and start individuals on the path to becoming lifelong and knowledgeable visual arts consumers.

[48] See for example, Cuno, 2004b; Solomon, 2002; Vogel, 1996a; and Cuno and Rogers, 2000.

[49] See McCarthy et al., 2004.

Changes in collecting patterns have been even more dramatic than those in appreciation. Although still dwarfed in absolute numbers by the millions who go to museums each year, the number of collectors appears to have increased during the last two decades by an order of magnitude. In addition, the tastes of collectors appear to have become more diverse in terms of what they collect, e.g., periods and styles of work and the media used.

Whether these trends will continue into the future, however, is less certain since they appear to have been driven by three phenomena: first, rapid growth in the most affluent segments of the population; second, that population's increasing attraction to fine art collectibles; and third, a growing tendency to view fine art as an investment. The first and third of these trends will largely be determined by such macro-level forces as the growth of the economy and the relative returns on different kinds of assets, which are largely beyond the purview of the arts market per se. Therefore, the key questions may well be whether the more affluent will continue to purchase art and what types of art they will purchase. As the prices of fine art have risen, the range of art that collectors have purchased has expanded to include less expensive items that were not formerly prized (we discuss this topic in greater detail in Chapter Five). This trend may well continue, but it may also spread to the general commercial and design markets—particularly if purchasing and collecting art becomes more of a middle-class pastime.

In any case, the tremendous growth of the arts market has raised questions about its longer-term effects on the quality of art more generally—particularly among those who fear that continued growth will be driven by speculation.[50]

[50] See Hughes, 1984, and Plagens, 1999.

Artists

In this chapter we turn from demand for the visual arts by appreciators and collectors to the artists who create the art itself. Most of the artwork displayed in museums (as well as that sold in the secondary elite arts market) has been created by artists who are no longer alive. They are not the subject of this chapter. Instead, our analysis focuses on the number, characteristics, and career paths of living artists, and on how these features of contemporary artists are changing and why. The characteristics of visual artists, both living and dead, who are no longer producing art is relevant here only to the extent that they offer insights into how the circumstances in which current artists work, create, and develop careers have been changing. Given that the vast majority of these artists produced their work in the distant past—when artists were more likely to be considered craftsmen than professionals, when the features of today's visual arts market were virtually inconceivable, and when the role of art in society was very different—the longitudinal comparisons in this chapter focus on how the circumstances of visual artists have been changing over the last 50 years.

As in our earlier analysis of performing artists, we begin this examination of visual artists by presenting basic data on their numbers, their sociodemographic characteristics, and their working and living conditions. We then compare how these features of visual artists and their career patterns have changed over the last few decades, suggest reasons for these changes, and finally discuss the implications of these changes for the future.

Key Concepts

The initial challenge in analyzing visual artists is defining who they are. At the most basic level, visual artists create original work intended for viewing and purchasing either by an individual or by an exhibiting organization. In contrast, performing artists are by and large involved in the re-creation and interpretation of art in a performance, a fleeting and unique work of art. Of course, composers, playwrights, and librettists also create original work intended for sale, but the ultimate goal for their work is a live performance. Conversely, some visual artists intentionally create works

that are ephemeral and may involve performances of some kind. Indeed, some artists'—performing, media, and visual—primary interest is in blurring or eliminating such distinctions among the different disciplines.

Beyond this basic distinction, visual artists can also be defined by artistic discipline and by professional versus amateur status. First, visual artists broadly defined can include not only painters and sculptors, but also designers, graphic artists, and architects. Focusing on the fine arts end of this spectrum as we have in this study, visual artists can be sorted into different subdisciplines (painting, printmaking, sculpture, and photography). While performing artists can also be sorted by subdiscipline, visual artists are more likely to work across these categories than, say, a dancer, musician, or opera singer.

Second, while visual artists can also be defined as professionals or amateurs, they are more accurately defined by achieving—or attempting to achieve—certain benchmarks in professional status (e.g., representation by a gallery, a group or solo exhibition, a commissioned work, a work purchased by a museum, etc.). The distinction between professional and amateur is important in the performing arts, where unpaid performers at a wide variety of skill levels often play a critical role in small and midsized performing arts organizations, especially in the volunteer sector. But in the visual arts—primarily as a result of the difference in the nature of the art—the work of amateur or semi-professional visual artists is not likely to be viewed as a substitute for the work of professionals. We exclude from the definition of professional visual artist those individuals who paint or draw for their own enjoyment or even for sale, with no expectation of their work entering the world of arts discourse. Interestingly, in the visual arts the distinction between professional and amateur does not refer to employment and earning status of the artist. Indeed, as discussed below, most professional visual artists are self-employed but fail to earn a living through the sale of their art. The average income of artists typically consists of three different sources of earnings: from their art, from arts-related jobs (e.g., teaching), and from nonarts employment. Consequently, professional visual artists are defined in part by their presence (actual or potential) in museums, in the world of discourse, and in the marketplace rather than by employment status or earnings.

In addition to their numbers and professional status, artists can also be distinguished in several different ways, including their sociodemographic characteristics (e.g., age, gender, and education); their geographic location; their employment circumstances and earnings patterns; and their career patterns. In this chapter, we describe visual artists along each of these dimensions.

The Current Picture

The Number of Visual Artists Depends on How They Are Defined

As noted above, identifying the number of practicing visual artists depends on how visual artists are defined. There are two main distinctions drawn among visual artists in the data. The first is which artistic disciplines are included when defining the visual arts. The Census Bureau, for example, classifies visual arts professions along a continuum from the fine to the applied visual arts. At one end of this continuum are the traditional fine arts professions of painters and sculptors, next come photographers, then architects, and finally, at the applied arts end of the continuum, designers.

As Figure 4.1 indicates, the Census Bureau estimated that there were close to 250,000 painters, sculptors, printmakers, and craft artists in 2000, constituting about 12 percent of all artists. This figure is about 100,000 less than the number of performing artists and about 100,000 more than the number of authors in the 2000 Census. However, if we include photographers as well, then visual artists constitute about one-quarter of all those pursuing an artistic occupation—more than either literary or performing artists. If we add to this total the two categories of applied visual

Figure 4.1
Distribution of Artists by Type

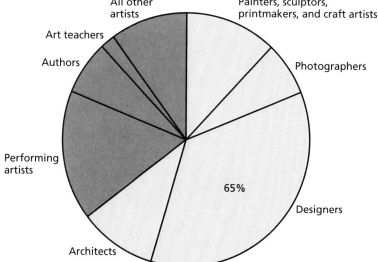

SOURCE: Current Population Survey, 2000.
RAND *MG290-4.1*

artists—designers (approximately 750,000) and architects (nearly 220,000)—then visual artists represent almost two-thirds of all those who are listed as artists by the 2000 Census. The focus of this study is on the painter-sculptor-photographer end of the spectrum, not on architects or the many types of designers (graphic, interior, set, landscape, etc.).

Menger (1999, p. 545) suggests that their numbers as well as unemployment rates may be underreported in Census data if they are employed in nonarts occupations at the time they are surveyed yet are still producing their artwork on their own time.

The other distinction is the definition of "professional." As we will discuss in greater detail in the next chapter, there are two distinct markets for visual art works. One involves elite artists who are represented by prestige dealers and galleries and whose work is reviewed by recognized critics. The other is the general market for other artists. The nature of the operations and the average prices paid differ sharply between these two markets. Thus, artists who operate in the elite market will likely differ from those who sell their work in the general market, and most particularly in the prestige within the visual arts community. Moreover, the elite market is covered by the media and is the focus of discourse among the cognoscenti of the art world.[1]

Unfortunately, there is no clear way to identify to which class professional visual artists belong. Instead, as Jeffri and Throsby (1994) point out, there are at least three different standards that can be used to make this distinction. The first is a marketplace standard that defines professional visual artists as those who either make a living from their art or (since most artists rely on nonarts income for at least part of their income) receive part of their income from their artwork. However, since artists can make a healthy income in the general market, this marketplace test fails to distinguish between these two categories of professional artists. A second standard distinguishes artists in terms of their training (professionals are those who are formally educated in an arts school) or their affiliation with artists' associations. A third standard identifies professionals as those who are recognized as such by their peers, those who identify themselves as artists, or those who receive public recognition for their work.[2] Although this last standard most closely approximates the distinction between artists in the elite versus the general market, it is more useful as a conceptual than as an operational tool.[3]

[1] See Szántó, 1997.

[2] The Census Bureau estimates reported in Figure 4.1 are based on self-reports of primary job and, as such, are likely to most closely approximate the marketplace definition.

[3] To the best of our knowledge, this distinction has not been used in collecting information about visual artists. We cannot, for example, determine how many of the 250,000 visual artists identified by the Census fall within each category, although we suspect that the overwhelming majority would be in the general market rather than the elite category.

These distinctions are important because, as we will show, changes in the visual arts market and in training and education patterns of visual artists could well have important implications not only for who is recognized as an artist but also for how statistics about the characteristics and employment circumstances of artists are collected and reported. Unless otherwise noted, the empirical descriptions of artists reported here are based on Census definitions.

In Most Respects, the Sociodemographics of Visual Artists Resemble Those of Other Artists

Table 4.1 compares the sociodemographic characteristics of visual artists, both with other artists and with all professionals whose education levels most closely resemble those of artists. The median age of visual artists is approximately the same as each of the three benchmark populations used in this comparison: applied visual artists (designers and architects), performing artists, and all professionals. Visual artists are more likely to be female than other artists (with the notable exception of architects) and are somewhat more likely to be minority (with the exception of all professionals). The principal difference among these groups is in their levels of education. The education levels of visual artists appear to lie midway between architects (by far the best educated) and designers and close to that of performing artists.

Visual artists are also clustered geographically in this country. Using Census data, Markusen, Schrock, and Cameron (2004) found the highest concentrations of artists of all kinds in New York, Los Angeles, and San Francisco. They found disproportionately high numbers of visual artists since the 1980s in Orange County and San Diego among midsized metropolitan regions, displacing Boston, Minneapolis–St. Paul, Portland, and Chicago. These trends reversed the trend toward decentralization of artists between 1980 and 1990. They argue that artists are attracted to certain midsized cities at the expense of other cities and rural areas by an inviting arts

Table 4.1
Sociodemographic Profile of Visual Artists

	Female (%)	Minority (%)	Median Age	College Degree (%)
Visual artists Painters, sculptors, printmakers, and craft artists	56	12	39	42
Designers	55	10	40	36
Architects	17	9	38	80
Performing artists	40	8	39	39
All professionals (arts and nonarts)	47	16	40	59

SOURCES: 1990 Census and 2000 Current Population Survey.

environment, and to midsized rather than the larger metropolises by cost of living and general living conditions. The relatively "footloose" nature of artists, particularly those like visual artists who tend to be self-employed, enables them to move to new cities and regions based on living and working conditions.

These comparisons report data for all workers in each occupation and as such include workers who are just entering their fields, those who are in the middle of their careers, and those who have been working in their occupations for a long time. As such, they present a composite picture of these artists that may obscure changes in the characteristics of visual (and other) artists. Of particular note are the changes in the patterns of training and education among visual artists—a point that we will discuss shortly.

Visual Artists Are Largely Self-Employed, But Also Earn a Significant Portion of Their Income from Nonarts Employment

Although artists in many respects resemble other professional workers, a host of studies have reported that their employment and earnings profile are decidedly bleaker. About three-quarters of all professional artists, for example, hold nonarts jobs at least part of the time.[4] This situation makes it difficult to compare artists' incomes with other workers since a significant share of artists' total income is not related to their art. Despite this difficulty, we do know that artists' incomes are significantly lower than those of other professionals with comparable levels of education and qualifications—a disadvantage that varies depending on the artists' ability to find well-paying nonarts jobs.[5] An NEA report (1982) describing the lives of visual artists in four major cities found that the median annual income of artists from sales, commissions, grants, and awards was $718, with only 5 percent earning over $10,000. Median production costs were $1,450, about twice the median income. In addition, over a quarter of visual artists reported earning nothing at all from their art over the three-year period during which they had exhibited.[6] More recent surveys have reported essentially the same pattern for painters and sculptors: below-average levels of total earnings, with their arts-related earnings (primarily from sales of their work) constituting less than 20 percent of their total earnings (see the 1987 SPPA—NEA, 1988).

A major factor in the low average earnings of visual artists is their employment circumstances, particularly high self-employment rates. Unlike performing artists who typically work for arts organizations that produce musical, theatrical, and dance productions, visual artists typically work alone or with a limited number of colleagues

[4] See, for example, Alper and Wassall, 2000, and Alper et al., 1996.

[5] See McCarthy et al., 2001.

[6] See Kreidler, 1996.

in creating their work. They also work without time limits, like writers and composers but quite unlike performing artists, who sing, dance, or act within a specific time frame. The income visual artists receive from their work is based on their sales rather than, as with performers, from the pay they receive from their employers for at least a portion of the time they work (rehearsals and performances).

It is not especially surprising then that approximately half of all painters and sculptors function as self-employed professionals. By contrast, less than one-third of performing artists consider themselves independent contractors. The significance of this distinction is suggested by recent data on the earnings of artists who are employees of commercial and nonprofit employers.[7] Although the average annual wages of painters and sculptors who are employees are approximately the same as all other employees in the arts, design, entertainment, sports, and media occupations (and significantly higher than those of actors, dancers, and choreographers), the high rates of self-employment among visual artists mean that they rely more on earnings from the sale of their work than from salaries. It also means that visual artists are significantly less likely to collect the types of fringe benefits—e.g., health care and pensions—that are associated with employment in established organizations.

Visual Artists Follow One of Several Different Career Paths

Based on a survey of mid-career visual artists who graduated from the Chicago Art Institute and spent more than three-quarters of their working lives creating art, Stohs (1991) suggests that professional visual artists follow three different career paths. The first path, which she describes as the stable career path, consists of employment in exclusively arts-related jobs. The second path, which she describes as the sporadic career path, consists of multiple jobs both inside and outside the arts field. The third path, which Stohs terms the disrupted career path, consists of employment in no more than two jobs outside the arts and multiple jobs in the arts.

There are several consequences of these different career patterns for artists' total earnings and the source of those earnings, as reported by Stohs. Artists who follow a stable career path, mostly teaching art, earn over 90 percent of their income in arts-related work, but less than 10 percent of those earnings are from the sale of their art. Instead, they appear to rely primarily on teaching jobs for their income.[8] In contrast, those artists who follow the disrupted career path earn all of their income from their art but appear to depend on a combination of arts-related work, perhaps teaching, in addition to the sale of their work. Thirty percent of their income comes from such sales. Finally, those who follow a sporadic career path depend on the sale of their work for about half of their total income and supplement these sales with income

[7] See U.S. Department of Labor, 2002.

[8] However, many teach part time without benefits, which is indicative of self-employed status.

from nonarts jobs (about one-quarter of their earnings) and arts-related jobs. Stohs further suggests that the choice of a particular career path is at least partly influenced by the different value visual artists place on such factors as a conventional lifestyle and career stability. Interestingly, however, artists in all three of these groups express considerable satisfaction with their lives and career choices.

To the extent we can generalize from Stohs' findings to visual artists more generally, they suggest that visual artists' career patterns resemble those of other artists in several ways. First, uncertainty plays a major role in their careers. They, like other artists, face considerable employment uncertainty as a result of their career choices. This uncertainty is reflected not just in their prospects for commercial success but also in the likelihood that they will be able to pursue their chosen field on a full-time basis. Indeed, a second characteristic that they share with other artists is the likelihood that they will be forced at some point in their artistic careers to rely on employment outside the arts for a significant portion of their income. Third, unless they achieve commercial success, their prospects for finding stable employment and incomes are probably limited to institutional settings (e.g., universities and museums) or commercial firms that employ visual artists (e.g., design firms and advertising agencies). Unlike performing artists, however, visual artists are much more likely to be self-employed and to depend on the vagaries of a commercial marketplace that, as we will discuss in greater detail later, can change rapidly in terms of the work it values.

There Are Several Different Strata of Visual Artists in the Arts Market

As we have repeatedly noted, the employment and income prospects of visual artists depend directly on the commercial value attached to their work. In this context, the superstar phenomenon that characterizes the performing arts is even more apparent in the visual arts.[9] Contemporary professional visual artists can be sorted into three strata. At the top are a handful of superstars whose work is sold internationally and commands substantial prices in both the primary and secondary visual arts markets. At the next level is the larger but still relatively small number of prominent artists, whom one commentator has referred to as the "bestsellers"(Pye, 1991, p. 20). Their work is promoted and sold through galleries, dealers, and auction houses; sold in the major arts markets at substantial prices; and collected by art aficionados. The third stratum consists of the vast majority of professional artists, who often sell their work to buyers and dealers throughout the country at much lower prices than those in the other strata and probably lack an established relationship with a dealer.[10] Although

[9] We discuss the superstar phenomenon and its role in the performing arts in McCarthy et al., 2001. Rosen (1982) provides a more general description of this phenomenon.

[10] Horowitz (1993) reports that two-thirds of all contemporary visual artists represent themselves (i.e., they lack established relationships with dealers).

there are no studies on this topic, it also seems likely that the work of the first two strata is sold in the elite market and the work of the third is sold primarily in the general market and in regional markets throughout the country. Markusen, Schrock, and Cameron's (2004) analysis of artists' geographic distribution identifies midsized metropolitan regions where regional marketplaces are likely to help support visual artists who then choose to live there. For example, Orange County ranks high on the list for visual arts, in part because of such thriving visual arts communities as Laguna, where the combination of an affluent and interested audience and municipal and foundation support of such activities as the Sawdust Festival provides a sustainable environment for artists.

While there is no explicit formula for identifying which artists will fall into which stratum *a priori*, we use a variety of criteria to sort artists *post hoc*. These criteria or signs of certification include the number and types of shows (one person versus multiple artist and retrospectives); location and prestige of the galleries in which their work is exhibited; whether the artists have an established relationship with a dealer and/or gallery (and the prestige of the dealer/gallery); critics' reviews of their work;[11] the prices that have been paid for their work;[12] and the reputations of those who collect the artists' work. These signs of certification make an enormous difference in their commercial success, the markets in which their work is sold, and thus their incomes and employment.[13]

In many respects, visual artists resemble other professionals as well as other artists in terms of educational achievement, median age, gender, and ethnicity. They also resemble their predecessors in the visual arts: Current earnings and the employment picture of visual artists are not radically different now than they were several decades ago. Visual artists remain largely self-employed, earning a major portion of their income other than through the sale of their work. While much of the environment in which they present their art has changed significantly, as discussed in later chapters, they fare about as well as they always have. The main differences are in the path and pace of the credentialing process. Aspiring artists are now highly likely to ascend through the art school and university art department route, gaining both artistic training and a support network upon graduation. Emerging visual artists now pass through the early steps in their careers of training and developing a body of work at a much faster pace than previous eras, cycling through the world of discourse at a higher rate. For some artists, this newly accelerated pace means much earlier financial

[11] See Galenson, 2000.

[12] Hughes (1984), among others, has commented on the role that speculation has played in the dramatic expansion of the arts market over the last 30 years and the importance that prior sales have had on current prices.

[13] In a 1982 article (Fingleton, 1982), *Forbes* reported that "probably twenty and maybe thirty American artists gross more than $1 million a year (the Superstars) . . . and probably more than one thousand others earn at least $100,000 a year (the bestsellers)."

success than prior generations of visual artists. For others, it means they may ascend and descend based on a few years of studio experience and a limited body of work. We discuss the impact of these trends in the next section.

Key Trends

As we suggested in the last chapter and will discuss in greater detail in the next chapter, the last 25 to 30 years have witnessed dramatic changes in the visual arts environment. Foremost among these changes has been the dramatic transformation of the market itself. Since the late 1970s, the arts market has expanded exponentially in size, prices have soared, operating practices have been transformed, and the role of various market intermediaries has shifted. In addition, changes in the shape of the discourse about contemporary arts and the technologies visual artists use to create their work have altered the environment in which they work. We now describe how the major features of those changes have affected contemporary visual artists.

Artists Increasingly Begin Their Careers with Professional Training and Credentials

Driven by the factors outlined above, such aspects of visual artists' careers as the nature of their training, the ways they are certified, and the speed and paths toward commercial success have also been changing. Gregg and Solomon, for example, have highlighted the changing patterns in how artists are trained. Typically, the leading visual artists of the early post—World War II period received their training in trade school, private studios, or nondegree institutions such as the Arts Student League or the National Academy of Design Schools of the Fine Arts.[14] However,

> the last half-century has seen a revolution in the way art is taught in this country. The first Bachelors of Fine Arts (BFA) degrees weren't offered until the 1930s, and most were in art history rather than in studio practice. . . . Today, the National Association of Schools of Art and Design, which had 22 members when it was founded in 1948, has 239 members, enrolls approximately 100,000 arts majors and 8,000 graduate students each year" (Gregg, 2003, p. 106).

Certainly in Los Angeles the importance of arts schools and university departments in particular has grown dramatically. One indicator of this change is that

[14] See Gregg, 2003. A similar point has been made by Solomon (1999b), who notes that many of the leading American artists of the post-war period attended such programs—e.g., Jackson Pollock and Mark Rothko (Arts Student League) and Robert Rauschenberg (Black Mountain College).

in the pool of applicants in the last five years for an L.A. Cultural Affairs Department mid-career fellowship, only two artists had not come out of the art school system.[15]

This shift toward academic training has not only produced a proliferation of new students and aspiring artists (and greatly expanded the market for academic positions in the visual arts), it has also affected what and how the current generation of visual artists are taught, how they are certified, and the professionalism with which they pursue their careers. As Solomon points out, "Young artists today have something in common with doctors and lawyers: they need to be academically certified. An MFA degree has become an essential credential."[16] Moreover, getting a master of fine arts degree has become an essential means of connecting to the network of curators, gallery owners, and collectors that will evaluate the artists' work. Through arts schools, artists develop a network of contacts among their peers, professors, and for a fortunate few, galleries. Most young artists know they have a slim chance of gaining recognition without it. This network is an essential asset after graduation for emerging artists to meet dealers, collectors, critics, and anyone else who can help put the artists' work in circulation. Professors who are practicing artists and in all likelihood have relationships with galleries provide introductions and recommendations for their students as they begin to make their way in the marketplace. Classmates provide another essential support system by providing reactions to each other's work, introducing the work to the outside world, and helping to market each other's shows.

Greater Opportunities for Early Commercial Success Alter Typical Career Paths

Not only have the gateways to artists' careers changed significantly, but the pace and paths to commercial success in the visual arts world have changed in recent years as well. As Galenson (2000) has noted, for example, artists are achieving commercial success much earlier today than they did at the turn of the 20th century. The successful ones are achieving it even earlier than their counterparts 30 or 40 years ago. Using auction data for well-known artists whose work was sold between 1980 to 1996, Galenson estimates that artists born before 1920 produced their most valuable work (in terms of sales price) in their late 50s, whereas for those born between 1920 and 1930, peak sales prices were reached in their mid- to early 30s, and for those born after 1930, the age at which peak prices were achieved was 30 years old. In addition, the escalation of prices for the works of living artists, as discussed in detail in the next chapter, most certainly crosses the minds of contemporary artists as more than a chimera. Indeed, as in the world of sports, widely publicized "superstar" sale prices for young artists' work might serve as an incentive for individuals who are inclined

[15] Interview with Joe Smoke, Cultural Grants Program Director, Cultural Affairs Department, City of Los Angeles, December 22, 2004.

[16] Solomon, 1999b, p. 38.

toward the visual arts. The possibility of substantial sums so early in a career was not something earlier generations of visual artists were likely to have entertained.

However, as Galenson and Passell among others have noted, early commercial success is no guarantee of continued success.[17] As the arts market as a whole experiences peaks and valleys, so too does the success of individual artists. Passell, for example, cites the experience of the painter Sandro Chia, whose work rose in price from $10,000 to $60,000 after several pieces were purchased by Charles Saatchi then plummeted after he sold them.[18] Earlier commercial success has also brought earlier museum recognition, which as we noted above, is an important symbol of certification. Colson (1997), for example, contrasts the experiences of several famous older contemporary artists whose work was not included in a museum retrospective exhibit until after their 40th birthdays, with that of a number of more recent artists who were having "mid-career" and retrospective shows when they were still in their early 30s. Gregg and Solomon similarly note that many of today's art students have had their work purchased by dealers while they were still in school—a phenomenon that would have been unheard of two decades ago. Many other examples abound of artists with early recognition who, after the initial limelight of a gallery opening, failed to live up to the hype or withstand the criticism and had limited experience and work to fall back on. According to some observers, the former path of artists toiling for years, developing their ideas, and maturing their style served them better once they did receive public recognition or even rejection.

Relationships Between Artists and Dealers Have Been Changing

Although contemporary visual artists often have more direct contact with the buyers of their work than they do with the audiences who view their work in museums and galleries, visual artists typically depend on a series of intermediaries (primarily dealers and gallery owners,) to sell their work. In 1970, Varian described the relationship between dealers and artists as typically more than a commercial arrangement between agents and the artists they represent. Although the specific arrangements between artists and dealers have varied, dealers and galleries typically performed a range of services beyond simply hanging works and making sales. As Varian (1970, p. 72) notes, these extra services might include:

> photographing works, cataloguing and circulating promotional materials accompanied by slides and graphs, keeping records about the artist and his works, organizing exhibits or arranging for participation in exhibits with the problems of transportation, insurance and record keeping.

[17] See Solomon, 1993; Galenson, 2000; and Passell, 1990.

[18] See Passell, 1990, p. 12. Other examples of early commercial success can be found in Vogel, 1997a and 1999.

Indeed, galleries and dealers often subsidized artists until demand for their work (typically five to seven years) provided sufficient income to cover these expenses. Indeed, galleries such as Leo Castelli's had at least one staff member scouting out new promising artists. In sum, the traditional relationship between artists and galleries/dealers was not just built on sales. It involved dealers nurturing new artists through their early years with little hope that the artists' work would sell in the short run. As a result, artists tended to develop a long-term allegiance to the specific dealers who first discovered and nurtured them.

Haden-Guest (1987) reports that this pattern had begun to change by the late 1980s. The arts market approached a then high point in 1989. This shift was encouraged by dealers who began to actively compete for "hot" artists,[19] but the shift was also encouraged by the artists themselves, who began to switch dealers in the hopes of improving their sales. Indeed, during the 1980s and 1990s, when the arts market and prices were heating up, artists became increasingly attuned to the importance of promotion and marketing as influential factors in their chances for commercial success. No doubt persuaded in part by the successful use of such promotional activities as glossy catalogues, presale screenings and receptions, and active attempts to court the media,[20] many contemporary artists (especially the bestsellers) began actively promoting their work through direct advertising to collectors, more frequent exhibitions, and even marketing-related products.[21]

Less commercially successful and less well-known artists (many lacking dealers) have also sought new ways of getting their work before the public. In addition to traditional art fairs and group exhibits, they have used a growing range of micro-galleries.[22] These micro-galleries run on shoestring budgets and include stay-at-home dealers, "nomadic" galleries popping in up in a variety of sites, and "alternative" spaces run by artists themselves as well as a new class of intermediaries who are not traditional dealers but rather serve as "something between business manager and literary agent"(Pye, 1991, p. 20).[23] These are not entirely new developments: Alternative spaces and artists' collectives have a long history of filling a void in the marketplace, often until the gallery world hears the buzz and begins to court the artists. As a form of support for artists, micro-galleries have been in turn supported in part by foundations. What is new is the maturity of the alternative spaces that survive the

[19] Dealers also competed for artists who were still in art school, as both Gregg (2003) and Solomon (1999b and 1993) (within the visual arts community) point out. Also see Pye, 1991.

[20] See, for example, Melikian, 2002b, and "Yesterday's Blooms," 1990.

[21] See Foltz and Malone, 1984; and Fingleton, 1982. Keith Haring, for example, emblazoned his cartoon-like drawings on sheets, clothing, and watches (cited in Foltz and Malone, 1984).

[22] The micro-gallery phenomenon in the visual arts parallels the micro-cinema movement in the media arts described in McCarthy and Ondaatje, 2002.

[23] See also Smith, 1994, and Alloway, 1983.

bust and boom cycles during their life spans. The surviving alternative spaces tend to have developed a loyal following and perhaps an earned income stream (e.g., rent), and they have withstood the pressures of occasional relocation when they can no longer afford the spaces they hold.[24] In sum, contemporary artists have become much more attuned to the new market environment. Although some critics bemoan the effect this awareness has had on their art, it appears to be pervasive. How different artists respond, however, varies according to their prominence, youth, and commercial success.[25]

Contemporary Visual Artists Find Acceptance for a More Eclectic Range of Work

As we discussed in Chapter Two, throughout the first six or seven decades of the 20th century, contemporary art followed a general progression of styles and movements that contributed to a forward-moving arc of art history. Reflected in what we have referred to as the arts discourse and supported by such art critics as Clement Greenberg and Carter Ratcliff, this modernist approach incorporated such specific movements as Abstract Expressionism, Conceptualism, minimalism, etc., which were designed to raise questions about art and visual perception.[26]

By the 1970s, the growing prominence of universities in training new artists, the application of techniques and new technologies from other areas, and the increasing lure of art as an investment had promoted a new eclecticism in the contemporary arts environment. First, as Gregg and Solomon have pointed out, the rise of academic arts schools shifted the focus of up-and-coming artists away from craftsmanship and toward cultural theory. As Danto put it, "Art had turned into philosophy."[27] Tom Wolfe (1976) asserted somewhat more pointedly that art had become mere illustrations for the text of visual art theorists.

Simultaneously, the application technologies and the technique of mixing those technologies in the creation of art (a technique widely found in the media arts) promoted a wide range of experiments in visual arts works. These experiments, in turn, led to visual artists working with a much more diverse range of media (video, installation, site-specific, and performance art).[28]

[24] Surviving against such odds may also reflect the increased business sophistication and entrepreneurship of the current generation of professionally trained contemporary artists. However, we know of no studies that have examined this aspect of their professional development.

[25] For a critique of this state of affairs, see Hughes, 1989a.

[26] The role of critics in supporting this dominant paradigm is discussed in Galenson, 2000. Also see Sandler, 1996.

[27] Quoted in Solomon (1999b, p. 40).

[28] For a discussion of how the technologies of video, computers, and photography have been fused in the media arts, see McCarthy and Ondaatje, 2002.

Finally, the tremendous growth of the visual arts market and, most particularly, the promotion of the concept of art as an investment vehicle has encouraged both collectors and speculators to view contemporary art in particular as akin to a futures market.[29] As we will discuss in greater detail in the next chapter, such buyers have actively sought out potential "bestsellers" and "superstars" before their work has become well-known. This practice has encouraged a considerable element of volatility in the prices in this market and eclecticism in the styles and nature of the art produced. The net result of these changes has been a more eclectic contemporary art scene and a more open market with more opportunities for a diverse array of artists to achieve some commercial success at younger ages. At the same time, the trendiness and resulting volatility of the contemporary arts market have meant that initial success is no guarantee of continued success. Commentators have questioned the quality of contemporary work and its likely enduring value in the canon of art.[30]

Future Issues

The central issue for visual artists, even more so than for performing artists, is how to secure an adequate income while pursuing their chosen career. There have traditionally been a variety of career paths for visual artists to follow. For the few artists who achieve commercial success, the benefits in terms of income and prominence can be substantial. In addition, many visual artists are able to maintain reliable incomes by teaching (likely to be more attainable given the growth of enrollment in arts schools) or by working for an employer in applied design and other artistic areas.[31] Such career paths provide more stable employment than relying solely on sales and commissions. For reasons we discussed above, determining how many visual artists are practicing their profession is difficult (much less how many are doing so successfully). However, it appears that many, if not most, visual artists follow a career pattern that includes a mix of creating and attempting to sell their art, pursuing opportunities for employment related to their art, and nonarts-related employment. This pattern produces irregular income and employment for most visual artists.[32] It also creates the

[29] There have been a host of articles written about the growth of the arts market over the last 25 years—many of which highlight the importance of buyers viewing art as an investment. See, for example, Hughes, 1984 and 1989a; "Special," 1997; Smith, 1987; and Melikian, 2002a.

[30] See Plagens, 1999; Vogel, 1994; and Hughes, 1990a.

[31] The expansion of the visual arts market has also opened up new opportunities for visual artists advising collectors, opening galleries or working in other people's galleries, and advising artists. See, for example, Vogel, 1997c; Bahrampour, 2000; and Alloway, 1983, pp. 29–30.

[32] We recognize that not all artists aspire to high incomes and that the nonpecuniary rewards of an artistic career are often the motivating factor behind their work. A particularly interesting example of this perspective is pro-

paradox of simultaneous increases in the employment *and* unemployment or under-employment of artists (Menger, 1999).[33]

As a result, many aspiring visual artists, like many aspiring performing artists (and many aspiring professional athletes who have career profiles similar to those of artists), decide either to change professions or to pursue more stable employment in careers related to their field. Given this situation, many advocates for visual artists have argued for artists' retaining a right to a share of the profits when their works are resold or for a variety of "moral rights" (attribution and integrity rights) to their work. For example, California passed a law requiring artists to receive a percentage of subsequent sales of their work, but it is rarely if ever enforced.[34] The 1998 Sonny Bono Copyright Extension Act, which lengthened copyright protections, and the 1998 Digital Millennium Copyright Act, which places severe limits on the use of anything that circumvents digital copyright controls, have mixed implications for visual artists. For some, the protection of the images and objects they create will en-sure they are compensated should those images be used by others. For others, ex-tending the copyright and limiting access keeps earlier artists' images—particularly in film, video, and digital media—out of the public sphere and unavailable for artistic purposes for a longer period of time.[35] Given the mixed effects of these various meas-ures, they are unlikely to provide a solution to the underlying problems facing visual artists' careers.

Another innovation for providing financial security to erratically employed vis-ual artists is the Artist Pension Trust launched in May 2004. Under this plan, visual artists will be invited to donate their work (rather than cash) to a series of trusts set up around the country. Proceeds of future sales of their work will go into the Artist Pension Trust, which after 20 years will provide income to the participating artists' retirement accounts.[36]

Much like for performing artists, the central issue for visual artists' employment and career prospects is fundamentally the balance between supply and demand. We have argued elsewhere that for performing artists, the basic problem is inadequate demand.[37] However, given the dramatic expansion in prices and sales that character-ize the arts market during the last two decades and the surge in overall museum at-

vided by Solomon (1993, p. 33), who quotes one visual artist as follows: "I don't think artists should starve. But I think they should struggle."

[33] Menger defines underemployment as including part-time work (when full-time work is preferred), intermit-tent work, and fewer hours of work.

[34] The mixed results of such measures are described in Maier, 1992, and Landes, 2001.

[35] See McCarthy and Ondaatje, 2002, regarding the effects of these regulations on media artists in particular.

[36] Based on the mutual assurance model, 50 percent of the income from a specific sale will go into a general re-tirement account to benefit all participants, and the other 50 percent will go directly to the donating artist's re-tirement account. See www.artistpensiontrust.org (online as of June 8, 2005).

[37] See McCarthy et al., 2001.

tendance, it is difficult to argue that there has been inadequate demand for the visual arts. Instead, it appears that the current supply of visual artists nevertheless exceeds the demand for their work.

Figure 4.2 presents an examination of growth rates among artists and other professionals over the three decades between 1970 and 2000 (Figure 4.2).[38] Despite the dramatic expansion in prices in the arts market, the growth in the number of new painters and sculptors over this period dropped sharply. Conventional wisdom is that government programs and foundation grants for visual artists increased their numbers beyond what the system of critical opinion and peer recognition would support.

Figure 4.2
Growth Rates in Selected Arts Occupations, Compared with Those for All Professionals, 1970–2000

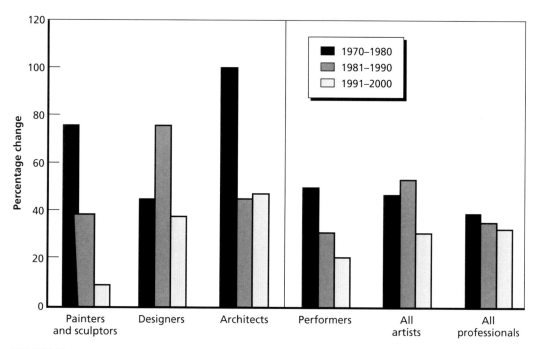

RAND *MG290-4.2*

[38] Figure 4.2 depicts growth rates in various professions. All the categories of professions have expanded the number of people joining them over the 30 years reported here. But some grew rapidly at an earlier time. For example, the percentage increase in the number of painters, sculptors, and architects was dramatic in the 1970s, with 80 to 100 percent increases, compared with a 40 percent growth rate for all professionals). In the 1990s, the rate of growth among painters, sculptors, and performing artists slowed to 10 to 20 percent, compared with an overall growth rate among other professionals of about 35 percent.

Indeed the growth in the number of painters and sculptors exceeded that of performing (and all artists) between 1970 and 1980. However, growth now lags behind in those categories of artists as well as among professionals in general. Thus, despite the apparent increase in the number of enrollees in university programs in the visual arts, many of these graduates are unlikely to succeed in the visual arts profession. As Gregg (2003, p. 109) has put it, "Many art-school alumni end up earning a living as illustrators or gallery assistants—or leave the fine arts altogether for jobs with regular paychecks and benefits." Or as Hughes (1984, p. 6) has described it, "It means that we have a severe unemployment problem at the bottom and an exaggerated star system at the top of the artistic profession."

We see this income variability and the mismatch between the number of people who want to be visual artists and the number who can make a living at it as endemic problems for this profession. Moreover, the flexibility of self-employment and the possibility of arts-related and nonarts earnings contribute to oversupply in this field. One key difference between visual artists and performance artists is that those who have invested heavily in their own training through arts schools and university art departments may need to pursue other careers to pay these debts. [39] To the extent that these artists migrate at some point into the applied arts fields (graphic design, interior design, set design, and landscape design) as well as related fields of advertising and graphic arts, we may see further aesthetic innovation and richness in these areas. Furthermore, if the expansion and pluralism of the arts market continue, possibly drawing in more middle-income collectors with greater disposable income, we might see growth outside the elite arts market and further into the general and design markets.

Another key difference between visual artists and performance artists is in the impact of a volatile, speculative contemporary arts market on visual artists. Rather than slowly building a reputation and an audience, artists might see a meteoric rise in their popularity in the art world. However, as we know from the literature, this type of market is notable for its sudden shifts in demand toward new artists and the volatility of artists' reputations (Menger, 1999, p. 552).

While the gender and minority composition of the pool of visual artists indicates that these populations are well represented (see Table 4.1), we do not have information on possible self-selection biases that stifle the visual expression of other groups, such as rural or lower income populations. Are fine arts careers affordable only to those with other means of support, only those capable of taking this economic risk and challenge, and only those with access to urban centers? Or is the vocational drive of visual artists the overwhelming force in determining who enters and sustains themselves on this inherently uncertain career path?

[39] It is also likely, though unknowable based on available data, that a portion of the increases in enrollment are a function of individuals whose intended careers were already in design, graphics, and related fields.

The Arts Market

The visual arts market has no direct counterpart in the other arts. Its distinction arises from the fact that original artworks can be bought, sold, and collected. The possession of original artwork is valued not just for viewing pleasure, but also for the status the artwork can convey to its owner, and for the value it assumes in the marketplace. Even though the number of buyers and collectors represents only a tiny fraction of the number of people who attend museums, the arts market and especially the changes that have occurred over the last three decades have had a profound effect on visual arts as a whole. These changes, as we will discuss, have affected the nature of the art being produced, the shape of the discourse about art, and the role and relative power of different constituencies within the visual arts environment.

In this chapter, we focus on the elite market, how it is organized, who are the traditional players, how value/price is determined and on how the market is changing, why, and with what effects. We begin by describing the key features of the market and how it has traditionally operated. We then discuss how the market has changed in ways that few would have anticipated 30 to 40 years ago. Finally, we discuss how these changes have affected the visual arts world more generally and what these changes suggest for the future of the visual arts.

The Traditional Picture

The Elite Market Is Organized into Submarkets

As we discussed in Chapter Four, there are two distinct markets for visual arts objects: the general commercial market and the elite fine arts market. Each of these markets can in turn be disaggregated into a series of submarkets. These submarkets can be distinguished in terms of the types of work they sell, the intermediaries who operate in that market, and the level and volatility of the prices. We focus on the submarkets within the elite market.[1]

[1] For a discussion of the general commercial market and how it differs from the elite market, see Budick, 2004.

Submarkets within the elite market are typically defined in terms of the period during which the work was originally created and, for contemporary work, whether the work is being sold for the first time (the primary market) or is up for resale (the secondary market).[2] Although a wide variety of periods, styles of work, and media (e.g., paintings, prints, sculpture, and photographs) can be used to differentiate artwork, Moulin (1987, pp. 26–27) delineates a tripartite classification of periods widely recognized among art experts: "older paintings (prior to Impressionism); Modern paintings (from the Impressionists to the twentieth century masters); and contemporary painting (the work of living artists or those born after 1900)." Finer distinctions among styles and historical eras can be drawn within each of these periods, and different dates can mark the boundaries between them. The two principal auction houses, Christie's and Sotheby's, for example, have repeatedly changed the dates they use to distinguish between modern and contemporary art.[3]

Whatever the specific dates and categories used, work in these different submarkets can be distinguished in several important ways. First, they are typically handled by different sets of dealers and, if sold at auction, packaged in different sales by auction houses. Second, they generally appeal to different sets of buyers. Third, they are classified into different periods in museum collections and thus evaluated and managed by different sets of curators. And finally, the nature of the markets for each category can be differentiated in terms of the types of investment they represent and the volatility of their prices. As Moulin (1987, p. 27) put it, "As investments, Old Masters are roughly equivalent to gilt-edged bonds, modern masterpieces to blue-chip stocks, and contemporary paintings to highly speculative stocks."

Although the size and operation of the visual arts market changed dramatically after 1980, the major players largely remained the same. They included dealers and galleries, auction houses, critics, and major collectors. Prior to the market's takeoff in the 1980s, dealers and their galleries were the most important intermediaries in the market. They were the principal link between artists and other sellers and buyers. As intermediaries, dealers provide and promote a supply of marketable artworks from sellers (including artists) to potential buyers. The specific form these functions take varies depending on dealers' specializations (e.g., classic or contemporary art) and whether they deal primarily in the primary or secondary markets. Specialization in particular categories or styles of art is important for galleries and dealers since as small businesses, specialization allows them to develop relationships and reputations with artists, buyers, and sellers. In a market where information about originality, value,

[2] Pommerehne and Feld (1997) separate the secondary market into two components. They refer to items resold by dealers as the secondary market and items sold by auction houses as the tertiary market. Their work, however, covers sales prior to 1970, before auction houses became actively involved in the retail market, and thus does not reflect the operation of the market post-1980, which is the focus of this chapter.

[3] See, for example, Vogel, 1997b.

quality, and availability requires specialized knowledge, their expertise is essential. Those who specialize in one of the various classical submarkets rely on their knowledge, reputations, and contacts with networks of collectors and institutions to identify works that might be available for sale. Prior to the 1970s, auction houses' primary role was to provide artwork to dealers. However, their role changed dramatically in the 1980s when auction houses themselves became the major trader in classical art to buyers in the secondary market.[4] Marketing classic work might, in turn, be done in several different ways, including displaying work in the dealers' galleries, through personal contact with major collectors, or through collaboration with other dealers.

Prior to the market boom that began in the 1980s, dealers specializing in contemporary work, especially in the primary market, actively sought to recruit promising new artists through word of mouth, studio visits, and references from other artists. Moreover, as we indicated in the last chapter, many of these dealers maintained a mentoring and nurturing as well as a commercial relationship with their artists. As such they lent them money against future sales, subsidized the production of work (covering the more routine expenses involved in putting together slides, portfolios, and handling transaction expenses), advised them on their careers, and promoted their work by introducing them to major collectors, exhibiting their work in their own galleries, and attempting to get their work placed in shows and museum exhibits.[5] In sum, dealers served many artists as friends and mentors rather than simply as business representatives. Following the boom of the 1980s, dealers continued to develop close relations with artists, but the degree of competition among dealers to represent artists (and consequently, the movement of artists among dealers) has increased.[6]

As might be expected, the reputation of dealers often varies dramatically depending on the commercial success of the artists they represent. Correspondingly, their prestige and ability to attract both artists and collectors vary with their reputations. This is true of dealers in both the classic and contemporary markets but has been particularly important in the contemporary market. In this market, the value and quality of artwork are best perceived in hindsight. But by its very nature, contemporary artwork has not passed this test of time. Since the value of an artwork is not determined by the costs of its production or marketing but rather by the opin-

[4] See Melikian, 2002b. In addition, much more aggressive marketing practices by auction houses and the public nature of auctions (and thus the prices paid for specific works) were major factors in this change.

[5] See Varian, 1970. Varian quotes several dealers as saying it typically took between five and seven years of such support before a new artist's work became established and thus marketable.

[6] See Haden-Guest, 1987.

ions of experts, the prestige of the artist and his or her dealer is important. Therefore, the reputations of both are often intertwined.[7]

For at least the last century, art critics, museum curators, and selected major collectors (together with the most prominent dealers) have served as the experts on the contemporary market. As we describe in greater detail below, they traditionally play a central role in determining which artists and artwork are recognized and how they are valued.

The other major players in the elite arts market are the auction houses. Although at one time primarily wholesalers, the two leading auction houses—Christie's and Sotheby's—became the major drivers in the market during the run-up of the market in the 1980s. As Melikian points out, their rise to prominence began with the ascension of Peter Wilson to chairman of Sotheby's in the late 1950s. After acquiring the "quasi-moribund" (Melikian, 2002a) auction house of Park Bernet in the mid-1960s, Wilson began to target the retail market, streamline the auction business, and revolutionize the marketing and operations of the auction houses. By the end of the boom, auction houses were dominant players in the secondary market, not only for classic works but also for contemporary art. How this shift occurred and its effects on the market will be discussed shortly.

Traditionally Aesthetic Values (and Consequently Prices) Were Based More on Expert Consensus Than on Market Forces[8]

The tremendous growth of the arts market that began in the 1980s brought about several dramatic changes in its operation. Perhaps the most important was in the way artwork was evaluated and prices were established. Before we discuss these changes, however, we must first provide a benchmark of practices against which to compare the extent and effects of this change by describing how value was established previously.

Most specialists in or qualified judges of the arts agree on which works and painters deserve to be considered classics. But a key issue for contemporary work has been which works and artists deserve to be considered "legitimate." Indeed, much of the modernist discourse about the visual arts in the 20th century revolved around the question of what art is or ought to be and how to distinguish artwork from a mere ordinary thing (Danto, 1986). The principal arbiters of legitimacy have been the circle of critics, prestigious dealers, museum curators, and major collectors who made up the inner circle of the art world. Requiring time and interaction, the process of

[7] See Crane, 1987. The linkage between artists' and dealers' reputations can sometimes work to their mutual disadvantage. For example, dealers representing contemporary artists whose work sells well but has not received critical acclaim can be judged critically themselves.

[8] The discussion in this section borrows heavily from Szántó, 1997.

acquiring legitimacy was arbitrated through a slowly evolving consensus among these experts.

As Szántó (1997, p. 18) has described it,

> Legitimacy is the art world's principal measure of merit. It refers to the rules and dispositions that make for a hierarchy of value among cultural artifacts. . . . A legitimate artifact claiming the title "artwork" is valued based on a finite set of attributes that distinguish what is or ought to be art. The attributes place the artwork in referential relationship with other legitimate works and forms of art. It is not a positive or negative judgment along these attributes that classifies something as "art," but the sheer fact that the artwork is deemed fit to be appraised in terms of the prevailing aesthetic. Legitimacy, in short, is the privilege of being judged.

Briefly, there were several key features of the process by which artists and their work were evaluated. First, values were determined by a consensus among a small set of experts. Second, this consensus was developed through interaction and discourse among these experts—a process that was facilitated by their geographic concentration, primarily in New York and a few other market centers (e.g., London and Paris). Third, a key feature of this discourse was placing the artists and their work in the context of the modernist canon about what art is and should be—a discussion in which, as Galenson (2000) points out, such prominent critics as Clement Greenberg played a major role.[9] Fourth, the process through which an artist's work obtained certification consisted of a relatively well-established series of steps, each of which conferred its own type of legitimacy. These steps included discussion of the work among artists, multi-person and single-artist gallery shows, reviews by critics, purchase by collectors, and finally, exhibits in museums and eventually incorporation into museum collections. Szántó (1997, p. 19) writes,

> Opinion forming in the ranks of artists tends to spread first to the inner-circle art world participants (dealers, curators, critics, and some collectors) and then begins by degree to the art world's outer circle (secondary dealers and collectors, auction houses, the media). Long-term confirmation is given by museums and through inscription into the official canon of art history.

Fifth, the process through which consensus developed typically took time. Emerging artists often waited a half a dozen or more years before their work was recognized and marketable. Indeed, although there were exceptions, artists were typically required to wait many years for recognition, one-person shows, and eventually museum exhibitions—all while their styles continued to develop. Finally, the value and marketability of an artist's work depended more on his or her reputation than on

[9] Wolfe makes a similar point in *The Painted Word,* 1976.

the normal market forces of supply and demand. The traditional economic relationship between price and demand was reversed in the arts market. Typically, the lower the price of a good, all else being equal, the higher the demand. But in this market, as is generally true for luxury goods, the higher the price, the higher the demand.

How the Market Has Changed

Prices and Volume Have Risen Dramatically

The most visible change in the arts market during the art boom of the 1980s was the remarkable escalation in art prices. As pictured in Figure 3.4 in the chapter on demand, the value of the Mei and Moses index of fine art prices rose seven-fold between 1982 and 2002 (from 50 to 350). Although the work of Impressionists and old masters has generally garnered the highest prices (Picasso's *Boy with a Pipe* sold for $104 million in 2004 and Van Gogh's *Portrait of Dr. Gauchet* for $82.5 million in 1990), perhaps the most dramatic increases were in the values of contemporary artists. The first $1 million sale of a work by a living artist (Jasper Johns' *Three Flags*) occurred in 1980. Nine years later, Johns' *False Start* sold for $17 million, and more recently another work by Johns reportedly was sold for $40 million in a private sale—a forty-fold increase in price in just over 20 years. Today, the size of the market for contemporary work is considered to be equal to or greater than the market for historic works.[10] This phenomenon may be partly because the supply of contemporary work, unlike that of old masters and modern art works, is constantly expanding. Nonetheless, at least ten living artists are known to have one or more works purchased for $5 million and up.

Not surprisingly, the increase in prices was accompanied by a tremendous increase in the volume of sales. Since most galleries and dealers are privately owned and thus not required to report their sales volume, the change in the volume of sales of the two major auction houses provides the best indication of the increase in the volume of sales in the market over this period. In 1958, Christie's had sales of $5.8 million; by 1987, the total had soared to $900 million. Similarly, Sotheby's sales in 1958 totaled $16 million, and by 1987 they had reached $1.3 billion (Susan Lee, 1988).[11]

The rise in prices, however, was not uniform, either over time or across submarkets. The price increases during the 1980s, for example, were followed by sharp price declines in the early 1990s before prices began to surge again in the late

[10] Recall the quote from Watson (1992) in the prior chapter that the number of collectors in the contemporary market is twice as large as the number in the next largest submarket, modern art.

[11] Volume in sales is inferred here from total sales figures for the two auction houses.

1990s—an increase that more or less continues to the present.[12] Moreover, the price retrenchment during the early 1990s was particularly pronounced in the contemporary submarket. Indeed, echoing Moulin, Hughes described the contemporary market as "the junk bonds, as distinct from the Impressionist blue chips" (Hughes, 1990b, p. 69). As we suggested in Chapter Three, a major reason for the initial price increases and their subsequent volatility was the trend toward treating contemporary art as an investment.

The Operation of the Arts Market Has Become More Like Other Markets

In conjunction with the escalation of prices, the operation of the arts market has changed as well. These changes have occurred on both the demand and supply sides of the market. As we discussed in Chapter Three, the growth of demand has been driven by several factors including the presence of huge amounts of disposable income caused by the rapid growth of highly affluent segments of the population; the movement into the prime earning years of populations with more education and a greater familiarity with contemporary art; the globalization of the arts market as wealthy Europeans, Japanese, and more recently Russians and Middle Easterners have become major players in the market; and, of course, the growing perception and social acceptance of the notion that art is not only a luxury good to be collected and appreciated but can also serve as an investment.

At the same time that demand was surging, the practices of intermediaries on the supply side were also changing. Perhaps the most important of these changes was the elaboration of the marketing practices Peter Wilson had introduced in his efforts to transform Sotheby's from a predominately wholesale into a retail operation. Wilson's initial efforts were subsequently expanded and intensified by Alfred Taubman, who bought control of Sotheby's from Wilson in 1983. Taubman's approach was to provide a whole array of marketing services that had not been offered before in the arts market. These services included the production of showy catalogues for individual auctions, symposia to educate potential clients about the works up for auction, presale viewings not just in New York where most auctions took place but wherever the major buyers were concentrated, and lavishly entertaining clients prior to a sale. These marketing efforts helped transform auctions into major events in the seasonal arts calendar, drawing packed audiences and widespread media coverage.[13] In response to the success of these tactics, Christie's followed suit, and the competition between these two major auction houses escalated. This new service-intensive marketing approach transformed auction houses into major players in the market and led

[12] For a description of the decline in the 1990s, see Hughes, 1990a and 1990b, p. 65; and Tompkins, 1992. For a description of the recovery in the late 1990s, see Vogel, 1996b and 2000; Dobrzynski, 1999; and Gleadell, 2003.

[13] See Russell, 1989.

both houses to expand the scale of their operations dramatically. Christie's, for example, had one representative in the United States in the late 1950s. By 1988, it had two sales rooms in New York, nine regional offices throughout the United States, 77 offices in 26 countries, and 1,400 employees. Sotheby's similarly expanded to 71 offices in 27 countries and over 1,400 employees by that same year.[14]

These expanded marketing efforts, however, were only one facet of the changes that have occurred in the operation of the arts market over the last 30 years. Prior to the boom that began in the 1980s, the arts market differed in a variety of ways from the market for other assets. The arts market, for example, lacked the transparency and regularity of the stock market.[15] Transaction costs were high, and the market lacked liquidity since major works were traded infrequently and to a limited set of collectors. However, the changing practices of the auction houses as well as the entry into the market of a whole new set of intermediaries transformed the arts market in several ways.[16]

Before the aggressive marketing efforts by the auction houses, "buying and selling was discretely done. Good manners required it from the establishment, and collectors did not wish to draw themselves to the attention of competitors, private foes or tax authorities" (Melikian, 2002b, p. 1). As a result, information on the market was limited, and buyers relied on information supplied by dealers and other experts who had a vested interest in controlling that information. Because auctions are public events where the prices paid are matters of public record, the information available about prices in the market expanded dramatically as auction house activity expanded. The extensive marketing services that auction houses introduced, such as catalogues and seminars on works up for auction, were widely distributed to interested parties. In addition, the entry of new information intermediaries dramatically expanded the amount of information available to buyers and sellers. There are over 100 magazines providing information on the arts,[17] newspapers reporting on the arts market, as well as online sites like http://www.art-sales-index.com and http://www.kusin.com. For major collectors who seek advice on what to purchase and how much to pay, there are private advisors (Vogel, 1997c; Bahrampour, 2000). Indeed, even banks entered the information arena. Some of the largest banks—including Citibank, Credit Suisse,

[14] These figures are reported in Susan Lee, 1988, p. 73.

[15] See Adams, 2000a.

[16] Susan Lee, 1988, pp. 71–75. In other respects, art differs markedly from other investments: It can be hard to sell and expensive to store and insure. Moreover, fees to dealers and brokers are substantially higher than for stocks and bonds.

[17] See Susan Lee, 1988, p. 72.

Deutsche Bank, and Chase Manhattan—set up art advisory services to assist wealthy clients with investing in art.[18]

The auction houses' institution of commissions for both buyers and sellers of artwork has drawn complaints and was one aspect of the Justice Department's anti-trust investigation of Sotheby's and Christie's, which eventually led to Taubman's conviction for price fixing (Pollock, 2000; Day, 2002; Mason, 2004). However, Susan Lee notes that the 10 percent commissions that auction houses began charging to both buyers and sellers, although high relative to the commissions charged on the purchase of other assets, were actually an improvement on past practices. As she puts it,

> When dealers dominated the art market, they had enormous freedom in pricing. And why not? There were relatively few places a seller could take an expensive piece—and collusion among dealers was not unknown. Dealer markups were routinely two, three, or even four times the wholesale price" (Lee, 1988, p. 72).[19]

More recently, the arts market has begun to rely on the Internet, not simply to provide more information but also to extend the reach of the market beyond the wealthy to the middle class.[20] Although the success of these efforts has not yet been solidly established, by 2000 close to a dozen sites provided online shopping for serious art. The main auction houses started online ventures (Christie's in a solo venture, Sotheby's in a joint venture with Amazon.com). Internet retailers found auction house partners (eBay with Butterfield & Butterfield), and new firms such as Art-net.com joined in the fray. By and large, the principal focus of these online marketing efforts became the mass market for relatively low-value collectibles, prints, and lithographs, although some sites report sales in the $20,000 to $40,000 range (Peterson, 2000, p. 1). When Sotheby's joint effort with Amazon.com was launched, hopes had been expressed that online sales might eventually constitute half of their total sales volume, but Chief Executive Officer Diane Brooks admitted that "high-end luxury goods" that require personal inspection "don't sell all too well on-line" (Zielbauer, 1999, p. B3).

In addition to the proliferation of information available and the regularization of commissions, a variety of changes in financing practices also increased the liquidity and thus the efficiency of the arts market. Auction houses and commercial banks provided financing for wealthy collectors. Citibank, for example, was willing to lend up to half the appraised value of collections and to finance substantial portions of the

[18] As the head of Citibank's art advisory service remarked, "We don't advise our clients to invest in art, but wealthy people have art and so we have a unit for them" (Adams, 2000a).

[19] Indeed, in an effort to introduce more transparency into the market, in the mid-1980s, New York City mandated that dealers visibly display the purchase price of art in their galleries.

[20] See Zielbauer, 1999, p. B3; Peterson, 2000; Lunden, 2000, p. 69; and Atkins, 1999.

purchase price, thus allowing collectors to leverage their investments while keeping the use of a substantial portion of the capital that otherwise would have been tied up in the purchase.[21] The auction houses also became involved in financing art purchases.[22] Sotheby's, for example, has not only financed purchasers, it also provides capital to dealers to purchase art for which it charges interest and is guaranteed a share of the profits when dealers later sell the work.[23] Both Sotheby's and Christie's routinely provide guarantees to prospective sellers (and often advance them a portion of the guarantee) to encourage them to put works on the market (Susan Lee, 1988; Mason, 2000).

Adding to the efficiency and liquidity of the arts market were the globalization of financial resources that "made the transfer of funds and information across national boundaries a snap" (Susan Lee, 1988, p. 73). The globalization of resources encourages the globalization of demand and the entry of other intermediaries providing such specialized services as art insurance, public relations, cultural merchandizing, and event planning.[24]

The net effect of these changes was that the arts market became more transparent, more efficient, and more liquid—in sum, the arts market began for the first time to look like the market for other types of assets. Although these changes made the arts market appear more conventional by contemporary business standards, they have been deeply controversial within the arts world.[25]

Despite the fact that the arts market increasingly resembles other asset markets, it still differs from those markets in one particularly significant way: It is still largely unregulated. Indeed, although both Sotheby's and Christie's were indicted for price fixing by the Department of Justice and Sotheby's former chairman was convicted, there is very little regulation of the arts market, compared with the stock and even the real estate market. Little regulation continues even though a variety of observers have noted the following suspect practices: agreements among dealers not to engage in competitive bidding at auctions, "bidding off the chandelier" and "buying in" among auction houses, overcharging purchasers to raise commissions, and representing both the seller and buyer in art transactions.[26]

[21] See Susan Lee, 1988; Walker, 1987; and Adams, 2000a and 2000b.

[22] Sotheby's, for example, reportedly lent Australian entrepreneur Alan Bond half the purchase price of $49 million for Van Gogh's *Irises,* on which he later defaulted. See Hughes, 1989b, pp. 66–67.

[23] See Vogel, 1998.

[24] See, for example, the series of profiles on art insurers, public relations experts, cultural merchandising specialists, and event planners in Vincent, 1997.

[25] See Hughes, 1984, 1989a, 1989b, 1990a, and 1990b.

[26] "Bidding off the chandelier" refers to the practice of announcing fictitious bids at auction to drive up the price. "Buying in" refers to the practice of leaving an item unsold if it does not meet the seller's reserve price.

Nevertheless, the increasing liquidity, transparency, and efficiency have encouraged more potential buyers to enter the market and to view fine art not simply as a luxury good but as a potentially profitable investment. As a result, the market has not only become much larger but also much more active. As Susan Lee (1988, p. 72) notes,

> there has been a stunning increase in how fast works of art turn over. In the old days, pieces usually disappeared for 40 years. Nowadays, they typically reappear on the market within 5 to 7 years. And, in a hot market, turnover can be lickety-split, sometimes a matter of months.

Perhaps the most significant effect of these changes was undermining the traditional process by which prices and value had been determined in the market. As we discussed above, consensus among experts dominated the determination of legitimacy, and the value assigned to artists' work depended on interaction and discourse among the experts—a process that required time, specialized expertise, and judgments about how contemporary work, in particular, stacked up against the modernist canon. As the market became more transparent and turnover increased dramatically, the conditions upon which the traditional value-setting consensus depended (time, interaction, and discourse) broke down. This process was intensified by the globalization of the arts market, which made frequent discourse among experts more difficult. No doubt the sheer growth in the size and the volume of the arts market contributed to the disruption of frequent discourse.

Moreover, the increasing tendency for buyers to view art as an investment and thus to identify work before it became popular (and thus more expensive) created what has often been described as a frenzy for spotting trends early and speculating on future value. In sum, in place of the traditional consensus among experts, prices in the market, particularly the contemporary market, were increasingly driven by market forces and speculation.

Experience Suggests That Art Remains a Risky Investment

Given that speculation and the view of art as an investment appear to have played a role in the market run-up that began in the 1980s, the obvious question is, How does art as an investment compare with other types of investments? Despite some notable success stories,[27] the answer in general is not particularly well. Two major studies conducted of this issue both conclude that over the long-term investments in

[27] One of the most notable of these success stories was the British Rail Pension Fund's investment in art during the 1970s, which reaped a 14 percent return when the pension sold the purchases in 1989. See Sheer, 1987, and Watson, 1992, pp. 423–424. In fact, as Watson points out, the rate of return for the pension fund on works from different submarkets varied dramatically.

art yield lower returns than investments in government securities.[28] Moreover, the variance of these returns is also much greater than in other forms of security.

Art, unlike equities or investment properties, produces no income until it is sold (but will require expenditures for insurance, maintenance and storage). Also, the rate of return on art as an investment appears to depend on the starting point for the calculation and the submarket to which it belongs. There is some evidence, as Watson suggests, that during periods of high inflation, art is a better investment than at other times. Indeed, Frey and Pommerehne's results (1997) suggest that art has been a better investment after World War II than before primarily because inflation has been higher during this period. In addition, as we have already noted, the rate of return varies across submarkets and over time. It also depends on when a work was purchased and where its submarket falls in this price cycle. For example, the British Rail Pension Fund's investment in Impressionist work earned much higher returns than its other artwork because the Impressionist work escalated rapidly in price during the period that the pension fund held it.

The most important finding from these studies is that the rate of return on the purchase of an artwork appears to depend on the length of time the buyer holds the work. The more rapidly buyers turn the work over, the higher the potential return. However, the spread around that return declines the longer a work is held. In other words, the odds of both winning and losing appear to increase substantially for works that are bought and sold quickly. As a result, the longer the work is held, the lower the likely rate of return but also the lower the chances of a major financial loss on the purchase. Since investors overall can expect a smaller return on an investment in art than on other assets, art does not appear to be a particularly good investment. The best but also the riskiest strategy is to speculate in contemporary work whose long-term value has not yet been established. In light of these findings, it may not be particularly surprising that this appears to have been the strategy followed by many of the buyers during the boom period.

Future Issues

Changes in the elite market over the last 30 years have not only produced a dramatic increase in prices, but have also altered the role and importance of different players in the market. These changes have produced winners and losers. Among the winners were the auction houses. They became the dominant players in the market and, despite the price-fixing scandal of the late 1990s, remain the most influential actors in

[28] See Baumol, 1986, and Frey and Pommerehne, 1989. Baumol, for example, estimates a mean annual return of 0.5 percent and Frey and Pommerehne an annual return of 1.5 percent (versus a 3.7 percent return on government securities, adjusted for inflation).

the market. A second set of winners has been the new contemporary artists whose work became "hot" and thus reaped substantial financial rewards—although that fame and fortune have sometimes been fleeting in a market noteworthy for trends and buying and selling frenzies. A third group of winners are the buyers and sellers who profited from the market. In particular, high-end collectors, such as Charles Saatchi, through the scale and prominence of their collecting (buying up multiple works by an artist, promoting them, placing them in their own galleries) became particularly influential in setting market trends and prices.[29]

There were also losers. Dealers and galleries that had formerly dominated the arts market both won and lost. In the short-term, the value of their inventories climbed, and they reaped the benefits of higher prices. But over the longer-term they lost their dominant position in the primary and secondary markets (as well as the commissions that came with that dominance) to the auction houses. They found themselves competing both for buyers and artists against an influx of new dealers who entered a much more competitive (but potentially highly lucrative) market. A second set of losers was the art critics. They lost influence in a market in which legitimacy and value were no longer determined by consensus among a limited set of experts (among whom critics were particularly important) but by tastes and pocketbooks of buyers. Traditional collectors who had occasionally entered the market to build their collections but lacked the resources of the high-end collectors found themselves facing more competition and higher prices. Many were priced out of the market.

Finally, museums were losers as they found their buying power substantially diminished and thus their collecting mandate circumscribed. Even the wealthiest museums lost purchasing power and the ability to make more than very selective acquisitions. Instead, they have become increasingly dependent on the largess of such benefactors as major collectors, dealers, and artists—all of whom have an interest in the art world's discourse—and on de-accessioning from their current collections to purchase new art. Although de-accessioning is a common practice, benefactors often place constraints on how and whether museums can dispose of their donations. Thus, the museums' autonomy and prestige have suffered. As a result, their traditional role as arbiters and protectors of the canon has been usurped to some extent by the market. Moreover, the deliberate pace at which museums had traditionally evaluated new artists and their work, and thus determined what art should be exhibited and collected, was assaulted by a market that anointed stars seemingly overnight.

What do these changes portend for the future of the art itself? Clearly there has been a growing pluralism in the work that is produced and the standards used to evaluate the long-term importance of the art. This pluralism is, of course, partly a

[29] See, for example, Solomon's (1999a) profile of Charles Saatchi. Also see Dinitia Smith, 1987.

result of the collapse of the modernist canon. Contributing to the current state of affairs is the challenge to the traditional importance that consensus among the experts played in determining legitimacy and value. Perhaps, not surprisingly, critics like Robert Hughes and Peter Plagens have excoriated these trends and their implications for the quality of contemporary work. They note, for example, that the traditional pace of artistic development and maturation that has allowed artists to develop has been significantly shortened. Artists now feel compelled to meet a production schedule driven by multiple annual shows. Indeed, Plagens (1999, p. 7) complains that too much contemporary art is "not that much different anymore from the products of the entertainment industry." Other observers dispute these judgments and hail the new pluralism of the visual arts world. Time will tell which contemporary artists and work will endure. It seems clear that the changes in the elite market will not be reversed, and the traditional system of assigning value and price will not be restored.

The future of the market appears to revolve around three issues. First, will demand continue to grow and what shape is that growth likely to take? Second, will prices continue to climb? Third, will the largely unregulated character of the market continue uninterrupted? The answers to these questions may well be related. A continued escalation in prices will, of course, be determined by the interplay of supply and demand. To the extent that rising levels of affluence continue and art is perceived as an attractive investment for the wealthy, then demand is likely to remain strong. Indeed, as we suggested in Chapter Three, it is conceivable that the taste for collecting could become broader, spreading into the upper and middle classes—a development that would also expand the range of artwork available in the market to include both prints and reproductions and work that has heretofore been relegated to the general commercial market. Whether prices in the elite market will continue to rise will depend not only on growth in demand but also on the expandability of supply. As we discuss in more detail in the final chapter, we think that such growth in supply and demand is very likely to occur. Another major issue for the future is how the operation and structure of the market will develop. How this issue is resolved may well depend on whether the market remains largely unregulated or whether an expansion in the size and a broadening of the scope of the market lead to greater pressures for regulation.

Visual Arts Organizations

As we noted in Chapter Two, the organizational ecology of the visual arts has been dominated by three sets of institutions: the various commercial intermediaries that structure the operation of the arts market and thus purchasing; art museums, which dominate public appreciation of visual arts; and the world of arts discourse, which provides an ideational underpinning for the operations of the other two. In the previous chapter, we described the commercial market, how it is changing, and how those changes are affecting art purchasing and collecting. In this chapter, we turn to the nonprofit sector with a particular focus on art museums, by far the dominant nonprofit institutions in the visual arts.

Once again, we begin by delineating the key concepts we use to describe the nonprofit sector. Then we provide a profile of the organizational structure of the nonprofit sector. This description is followed by an examination of current trends, their shape, and the dynamics that appear to drive them. Finally, we explore the major implications of these trends for the future.

Key Concepts

Visual arts works can be displayed, sold, and purchased in either the commercial (for-profit) or nonprofit sectors. The distinction between the two sectors lies not in the nature of the work but in that of the organization that supplies it. There are several noteworthy differences between for-profit and nonprofit organizations. The most obvious is their tax status. Unlike the taxable revenues of for-profit firms, nonprofits' revenues are largely untaxed as are the contributions of their benefactors. In exchange for their tax-free status, nonprofits are expected to provide educational, cultural, and scientific benefits to the public. A second and related difference between for-profits and nonprofits is the composition of their revenue stream. For-profits derive most, if not all, of their revenues from earnings, whereas nonprofits typically rely on a combination of earnings (admission fees and proceeds from gift shops, rentals, and food services), contributions (from foundations, corporations, and individuals), and grants and contracts from government sources.

These very different sources of revenue contribute to a third major difference between for-profits and nonprofits—specifically while for-profits' organizational strategies are principally designed to maximize their profits, nonprofits' operations are more typically mission driven. Moreover, the nature of these missions is typically multifaceted. Art museums, for example, have at least five traditional missions: collecting, preserving, studying, exhibiting, and interpreting arts objects. Thus, in contrast to for-profit institutions, whose performance can be measured against a single benchmark (i.e., their profit), there is no single criterion against which to measure nonprofits' performance. Indeed, as we will discuss later in this chapter, museums often face conflicts in determining how to balance these various missions.

In addition to multiple missions, nonprofit organizations in the visual arts differ in a variety of other ways. Some are principally dedicated to displaying and conserving art, such as museums and galleries, while others have a much broader purview—such as promoting the production of art, cultivating the public's taste for art, providing services to artists and such intermediaries as professional and trade associations, conducting research, and training artists. Many of these organizations are founded primarily to promote some aspect of the visual arts, but others—e.g., art galleries in universities—are simply one component of an institution that is dedicated to much broader nonartistic purposes.

Finally, nonprofit visual arts organizations, like for-profit organizations, must contend with the fiscal realities of revenues and expenses. But the financial structures of visual arts organizations, especially museums, differ notably from those of performing and other arts organizations, complicating comparisons of their fiscal circumstances. Although both sets of organizations have operating constraints that require them to balance their revenues against their expenses on an annual basis, their asset structures are very different. The principal assets for most performing arts organizations are the artists affiliated with the organization. By contrast, the principal asset for most museums is their collection of art objects. Put in economic terms, visual arts organizations' principal asset is physical capital, while performing arts organizations' principal asset is human capital.

Correspondingly, the cost structures of these two types of arts organizations differ. Because the costs of acquiring arts objects for a collection can be enormous, museums typically face very high start-up costs. Indeed, given the trends in arts market prices discussed in the prior chapter, those start-up costs have been climbing dramatically. By contrast, start-up costs for performing arts organizations are relatively low since the dominant factor in their cost structure is the variable costs of salaries of paid performers and other staff.

The unique asset structure of museums has a second implication for visual arts organizations' operating budgets that differs dramatically from organizations in the performing arts. Since museums' wealth consists overwhelming of their physical capital—their facilities and most importantly their collections—the value of their assets

typically dwarfs the size of their operating revenues. Stone (2002) estimates, for example, that the value of an average art museum's collection is about 55 times larger than its operating revenues. Maintaining that collection is, of course, one of an art museum's principal missions and thus entails annual storage; insurance; and, when necessary, repair costs. All of these costs constitute a significant share of a museum's annual expenses. However, unlike other assets, a museum's collection does not yield offsetting annual revenues. Moreover, as we will note, there are very strong norms within the museum community against selling off parts of the collection for anything except financing acquisitions. This situation is very different from that of performing arts organizations, where the dominance of wages and salaries has subjected them to, as Baumol and Bowen (1966) comment, the "cost disease" that causes wages to increase much faster than productivity.[1]

Given the substantive importance of museums to art appreciation and an unfortunate absence of statistical information on the characteristics of other nonprofit organizations and their expenses,[2] our analysis here concentrates on art museums—although where possible we provide information on other types of visual arts nonprofits.

The Current Picture

Museums Dominate the Organizational Profile of the Visual Arts

In the visual arts, just as in the live performing arts, nonprofits dominate the organizational landscape. Figure 6.1 provides a general profile of this landscape. The first panel of this figure, for example, indicates that 89 percent of all visual arts organizations are nonprofit. Panels two and three of this figure provide additional details about the nature and focus of these nonprofits. Panel two indicates that approximately one-quarter (27 percent) of these nonprofits are principally dedicated to dis-

[1] The idea of the cost disease is based on the observation that labor productivity increases in the economy as a whole have generally driven up labors' price over the last 100 years. Certain labor-intensive industries, however, are less conducive to exploiting labor-enhancing technologies in their production processes and thus fail to realize the labor productivity increases of the economy as a whole. Yet the need to compete with other industries forces them to keep pace with economy-wide wage increases. As a result, real costs in these industries rise faster than productivity, resulting in labor cost inflation.

[2] Organizations like universities, which may have some visual arts activities but are primarily engaged in some other industry (e.g., education), are not captured in organizational data on the visual arts. Moreover, systematic expense data on nonprofit arts organizations (in the visual and other arts together) are sparse to nonexistent.

Figure 6.1
Percentage of Total Number of Visual Arts Organizations by Type

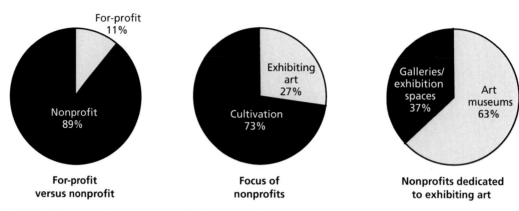

NOTES: This comparison is based on 1997 Census of Service Industry data. These data do not include organizations that may include a visual arts component but are primarily involved in some other industry, such as art galleries that are operated by universities.

RAND *MG290-6.1*

playing art, such as museums and galleries. The remaining three-quarters (73 percent) are involved in cultivating art and/or the public's taste for art and in providing services to artists or arts organizations—such as providing funds to other organizations, professional and trade associations, research associations, and arts schools. Finally, panel three demonstrates that among those nonprofits whose primary mission is displaying art, a little less than two-thirds (63 percent) are museums; the remainder are galleries and exhibition spaces.[3]

Looking only at the tally of visual arts organizations, however, provides an incomplete picture of the organizational environment of the visual arts because the distribution of revenues and other resources is so uneven among visual arts nonprofits. For example, close to 70 percent of these organizations have annual revenues of less than half a million dollars, and only a little over 20 percent have annual revenues of more than one million dollars. Indeed, Table 6.1 provides a more detailed picture of the degree to which the distribution of revenues and assets is concentrated in the hands of a select few visual arts nonprofits, specifically art museums. The share of total annual revenues that accrues to the top 20 percent of these nonprofits (166 organizations—all of which are museums) constitutes 95 percent of all nonprofits'

[3] The museums included in Figure 6.1 are classified under the National Taxonomy of Exempt Entities as A51 organizations, which include only art museums. This category excludes other museums such as those devoted to science, history, children, and mixed uses.

Table 6.1
Percentage of Revenues, Assets, and Donations Controlled by the Largest Visual Arts Nonprofits

Percentage of organizations	Percentage of revenues	Percentage of industry endowments and infrastructure	Percentage of donated revenues
Top 1%	45% ($1.50 billion)	48% ($5.97 billion)	41% ($554 million)
Top 5%	78% ($2.60 billion)	83% ($10.28 billion)	76% ($1.04 billion)
Top 20%	95% ($3.16 billion)	98% ($12.11 billion)	96% ($1.31 billion)

NOTES: Calculations are from the National Center for Charitable Statistics at http://nccsdataweb.urban.org/. Dollar figures are in parentheses. Assets refer to buildings and endowments, but not collection values. Donations do not include donated works or the value of volunteer time.

annual revenues. Moreover, the eight museums in the top one percent of the distribution control almost half of all nonprofits' annual revenues. The distribution of assets (column three) is even more concentrated.[4]

In other words, from the perspective of either total annual revenues or total assets, museums dominate the organizational profile of the nonprofit visual arts world. Indeed, the aggregate statistics on visual arts organizations are determined to a surprising extent by a handful of museums. Table 6.2 lists the eight largest of these museums and their total revenues in 2000.[5] These eight institutions are the superstars of the American museum world. All but one are located in major metropolitan areas and have a long history of involvement by very wealthy benefactors who have not only played major roles in their financing but also in donating major works to their collections. Indeed, half were established in the 19th century. During their relatively long histories (at least in comparison to other museums in the United States), they have been able to accumulate collections of works that are simply not available today.

[4] This comparison of assets does not include the works of art themselves. Since the ratio of assets (excluding the art) to operating revenues is roughly 3.7 to 1, while the average value of an art museum's collection is about 55 times larger than its operating revenues (Stone, 2002), were the value of art included in these comparisons, they would undoubtedly be even more concentrated. We recognize, of course, that the artwork in a museum is generally highly illiquid—indeed, in many museums up to 80 percent of it is in storage rather than on display—so estimates of the value of these assets were they to be sold are hypothetical.

[5] Conspicuously absent from this list is the Getty Museum. As part of the Getty Trust, a charitable foundation, its revenues, earnings, etc. are not publicly available. However, extrapolating from annual revenues and operating budgets of the trust as a whole and other available information, it is clear that the Getty Museum belongs in this list of the largest museums in the country. The Getty Museum shares key features with other institutions on the list: It is located in a major metropolitan area and is the product of an extraordinary endowment and collection from a wealthy benefactor.

Table 6.2
Largest Visual Arts Nonprofits

Name	Year Established	Total Revenues (2000)
The Metropolitan Museum of Art (New York)	1870	$464,313,204
National Gallery of Art (Washington, D.C.)	1941	$240,519,337
Art Institute of Chicago	1879	$209,586,434
Museum of Modern Art (New York)	1929	$191,873,634
Museum of Fine Arts (Boston)	1870	$162,260,726
The Henry Francis du Pont Winterthur Museum (Wilmington)	1951	$88,137,154
Philadelphia Museum of Art	1876	$76,541,361
Los Angeles County Museum of Art	1913	$70,954,762

NOTE: Calculations are based on 2000 Internal Revenue Service Form 990 data.

The more recent institutions have benefited from special circumstances: the National Gallery of Art from its status as the federal government's preeminent art institution as well as the donated collection of Andrew Mellon;[6] the Museum of Modern Art from its location in New York, the center of contemporary art in the 20th century; and Winterthur from the extraordinary collection and endowment of its founders. Thus, the prominence of these institutions suggests the importance that initial advantages due to history, location, and access to wealthy patrons play in the museum world.

Indeed, the importance that location plays in bestowing comparative advantage in the visual arts is further suggested by Table 6.3, which compares the share of total visual arts revenues received by visual arts institutions in eight major cities with their share of the total U.S. population. New York is clearly the dominant center of the visual arts world in the United States. Over one-third of national visual arts revenues accrue to visual arts institutions in New York, compared to the metropolitan area's 6.5 percent share of the total U.S. population. New York's advantage reflects its role as the center of the national/international arts market, the prominent role its art institutions play in the art world (The Metropolitan Museum of Art, the Museum of Modern Art, the Guggenheim Museum, the Whitney Museum of American Art, etc.), and as a center of artistic activity and visual arts tourism.

Moreover, this concentration exists despite the boom in the establishment of art museums in the post–World War II era. More than three-quarters of all museums in

[6] Andrew Mellon's remarkable art collection was donated to the National Gallery of Art upon his death in 1937. Mellon's collection formed the backbone of the National Gallery's initial collection when it opened in 1941, and this initial collection was subsequently expanded through other bequests.

Table 6.3
Nonprofit Visual Arts Concentration in Eight Major Cities

City	Percentage of Nonprofit Visual Arts Revenues	Percentage of the U.S. Population
New York	36.3%	6.5%
Chicago	6.7%	3.2%
Washington, D.C.	5.0%	1.7%
Los Angeles	4.8%	4.4%
Boston	4.8%	1.6%
Houston	3.3%	1.7%
San Francisco	3.2%	1.5%
Philadelphia	2.2%	2.0%
Total	67.6%	25.1%

NOTES: Calculations are from the National Center for Charitable Statistics at http://nccsdataweb.urban.org/. Population data are for metropolitan areas. If city populations are used instead, the geographic concentration is more striking, with these eight cities receiving 67 percent of all revenues but containing only 7 percent of the country's population.

the United States were founded during this period,[7] and over half since 1970. Indeed, art museums—along with opera houses and the symphony orchestras—appear to have become matters of civic pride that no self-respecting city can do without. There are over 3,500 U.S. art museums that draw over 50 million visitors each year. See the 2002 SPPA (NEA, 2003). They include a dizzying array of institutions—some with collections, others without; some focused on a particular period, style, or culture, others encyclopedic or eccentric. Some are regionally based or university based, while others are national or international in scope. Also, they serve an equally broad range of audiences and interests, from educational and experiential to recreational and social.

Museums' Multifaceted Missions Are Often in Conflict

Unlike the performing arts—where it is not uncommon for one set of institutions to produce, another to present, and a third to market a performance and where these functions are often performed by separate institutions for each of the different performing arts disciplines—museums typically perform all of these functions for the appreciation side of the visual arts. Indeed, since their establishment in the 19th century, American art museums have traditionally served multifaceted roles in the visual arts.

American art museums, unlike those in Europe, were overwhelmingly established as private not public institutions. However, their founders typically considered

[7] See Hudson, 1998, and Weil, 2002a.

exposing a wider public to art as one of their major missions.[8] Indeed, as we noted in Chapter Two, the earliest museums in the country were founded with the dual aim of fostering the creation of art and developing the public taste for the arts. That public included the upper and middle classes, for whom fine art might serve as a source of inspiration, and the poor and immigrants, for whom edification in the arts might provide a path toward assimilation and socialization. Thus, since their founding, American art museums have viewed providing public access to fine art as a central element of their mission. They have served this role by maintaining permanent collections, presenting special exhibitions, and providing educational programs and general outreach.

Museums are also the principal preservers of both the nation's and the world's visual arts heritage. In this role, they are involved in collecting, preserving, and, when necessary, repairing visual arts works. There is, of course, no direct counterpart to this range of functions in the performing arts, although there are institutions that are designed to preserve the country's dance, theater, and music patrimony.[9] Another major role that art museums play is establishing the visual arts canon and telling the story of the visual arts. As we noted in the discussion of arts discourse, museums have played a major role in establishing the legitimacy and artistic value of artists and their work through the process of exhibiting and collecting artwork. As legitimizers, they exert tremendous authority in defining and enforcing the canon. Museums perform this role through acquisitions, collecting, exhibitions, scholarship, and publications.

In addition to their general educational and exhibition role, as 501(c)(3) non-profit organizations, museums have an obligation to serve the public as dictated by the tax code. As noted above, in exchange for their own tax-free status and the tax benefits their contributors receive for their donations, museums are expected to promote the public benefit.[10] What specific activities this public mandate requires, however, is unclear and has tended to vary over time and among museums. Is it sufficient to design programs and exhibits that can promote a deepening of the museum experience? Is building the collection and holding relevant special exhibits part of the mission? Does it require outreach to both broaden and diversify museum audiences? Or are special outreach efforts into the community needed, e.g., bringing art to the people, creating special education programs, collaborating with other community organizations, etc.? In addition, there are questions about how the public should be defined. Is it limited to museum visitors and supporters? Does it include the wider

[8] In 1989, over 68 percent of American art museums had a private (versus public) governing authority (Schuster, 1998).

[9] For example, the performing arts library division in the New York Public Library, the Library of Congress, and Harvard's Theater Collection.

[10] For an analysis of the nature of these benefits and the role that the arts play in providing them, see McCarthy et al., 2004.

community? Should groups with little history of museum patronage be specially targeted? These are questions museums must address when they consider their broad public responsibilities if for no other reason than they are tax-exempt organizations.

Not surprisingly, there have historically been tensions in the priorities museums assign to these different functions and in the ways that they have carried them out. As we noted in Chapter Two, for example, the rising importance of aestheticism led many museums to de-emphasize the importance they placed on their public education mission in favor of greater attention to arts objects and the museums' roles of scholarship and legitimization of the canon. Similarly, Neil Harris has noted that a combination of financial difficulties and society's increasing concern with social equity led museums in the 1970s and 1980s to reemphasize public involvement and their social roles.[11]

In addition, many museums experience tensions between their outreach and education missions and their research and scholarly functions. Collection utilization, for example, is an issue for museums with an abundance of "treasures in the basement," which may serve scholarship or cultural preservation roles but limit public access to stored work. Providing more space to display a larger portion of the museum's collection would allow more work to come into the public view but costs money that might well reduce the resources available for research and preservation. Loaning works to other museums might also be an option, but museums are likely to keep their highest-quality work, and other museums may be reluctant to take "second-class" work. Finally, de-accessioning stored work is also a possibility. However, many collectors, upon whom most museums depend for a portion of their new acquisitions, are often reluctant to donate work that will later be sold. As a result, conflicts can arise between the museum's exhibition role and their ability to raise funds for their other missions. As Weil and others have pointed out, there is considerable debate about this tension between arts objects (the research and preservation functions) and people (the education and public involvement functions). Currently, greater emphasis is once again being placed on museums' public education and involvement missions.[12]

Even when museums agree about the priority assigned to particular missions—e.g., public education and involvement—there are often tensions involved in deciding how to carry out these missions. This issue often arises in light of recent museum practices to increase public involvement in museum activities. Some museum directors, for example, have criticized museums' growing reliance on blockbuster exhibits, commercialism, and other efforts to expand museum attendance and attract visitors who might otherwise not attend. These efforts are viewed as catering

[11] This example is discussed in Chapter Two.

[12] See Weil, 2002a, pp. 28–52. Also, Harry Parker, director of the Fine Arts Museums of San Francisco, notes "a shift of emphasis from collections to visitors" (quoted in Schwarzer, 2002, p. 42).

to an entertainment philosophy that threatens the special character of the museum experience and promotes the fleeting and sensational over the experience of the work of art.[13] Suffice it to say that these tensions among museums' missions appear to be endemic.[14] How these tensions are resolved appears to vary over time, depending on the social and economic pressures to which museums are subject.

Museums Rely on a Diverse Array of Sources for Their Revenues

Museums' revenues consist in relatively equal proportions of earned income, donations, government subsidies, and income from endowments. The Association of Art Museum Directors[15] reported that in 1998 American art museums earned an average of 26 percent of their revenues (the majority of which comes not from admission fees but from museum stores, special events, and food services receipts). In the same year, they received 28 percent from individual, corporate, and foundation philanthropy; received 27 percent from all levels of government; and had endowment income amounting to 19 percent.[16]

The composition of this revenue stream is notably different from that received by the typical performing arts organization, which relies on earnings, primarily admission receipts, for about 60 percent of its total revenues. These organizations also receive about 35 percent from a variety of contributed sources, including foundations, government agencies, the corporate sector, and individuals. Very few performing arts organizations have endowments and thus are rarely able, as museums usually are, to defray their annual expenses from the interest they earn on their endowments.[17]

Museums' greater reliance on donations than on earnings primarily reflects the historical importance they and their founders have attached to providing access to art to a broad cross-section of the public. Consequently, many museums view charging

[13] See Cuno, 2004a. Also see Cuno and Rogers, 2000.

[14] Prior to World War II, the focus considered the greatest service to the public was inward on the growth, care, and study of museums' collections (Weil, 1999, pp. 229–258, and 2002a, pp. 28–52). Since that time, the field has shifted toward a focus on the public itself and the quality of the museum experience (Hudson, 1998; and Weil, 1999, pp. 229–258, and 2002a, pp. 28–52. This shift in focus is manifested in accreditation requirements. In the early 1970s, these requirements focused on how institutions cared for their collections. In the 1990s, they shifted to broader considerations of how institutions used their collections programmatically. By 1997, the American Association of Museums evaluated art museums based on whether the museum knew its audiences, involved them in programming, and evaluated the effects of their exhibits on their audiences (Weil, 1999, p. 235).

[15] The Association of Art Museum Directors includes America's largest 175 art museums (minimum annual revenues of $2 million, with a few exceptions).

[16] This description of museum revenues focuses exclusively on museums' operating budgets and thus cash revenues and excludes donations of artwork, upon which museums have traditionally relied to build and supplement their collections.

[17] See McCarthy et al., 2001.

admission fees as at cross-purposes with this goal. Thus, even though museums, like performing arts organizations, have sought to increase their earned revenues, they have tended to focus on museum stores, food services, and special events rather than on raising admission fees. However, admission fees are customary for special and especially blockbuster exhibits. Moreover, as their costs increase, museums face increasing pressure to consider initiating or increasing general admission fees, which the Museum of Modern Art in New York did when it re-opened in its remodeled facility.

Smaller and newer museums, however, are often at a disadvantage in the competition for donations, since they typically lack prominent art collections and the prestige within their communities that comes with a long history and generous donors, and thus the reputations of their older and often wealthier counterparts. They typically have smaller endowments, find it more difficult to get government funding,[18] and are less likely to have the wealthy benefactors who not only provide donations to a museum's operating fund but also artwork to its collection. It is not surprising that, as Table 6.1 shows, donations to museums are just as concentrated among a select set of museums as are total revenues and assets.

Note that this discussion of revenue sources has not mentioned de-acquisitioning as a source of revenue, even though the collections of most museums are by far their single largest asset. One might expect that museums would consider selectively selling some of their collection to increase revenues—particularly since many museums keep up to 80 percent of their collections in storage rather than on display. Museums do, of course, sell parts of their collections, but the proceeds from such sales are used almost exclusively to purchase other works. Indeed, given their roles as preserver and exhibitor of the visual arts heritage, museums have a strong predisposition as well as associational norms against selling artwork to cover operational costs. Members of the Association of Art Museum Directors (AAMD), which represents the largest museums, have all pledged to use the proceeds from the sales of de-acquisitioned works only for the purchase of new work. In 2004, AAMD lodged a protest in federal court against the court's requirement that the trustees of the Barnes Collection consider selling part of the collection to cover operating budget shortfalls.[19] In short, there are very strong norms against using the proceeds from de-acquisitioning to cover operating expenses.

[18] See Alliance for the Arts, 2001. This report demonstrates that the larger and more prestigious art institutions get a disproportionate share of government and corporate grants.

[19] See "How U.S. Museum Directors Reacted," 2004. Another example of the norms against museums selling off artwork to cover operating costs is provided by the experience of the Guggenheim. When *The Wall Street Journal* reported in December 2002 that the Guggenheim had sold pieces to cover operating costs, the AAMD conducted an investigation of the incident, and only after a review of confidential documents did it exonerate the museum. See Kaufman, 2004b.

Almost Half of Their Expenditures Are Overhead Expenses

Museums' operating expenditures are heavily weighted toward overhead and mainte-nance—e.g., capital improvements, maintenance, utilities, and security—which con-stitute almost half of their total annual expenditures (see Figure 6.2). By contrast, spending for programs (curators, education, conservation, and libraries) consumes about one-quarter of their annual expenditures. Development (fundraising) and ad-ministration consume another quarter, which is not surprising given their depend-ence on donations for a substantial share of their revenue. This pattern reflects the diverse blend of functions that museums fulfill and the relative costs of these various functions. The relatively large share of museums' expenditures for overhead is pri-marily due to the high costs associated with the museums' role as principal guarantor of the cultural heritage of the visual arts. These costs include not only necessary capi-tal improvements but also the costs of maintaining a substantial asset base (both in artwork and fixed capital, e.g., facilities) as well as the ongoing costs of security and utilities.

Given the importance of overhead, development, and administration, pro-gramming typically faces tough competition for funding, giving rise to tensions among museums' multifaceted missions.

Figure 6.2
Art Museum Expenditures by Type

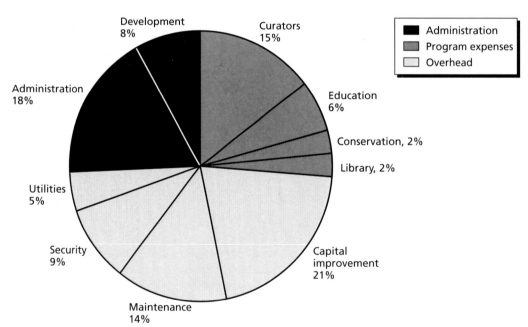

SOURCE: Heilbrun and Gray, 2001, p. 188.

Key Trends

Just as the arts market has been changing, so too has the environment in which museums and other nonprofits operate. In this section, we describe the major trends, the challenges they are posing for museums, and their potential implications over the longer term.

Visual Arts Organizations Have Been Growing

Whether measured in terms of the number of organizations or their revenues, the organizational structure of the visual arts has been growing (see Figure 6.3). Not surprisingly, during 1987–1997, a period when the arts market was exploding, the growth in the for-profit sector was particularly rapid. This fact is evident in both the more rapid emergence of new commercial organizations (the number of organizations increased 79 percent) and in terms of total revenue (which increased by 136 percent in inflation-adjusted dollars).

Figure 6.3
Growth in the Visual Arts Sector, 1987–1997

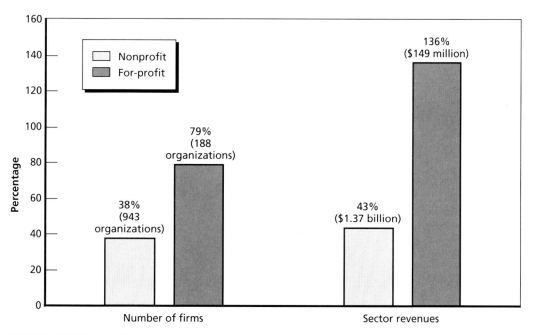

SOURCE: 1997 Census of Service Industries.

NOTES: This comparison is based on 1997 Census of Service Industry data. These data do not include organizations that may include a visual arts component but are primarily involved in some other industry, such as art galleries that are operated by universities.

RAND *MG290-6.3*

While increasing activity within the visual arts market may have prompted growth in the number and revenues of for-profit organizations, surges in museum attendance from 1987 to 1997 appear to have stimulated similar if somewhat slower growth in the nonprofit sector. Despite this more modest growth in the number of nonprofit organizations (38 percent) and their revenues (43 percent), the enormous size differential between these two sectors did not change much during this period. Indeed, because the nonprofit sector was so much larger than the for-profit visual arts sector, despite faster rates of growth in the for-profit sector, the absolute amount of increases were four (in terms of number of organizations) and ten times greater (in terms of total revenues) than in the nonprofit sector. Of course, as we have described in previous chapters, the size of the audience for museum exhibitions and gallery displays is many times larger than the number of buyers in the visual arts market.

Museums Have Adopted a Variety of Strategies to Increase Attendance

As we noted in Chapter Three, the two primary reasons for growing museum attendance were increases in the size of the total population and in education levels within the population. In contrast, the rate at which the population attended museums did not increase but actually dropped off slightly. This phenomenon reflects the fact that museums face increasing competition for their attendees' time and attention. The reasons for this competition, as we noted in Chapter Three, include increasing fragmentation of American's leisure time, more leisure-time options, and a trend toward home-centered leisure. Moreover, when people do venture out, they often appear to be interested in entertainment, sensation, and even spectacle (McCarthy et al., 2001).

Museums have adopted a variety of strategies in response to this competition that are designed to broaden and diversify their audiences. The underlying goal of these strategies is to get more people into museums and then to transform these attendees into return visitors, members, and donors. In sum, museums have attempted to pursue the traditional nonprofit approach of winning, keeping, and lifting audiences. In other words, their efforts are first designed to attract attendees to visit the museum in an effort to win over supporters. Next, they are designed to keep these supporters and transform them into members and patrons. Finally, they attempt to lift these supporters' level of contributions and involvement. In sum, these strategies are designed not only to compete with other leisure options but also to provide an expanded base to promote the donations that, as we noted above, are critical to museum revenues.[20]

[20] There are, of course, both costs and benefits to this approach. For example, as Anderson (2004, p. 8) points out, the typical $35 membership often ends up costing museums money after factoring in dedicated staff, marketing, events, printing, postage, and forgone revenues (in lieu of admission fees). "Only at levels of $150 and above do most museums begin to realize any net return from members." However, "it is easier to recruit the $150 member from the $35 member than starting out cold turkey."

A major component of these strategies has been the proliferation of special exhibits and especially blockbuster exhibits to attract a larger and more diverse audience. Indeed, the number of shows that attract more than 200,000 has grown from 14 in 1996 to 18 in 1997 to 25 in 1998 to 31 in 1999.[21] But blockbuster exhibits, even if they draw large crowds, cost money to produce. Participation fees (the costs of organizing and borrowing works) in addition to the costs of security, insurance, shipping, catalogues, ticketing, and marketing have all risen sharply in recent years.[22] In addition to these direct costs, the indirect costs of putting on blockbusters are also substantial, and as Anderson has pointed out, often excluded in calculating the costs of putting on a blockbuster exhibit.[23] Museums have relied on a combination of two approaches to try to cover these costs: special admission fees and corporate sponsorship.[24]

Museums have also broadened the scope of the special exhibits they mount to appeal to broader audiences. These exhibits focus less on traditional painting and other fine artworks and more on design and popular works such as on Faberge's "precious bibelots; costumes and designs by Cartier, Dior, and Ferragamo; or E-type Jaguar sports cars" (Kimmelman, 1996, p. 33). Many museums have also attempted to broaden their appeal as centers of refined entertainment by providing such events as movies, concerts, and social mixers. These programs are in addition to the upgrading of museum restaurant and retail facilities, which surveys suggest enhance some museumgoers' experiences (Ashworth and Johnson, 1996). Indeed, some museums have even considered exhibitions in which work by living artists is shown with the express purpose of encouraging the public to buy art.[25]

In addition to these programming initiatives, museums have undertaken more sophisticated marketing and public relations efforts. They have adopted more refined marketing and targeting strategies aimed at attracting not only a larger but also a more selective audience.[26] Sometimes these marketing efforts pair tickets to the museum exhibit with a basket of entertainment activities like lunch at the museum's res-

[21] *Art Newspaper*, Vol. 8, March 1997, pp. 24–25; *Art Newspaper,* Vol. 9, February 1998, pp. 16–17; *Art Newspaper*, Vol. 10, No. 89, February 1999, pp. 14–15; *Art Newspaper*, Vol. 14, February 2004, pp. 13–16; and *Art Newspaper* statistics for 1996–1999 reported in Dobrzynski, 2000.

[22] See Dobrzynski, 1998.

[23] Anderson (2004, p. 7) describes these indirect costs as including "the percentage of time on shows spent by the best compensated staff, the opportunity costs of neglect of the permanent collection's needs, the short-term surge in overtime and in part-time staff to handle visitor services, registration, marketing events, and the exhibition catalogue (and associated merchandise) that are not sold and subsequently written off."

[24] See Dobrzynski, 1998, for examples of the use of special fees. For examples of corporate sponsorship, see "This Exhibit Is Brought to You By," 1997.

[25] See Morgan, 2000.

[26] See BSM, 1998, and Collins, 1997.

taurant, wine tasting, Broadway shows, etc.[27] These and other programming and marketing strategies are designed to make the museum stand out in a crowded entertainment field. In the words of Malcolm Rogers, director of the Museum of Fine Arts in Boston, "I don't want to be a blockbuster junkie, but you need a Monet every now and then to create excitement" (Dobrzynski, 1998, p. 13).

As we have suggested, these efforts to expand museum audiences by popularizing the program, developing closer links to corporations interested in the marketing opportunities that museums can offer, and more sophisticated marketing and public relations have raised objections in some quarters.[28] The increasing popularity of blockbusters, although viewed as a central means of increasing attendance and bringing in new members, has a potential downside. Critics argue, for example, that the large crowds and "buzz" surrounding the blockbuster compromise the quality of the experience of viewing art. John Walsh, former director of the Getty Museum, suggests that at some point, "crowding becomes the enemy of any kind of deep experience of a work of art by any one person among the many people in the gallery" (in Cuno, 2004b, p. 185). Closer ties with collectors can also raise conflict of interest issues, either because they can affect the value of the collector's artwork (e.g., the Brooklyn Museum of Art's exhibit of Charles Saatchi's collection) or more generally serve the interests of the collector or sponsor rather than the museum's interests. Finally, using travel packages, wine tastings, membership benefits, etc. to attract a larger proportion of the sort of people who already attend museums will not necessarily diversify museum audiences. Reaching groups that are either not inclined or disinclined to attend is a challenge of another sort. This challenge involves addressing perceptual barriers (e.g., feelings of being out of place, ignorant, or too far outside social group norms) to their participation (as opposed to the practical barriers, such as price, time, and information).[29]

Museums Are Facing Increasing Financial Pressures

In addition to the growing importance museums have placed on their exhibition and public involvement missions, a major reason for their attempts to expand attendance has been increasing financial pressures.[30] Although museum revenues rose throughout the 1990s, a series of events has interrupted that trend. These events include a falloff in tourism following the events of 9/11, which reduced museum admissions

[27] See BSM, 1998.

[28] See Cuno, 2004b, and Cuno and Rogers, 2000.

[29] For a discussion of different strategies arts organizations can employ to address perceptual barriers to participation, see McCarthy and Jinnett, 2001.

[30] The importance of financial pressures as a stimulus to changing museum practices is not new. As Neil Harris (1999) has discussed, museums' renewed concern with their public involvement mission in the late 1970s was partly a byproduct of their financial situation.

and thus museum earned revenues (both admission fees and related food, gift, and special event sales);[31] the collapse of the stock market, which reduced the value and the income from museums' endowments as well as grants from foundations; the recession of the 2000s, which resulted in cutbacks in corporate and individual giving; and cutbacks in state and local government funding. Indeed, Ellis (2004, p. 1) refers to the combination of negative events as "a perfect storm."

Although the circumstances giving rise to at least some of these revenue pressures will, no doubt, ease over the longer term, they have placed many museums in a difficult financial situation in the short run, particularly because they have occurred simultaneously with a long-term trend of rising costs. A clear indication of the financial pressures facing art museums is the shelving or cutbacks in plans for museum renovations and expansion that were drawn up during the financial boom of the 1990s. Among the museums that were forced to shelve or substantially modify their plans at least for a time are the Los Angeles County Museum of Art, the Guggenheim, the Chicago Art Institute, Boston's Museum of Fine Arts, and the Whitney. Moreover, even museums that managed to complete their expansion have found the added maintenance together with the burden of debt service costing more than the entire pre-expansion exhibition, curatorial, and conservation costs combined.[32] Cutbacks in the general operating budget as a result of an expensive renovation have left the Milwaukee Art Museum, for example, with only two full-time curators (Kaufman, 2003). As Kaufman (2003, p. 6) describes it, "the age of unbridled expansion is over."

While the growth of museum revenues has stopped, at least in the short run, museum costs appear to be rising at an increasing rate. Although we lack comprehensive data on museum expenses, there is substantial evidence on the sources of these cost increases. Moreover, since cost increases affect both museums' operating and capital budgets, they also affect museums' operations.

Wages and salaries are one factor escalating costs. Internal Revenue Service data on museums, for example, indicate that from 1991 to 2001, the average wages paid per nonprofit visual arts organization increased by 125 percent (in inflation-adjusted dollars). In contrast, real wages in the overall American economy increased only 39 percent. For museums, this cost factor is particularly important because wages constitute a significant fraction of visual arts organizations' operating expenses. The Association of Art Museum Directors, for example, estimated that in 1998, management and curatorial salaries accounted for an average of 33 percent of all annual operating expenses.

[31] See Smith, 2001.

[32] See Neil Rudenstein's comments on the increases to operating budgets as a result of museum expansions in Feldstein, 1991, pp. 73–86.

Rising maintenance and operating costs, such as utilities and repairs, are a second influence on costs. Here the principal cost drivers have more to do with the overall escalation of prices in the economy than a change in museum revenues. Of particular interest in this context is an item often overlooked in most calculations of operating costs: storage and maintenance costs of museums' art collections. The care and maintenance of museums' collections are central to their cultural heritage function and, as such, are a primary museum obligation. The costs of this function, however, are neither widely acknowledged nor adequately understood. These costs, which have both a capital and an operating component, have risen as standards for maintenance have improved.[33] Capital costs, for example, include building or remodeling storage facilities and the purchase of climate-control and security systems. Annual operating expenses include utilities, insurance, conservation, inventory and record keeping, and security. Since most museums keep at least 70 to 80 percent of their collections in storage, these expenses are significant.[34] Stone (2002) further estimates that the total cost of maintaining these collections is approximately $480 million per year (in 2002 dollars) or roughly the size of the Metropolitan Museum's annual operating budget. Since museums regard increasing their acquisitions as a central element of their mission, these costs constitute a rising fraction of their operating budgets.

A third major factor contributing to the escalation of museum costs has been the rising costs of insurance. Ellis (2004), for example, reports that insurance costs associated with traveling and special exhibits (which as we noted are increasing as museums attempt to draw in larger audiences) have increased between 50 and 100 percent.[35]

Also, as museum education and outreach programs have grown with museums' social agendas, the median museum expenditures for K–12 educational programs has increased from 3 to 12 percent of museums' operating budgets between 1996 and 2001 (Ellis, 2004, p. 1). Similarly, as museums have increased their marketing efforts to reach larger and more targeted audiences and their development budgets to attract and expand corporate and individual donations, these elements of their operating budget have come to be regarded as necessities. Moreover, since many other operating costs (e.g., maintenance and storage) are fixed, development costs constitute a rising proportion of operating budgets at times when revenues are stable.

In addition to these pressures on museums' operating budgets, the dramatic explosion of prices in the arts market (described in the last chapter) is having a compa-

[33] An insightful discussion of these issues is contained in Stone, 2002.

[34] Stone (2002), for example, cites a 1985 American Association of Museums study, which reports that 72 percent of museums' collections are in storage, and a 1989 British study reporting that 80 percent of British museums' collections are in storage.

[35] See also Thomas, 2003, p. 34.

rable effect on museums' capital budgets. Specifically, many museums are being priced out of the market by the rising costs of artwork. This effect is particularly pronounced for museums that lack endowment funds specifically devoted to acquisition. Indeed, most museums face a situation where they are increasingly dependent either upon boards or patrons to finance new acquisition or donations of artwork from courted collectors.[36] With escalating prices, newer museums and museums with smaller budgets have almost no hope of amassing collections to rival those of the superstar museums that have built collections over time and maintain access to wealthy patrons. Indeed, these effects are not limited only to museums with lower operating and capital budgets. When Picasso's *Boy with a Pipe* sold in May 2004, the only museum mentioned as a bidder was the Getty. Even the Getty, it was reported, could not justify the $104 million price.

As a result of rising art prices, many museums are forced to rely increasingly on donations of artworks for their new acquisitions.[37] Securing such donations often entails a long and sometimes costly process of courting potential donors, who may, in the end, decide not to donate their artwork.[38] Stone (2002) points out that many museums accept donated works they are not particularly interested in to secure the pieces they are. In essence, museums may have to like what they get so they can get what they like. Such strategies, however, can result in rising costs since they increase the amount in storage. As more work is placed in storage, museums are then forced to expand their display and storage space or to face increased storage costs.

The effects of rising prices in the arts market, however, are not limited only to capital costs or to museums' ability to fulfill their exhibition functions. Higher acquisition costs are subsequently reflected in higher operating expenses, such as insurance, storage, and security. In addition, the booming arts market and its tendency to accelerate the pace at which art is evaluated and legitimated, put real pressure on museums' legitimization function. As keepers of the visual arts canon, museums have always been slow to accept new works and artists. Yet they suddenly find themselves pushed to legitimate art more quickly, without the time to evaluate the work.[39]

[36] Of course, museums have always relied heavily on donated artwork, but as we discuss, there are direct and indirect costs associated with these donations.

[37] Our discussions with museum curators suggest that this is typically the case.

[38] Changes in U.S. tax policy also play a role in donors' decisions by providing incentives to sell rather than donate art. See Molotsky, 1993.

[39] Hughes (2004) has described this phenomenon as follows: "There has been one huge and dominant reality overshadowing Anglo-Euro-American art in the past 25 years. This is the growing and tyrannous power of the market itself, which has its ups and downs but has so hugely distorted nearly everyone's relationship with aesthetics."

Museums Are Turning to New Types of Directors to Manage an Increasingly Complex Environment

In addition to increasing financial pressures, museums also face an array of challenges attributable to a more complex operating environment. These challenges arise from the expanded scale and complexity of their current operations, new governance norms, and a more complex legal and ethical environment.

As a result of pressures to increase revenues, to hold the line on costs, to expand the number and diversity of audiences, to find sponsorship for major exhibitions, to develop new programs and services to meet the demand for greater public involvement, to develop new marketing and public relations initiatives, and to manage expanding staffs, the scale and complexity of managing museums has increased exponentially. In the words of Philippe de Montebello, director of the Metropolitan Museum of Art, "the burden of maintaining this enormous machine is crushing."[40]

As museums grow in size and complexity, the job of managing them also grows more complex, requiring a whole new set of skills. Fifty years ago, it was unheard of to require management skills from curators and museum directors.[41] Today Kenneth Hudson (1998, p. 50), director of the European Museum Forum, identifies a "new breed" of museum director:

> They are well-educated, but not primarily scholars. They are not much given to carrying out research or writing books and learned articles. They are essentially communicators and organizers whose main interest lies in making their collections and exhibitions attractive and interesting to the general public and in widening that public and studying its needs and wishes. . . . They have a well-developed political and public-relations sense and they realize that their museum has to be regarded as a business to be run in an efficient manner.

Moreover, the pressures to opt for more business-like directors are increasing. As Philippe de Montebello (2001) has written:

> If we are to win the battle of the curator/director versus the administrative/director, a type with which boards of trustees are becoming instinctively more comfortable, then it is essential to enlarge the pool of curators with the qualifications to be tomorrow's museum directors. . . . Needless to say, a system that puts administrators at the head of art museums would inevitably tip the balance in favor of market rather than mission-driven policies.

Historically, the skills sought for board members have changed over time in response to museums' changing needs. As we noted in Chapter Two, Taylor recounts

[40] Philippe de Montebello in Cuno, 2004b, p. 200.

[41] Hudson (1998, p. 48) quotes a museum director in France who, upon taking early retirement, complained that she had been "trained to look after pictures, *not to* persuade people with money to give it to the museum."

the founding of early museums by community leaders and others with an interest in art and with the aim of fostering the creation of art and elevating public tastes. Einreinhofer (1997) further notes that the boards of trustees of the early American museums had a mix of individuals from a variety of backgrounds, including old families, landed gentry, and professionals with a strong interest in art, who were willing to devote their time and talents to museums. However, they were not necessarily people of great wealth. By the turn of the 20th century, the boards of the major museums became increasingly populated by corporate leaders with substantial wealth. This pattern continues today—museum boards currently have more business leaders (as opposed to wealthy art aficionados) among their members. These board members have been tapped in part to raise new and expanded sources of support, but also to grapple with the challenges of the increasingly complex operating environment. Of course, the presence of business leaders on museum boards is hardly unprecedented (indeed many museums were founded by them), but in the 1980s and 1990s they also brought a belief that museums should be administered more efficiently and should incorporate "for-profit" management practices.[42]

This trend has been intensified by growing pressure on all nonprofits for greater public accountability. Donors and the general public have become less willing to accept a nonprofit's word that it is serving the public interest and instead want evidence that public and donated resources are being used effectively toward a desired purpose. This higher standard marks a shift in attitudes toward greater transparency and public accountability to which museum managers and their boards must respond.[43]

An additional set of factors compounding the complexity of museum operations has been changes in the legal and ethical environment in which museums now operate. Traditionally, museums have had a great deal of latitude, beyond meeting basic legal requirements, in determining standards of practice and professional ethics. Although museums have always been subject to some degree of public scrutiny from funders, peers, and the media, they have largely operated in a self-regulating environment. In recent years, however, a number of new issues and standards have arisen that are affecting museum practices.

One such issue is the growing concern with the provenance of museum holdings and acquisitions. Museums today face issues of potential repatriation and restitu-

[42] See also Weil, 2002a, pp. 159–169.

[43] A classic example of this phenomenon is Mayor Giuliani's threatened withdrawal of government support for the "Sensation" exhibit at the Brooklyn Museum for offending the public's sense of decency. Anderson (2004) also emphasizes the increasing requirement that museums be able to develop metrics to document their performance in fulfilling their missions.

tion for works of questionable provenance.[44] Examples include the following: artworks confiscated by the Third Reich during World War II; the importation of illegally obtained art;[45] and works that, even if legally obtained, are claimed by their country of origin as part of their national heritage (e.g., the Elgin or Parthenon Marbles).[46] Museums have largely chosen to sort through the provenance of their collections quietly and privately, which until recently has satisfied critics. But some issues have caught the attention of Congress and the courts (e.g., art stolen by the Nazis). For example, the conviction of Frederick Schultz, a prominent New York antiquities dealer, for conspiring to illegally import antiquities from Egypt in 2003, suggests that these issues now draw greater public attention. Indeed, Schultz' conviction equated removing artwork from another country without that government's consent with stealing from a museum or private home ("Schultz Conviction Upheld," 2003).

In addition, efforts by museums to develop closer relations with the corporate sector and to expand their own commercial enterprises have raised questions about whether they should be allowed to maintain their nonprofit status. Indeed, Congress has held hearings on introducing tighter regulations on nonprofit organizations' commercial activities. Moreover, the reported $1 million lease by Boston's Museum of Fine Arts of 21 works by Monet to the for-profit Bellagio Gallery of Fine Art in Las Vegas prompted the Association of Art Museum Directors to review their professional standards for loans from a collection. While museums have long had commercial enclaves (gift shops and restaurants) within their walls, as well as deals with for-profit firms on the outside (e.g., greeting cards), the issue of where to draw the line between nonprofit and commercial enterprises is becoming increasingly controversial.

Finally, other issues have recently arisen with regard to museums' relations with sponsors, donors, board members, and the collectors they pursue. If museums display a collector-sponsored exhibit, it will likely increase the value of the collection, thus

[44] This is a thorny issue for more than just museums: Elizabeth Taylor is fighting a claim to a Van Gogh painting by the descendants of an earlier owner who claim the painting was stolen by the Nazis. In August 2004, the Pope returned a painting that had hung in his private chapel to the Russian Orthodox Church, which had disputed the Pope's ownership.

[45] It has been estimated that up to 80 percent of the antiquities currently on the market have been looted in recent decades, and up to 95 percent have been smuggled into the country. See Herscher, 1998.

[46] The New Acropolis Museum, which at the time was under construction for the opening of the Olympics in August 2004, had asked the British Museum to loan the statues for an exhibit. In the end, the museum construction and exhibit were delayed and the issue of the loan went unresolved (see Sennott and Liebowitz, 2004). In another example, the Italian Ministry of Culture's Sicilian department has accused the Metropolitan Museum of Art of purchasing ancient Greek silver that was stolen from a tomb in Sicily in 1981. While the case is pending, Sicilian museums have severed all ties with the Metropolitan Museum (see "Partial Ban on Loans from Sicily," 2004).

raising questions of conflict of interest for the museum.[47] Moreover, if the collector subsequently donates that artwork to the museum, then the exhibition boosts the value of the donation and, therefore, the donor's tax savings. Even without an exhibition, museums anxious to encourage collectors to donate important work might influence the appraisal of that work, with a similar effect on tax deductions.[48] Such issues are particularly sensitive given museums' obligations to the public at large and the public's willingness to continue to invest them with its trust.

The Concentration of Revenues and Assets in the Superstar Museums Is Increasing

At the same time that the challenges facing museums are growing, the distribution of resources is becoming more concentrated. As we demonstrated in Table 6.2, the largest museums control a disproportionate share of museums' total revenues and assets. In 2000, the largest 20 percent of all art museums, for example, controlled 95 percent of the total revenues in the nonprofit visual arts sector and 98 percent of the assets (not counting the value of the artwork itself). Even more indicative of this concentration is that the largest 1 percent of these museums controlled almost half of the total revenues and assets. These concentration ratios actually increased between 1990 and 2001, by between one and three percent.[49]

Why has the concentration of resources among the largest and most prominent museums been increasing? Several factors have contributed to this pattern, but the most important seems to be the initial advantages the largest museums enjoy and their ability to build on that advantage. As we noted above, the largest museums have several things in common. First, they are located in major metropolitan areas and thus have access to a large pool of potential attendees and members as well as to substantial numbers of wealthy potential donors. Second, they have been in operation a relatively long time and thus have had the opportunity to amass both substantial and prestigious collections and sizeable endowments. Third, as a result of their histories and their collections, they are all well known and well respected within their own communities, nationwide, and some worldwide.[50]

[47] Museums' increasing reliance on the generosity of patrons occasionally gives rise to crises over conflicts of interest, such as the furor over the "Sensation" exhibit from the Saatchi collection at the Brooklyn Museum of Art. The AAMD adopted new guidelines as a result of this crisis (see Barstow, 2000). An extensive discussion of this case is found in Zolberg and Cherbo, 2002.

[48] See, for example, the controversy surrounding the Smithsonian's role in appraisals and subsequent tax deductions for a donation of several Stradivari instruments to the museum (Browning, 2004).

[49] Between 1991 and 2001, another indication of this growing concentration was that the average level of museums' annual revenues increased by over 100 percent. However, the median level of revenues decreased by 24 percent. The average figure is, of course, strongly weighted by the experience of the largest museums, while the median figure (which divides the distribution of museums in half) is more sensitive to the typical museum's experience.

[50] The Winterthur Museum is an exception among the eight to ten largest museums: While it is well known regionally and among arts aficionados, outside of those circles it is relatively unknown.

In combination, these four factors (location, substantial and prestigious collections, sizeable endowments, and broad public recognition and prestige) have provided these institutions with a substantial initial advantage over newer, less affluent, and less well-known institutions. Recent trends in the visual arts environment have compounded these advantages.

The breadth and quality of major museums' collections, for example, have made them major attractions not only for visual arts aficionados but also for infrequent and occasional attendees.[51] This advantage derives in large part from the importance of individual objects to the visual arts and from the fact that collections that contain a wide variety of excellent works will have a special attraction for visual arts appreciators. In addition, the concentration of major museums in major metropolitan areas provides a large potential population pool from which to draw audiences, both those who are residents of the area and those who are drawn to visit the area, partly because of the major museums' collections.

Moreover, as the costs of blockbusters have risen, the range of museums that are able to host such events has diminished. The largest museums, however, are well positioned to mount blockbusters for two reasons. First, they have the financial resources, staff, and corporate supporters needed to host such exhibits. Second, museum participation in blockbusters has increasingly become quid pro quo, at least implicitly, whereby a museum's ability to gain the cooperation of the other museums needed to put a blockbuster exhibit together depends on its own willingness to loan pieces from its collection to those other museums. The largest museums generally have the strength of collections to make them attractive partners. This advantage has become increasingly important since blockbusters have become a major device for increasing attendance (and admission fees) as well as attracting new members.[52] Recent trends in the visual arts environment have compounded these advantages not simply because blockbusters have become increasingly important to expanding admissions and membership, but also because increases in the price of artworks (as well as their availability) have made it all but impossible for museums that lack such collections to acquire them today.

This ability to capture a larger share of potential new attendees and members, together with the prestige that the major museums enjoy and their substantial endowments, also provides substantial advantages in the competition for resources. As we discussed above, art museums rely in roughly equal measure on four sources of

[51] Although museum attendance is unlikely to be a zero-sum game for visual arts aficionados, whose attendance at one museum may actually increase the likelihood of visiting other museums, this is likely to be the case for infrequent and casual attendees, who make a limited number of museum visits per year.

[52] The Chicago Art Institute's membership, for example, increased from 65,000 to 157,000 after the Monet retrospective in 1995. Boston's Museum of Fine Arts membership jumped from 57,000 to 85,000 after a Picasso show in 1997. And the Los Angeles County Museum of Art's membership increased by 12,000 to 73,000 after a Picasso exhibit in 1998 (Dobrzynski, 1998).

revenues: earnings (admission fees and related business income from restaurants, gift shops, and special events); donations from individuals, corporations, and foundations; government grants; and endowments. The largest museums appear to have advantages in each of these areas. The larger a museum's endowment, the more income that endowment will generate. Moreover, the advantages we just discussed in terms of these museums' ability to draw higher attendance among local residents and tourists mean that these institutions are likely to receive higher earnings. More attendees as well as the prestige that the largest museums enjoy are also likely to increase the number and size of the donations they receive from membership fees, corporate sponsorship, and donations from wealthy supporters. Finally, the prestige of these institutions within local communities and their ability to attract visitors to the community are likely to make them more attractive as potential recipients of local government funding.[53]

Once again, compounding these advantages are such recent funding trends as the increasing importance of earnings to museums' revenue base, the growing role of corporate sponsorship, and the shift in government funding from the federal to the local level.

Finally, the size and scale of these museums' operations are likely to make them better able to exploit economies of scale and scope in their efforts to keep their costs under control.[54] Larger museums, for example, are able to internalize such critical functions as marketing, development, and security that smaller museums need to contract out. They are also able to expand services at decreasing costs per unit of output and provide multiple, complementary services at a profit—such as adding food and retail services to traditional appreciation experiences. Although large museums face many of the same cost pressures as smaller museums, they seem to be in a better position to control these costs.

Although we lack good information on the operations and finances of midsized and smaller museums, they are likely to be facing a quite different situation. Our analysis of the performing arts, for example, suggested that midsized organizations confront a unique predicament. Although they face many of the same pressures to increase their audiences and earnings that larger organizations do, they lack the resources to secure the stars and elaborate productions that appear to be needed to expand their audiences. In contrast, smaller performing arts organizations face less intense cost pressures than their larger counterparts because they rely much more heavily on volunteer labor. Although the revenue and asset cutoffs demarking large,

[53] See McCarthy et al., 2001, and Lowell, 2004, for a discussion of the shift in government funding from the federal to the state and local level. See Brooks and Kushner, 2001, for a discussion of local government use of arts policy to boost cultural tourism.

[54] Many authors have discussed this phenomenon among various types of arts nonprofits. See, for example, West (1987), Fazioli and Filippini (1997), Gray (1997), Taalas (1997), and Lange and Luksetich (1993).

middle, and small-sized museums are likely to be considerably higher in the visual than in the performing arts—largely because their asset values are so much higher—we suspect that a somewhat similar situation faces small and medium-sized museums.[55]

Smaller museums, for example, are likely to face fewer cost pressures than their larger counterparts since they do not have the costs associated with blockbuster shows and likely have lower operating costs for such items as insurance, storage, and programming. Moreover, to the extent that they focus on niche rather than encyclopedic collections (e.g., local artists and ethnic or other special population artworks), their acquisition and associated costs may be much lower. Finally, their relationship with their community and thus the emphasis they place on specific elements of museum missions may differ, with a greater emphasis on educational programs, community involvement, etc.

In contrast, midsized museums, particularly those that attempt to maintain encyclopedic collections, may face many of the same cost pressures of the larger museums but lack the ability to compete with larger museums for revenues. These problems may be particularly acute for midsized (and perhaps smaller) museums located in major markets with large and prestigious encyclopedic museums. Such museums not only face competition from entertainment and leisure industries, they also face competition from the larger (and more prestigious) museums in their market area. Midsized museums will need to think strategically about their basic objectives, the audiences they are trying to reach, and their comparative advantages. They will also need to consider ways to reduce their costs—for example, by cost sharing, loaning artworks, and joint ticketing. Although we are aware of several such efforts, many museums appear reluctant to engage in such joint efforts for at least three reasons.[56] Specifically, they are wary of the loss of autonomy that such arrangements might entail, fear that such efforts might interfere with their ability to establish a clear "brand" identity in a crowded market, and suspect that such cooperative arrangements might imperil their fundraising efforts by increasing the competition they face for donors and members.

In sum, the museum industry's concentration is notable at present and has been increasing over the last decade. Given the recent trends that have been shaping the visual arts environment, this concentration seems unlikely to decrease in the foresee-

[55] Although we lack statistical information on the financial situation of museums by size, we suspect that a closer equivalent to small performing arts organizations in the visual arts world might be found among the various non-museum nonprofits that concentrate on exhibiting, such as nonprofit galleries and artist cooperatives.

[56] Attempts at cost-sharing have been made by museums in the Los Angeles area where advertising costs, marketing costs, and scheduling are shared by several different museums. In other cities, museums (and other cultural organizations) promote ticketing that is valid at more than one museum. No doubt, other examples of such cost sharing have been tried.

able future. As a result, midsized and smaller museums will need to think carefully about their objectives and which mission aspects they will emphasize.

Future Issues

As we discussed above, museums have multiple missions and these missions can be in conflict with each other. Along with the financial pressures we have highlighted, art museums now face other assorted challenges. Therefore, it is increasingly likely that they will be forced to tradeoff among their "conflicting ambitions."[57] Indeed, the debate about how much emphasis to give to the various museum missions has already been joined.[58]

This debate revolves around two traditional positions. The first emphasizes museum missions that stress the importance of the visual arts object—e.g., collecting, preserving, and exhibiting collections. The second emphasizes missions regarding museums' public services—e.g., outreach, development, and community service. This debate centers on the tension between what Weil has referred to as the "museum being *about* something versus *for* somebody."

On the one hand, there are those who argue that museums must maintain their distinctiveness and distance from the commercial world to retain their artistic legitimacy and to retain the public's trust. Only by focusing on the collection and the qualities of the public's experience (rather than revenues, attendance, and press), will museums stay true to their artistic mission. The distinctive core of the museum (the museum's soul) will be destroyed or corrupted by diverting resources away from its artistic mission and toward ancillary revenue-building and outreach efforts. While the adherents of this position recognize that museums have a public responsibility, they believe that this responsibility is best served by emphasizing their distinctive artistic character.

On the other hand, there are those who argue that the obligation of public service means that museums need to engage their entire communities, not just museumgoers. This may require tradeoffs that shake up traditional museum practices (less attention to scholarship and more on outreach) and even put parts of the collection at risk (displaying works in other venues including outside museums). Without recognizing the need to engage the public, museums will cease to be relevant to all but the privileged few. If museums are an important element of the public sphere, a so-

[57] Anne d'Harnoncourt, director of the Philadelphia Museum of Art, quoted in Cuno, 2004b, p. 181.

[58] See Cuno, 2004b; Cuno and Rogers, 2000; and "When Merchants Enter the Temple," 2001.

cial attraction, a gathering place for different people, can that be contrary to the soul of the institution?[59]

A central issue in this debate is how to define and measure success. As the pressures for accountability increase, museums, like other nonprofits, are increasingly being called upon to evaluate and measure their performance vis-à-vis their goals and missions. Currently, the most common yardsticks by which museum performance is measured are attendance, membership, and the number and marketability of major shows.[60] These metrics lend themselves for use because they are easier to measure than other possible indicators of success (i.e., quality of the art objects, quality of visitors' experiences, and impact on the community), but also because they can be used to demonstrate public access, popularity, and service to the public.[61]

There is, however, a heated debate within the museum world about the appropriateness of relying primarily on attendance rates (or membership numbers and special exhibitions) to evaluate museums' performance rather than on the quality of the museum experience and the collection and scholarship.[62] If attendance is what matters, some observers are concerned about the effect that will have on museum practices and their allocations of resources. Already in some museums, the share of staff devoted to administration has increased, the status (and budgets) of curators has diminished, and the needs of marketing and development have prevailed over scholarship.[63] For example, blockbusters, which markedly increase the number of people coming through the door, are an important component of programming for the museums that can afford them.

[59] "Museum administrators often underestimate the value of their institutions' offerings. They focus on collections and exhibitions and overlook the possibility that visitors may also seek a contemplative space; a sociable encounter; a distinctive shopping experience; or a place where a family can spend quality time together" (Kotler, 1999).

[60] These measures of success and why they are used so often are discussed in Anderson, 2004, pp. 6–9. For additional discussion of the use of attendance measures, see DiMaggio, 1996, and Lowry, 2004.

[61] Anderson (2004) also points out that museum attendance figures are not always reliable. As he explains it, museums have several reasons for rounding up their attendance figures, including influencing the amount of public support they receive, seeking a competitive advantage over other museums, and the belief that unless a museum's attendance is rising, its performance is likely to be lagging.

[62] Addressing directors of the Metropolitan, the Getty, the Art Institute of Chicago, Harvard Art Museums, and the Philadelphia Museum of Art, Glenn Lowry, the director of the Museum of Modern Art, asserted, "Every one of us is attendance driven. We get judged and measured all the time, whether it's in the direct, bottom-line way or as a function of perceived success: that is, whether or not we are able to attract the same number of visitors as we did last year, or increase that number by 10 percent, 5 percent, 20 percent. It's seen by some as a failure if our attendance goes down. And yet the real measure of our success ought to be the quality of the museum experience. You cannot possibly have the kind of deep engagement with a work of art . . . in a room with five hundred people jostling each other, and yet we can't get off that attendance train" (Cuno, 2004b, p. 182). A March 2001 *Art Newspaper* editorial both decried the "pernicious tendency" to focus on attendance figures and accepted partial blame for the trend with their annual survey of museum attendance (see Cocks, 2001).

[63] See DiMaggio, 1996.

The downside, it is argued, is:

- The permanent collection will look duller and be more neglected in comparison.
- The artwork of blockbusters, which is necessarily limited in its complexity and controversy so that it will appeal to the widest audience possible, will not challenge or edify audiences over the long term.
- Museums will become purveyors of entertainment and spectacle, rather than sanctuaries from the commercial culture.
- Most museums take large financial risks that depend on high attendance to recoup costs.

Of course, tensions among missions are not new, and different institutions have traditionally emphasized different missions. Indeed, one of the reasons museums have succeeded is their tremendous diversity in size, types of collections, and programming. They have offered a broad range of aesthetic, cultural, intellectual, and social experiences to a diverse range of people and interests. Because the distribution of resources across museums is concentrated and becoming more so, how museums will respond to these tensions is complicated. Given this concentration, it is likely that the options that various museums entertain will be very different. Larger, more financially secure museums obviously have more options than most. And as our analysis of the concentration of revenues and donations indicates, their advantages are likely to increase.

Given this likelihood, smaller and midsized museums will need to define their objectives, determine which aspects of museums' traditional mission they want to emphasize, and carefully evaluate their comparative advantages. We suspect that they will increasingly focus on some combination of specialized art and greater involvement with their communities.

A central issue this discussion raises is what these and other trends we have described will mean for the visual arts as a whole.

Conclusions

We began this book by noting that the last two and a half decades have posed a growing set of challenges for the arts in America. The rapid growth of the art world that began in the 1960s has slowed and, in some cases, reversed. In addition, organizations in most disciplines have found it increasingly difficult to draw audiences, increase their revenues, and manage their resources. Many have been forced to rethink their missions and roles in an increasingly complex organizational ecology.

In contrast, judging by record museum attendance levels and booming commercial popularity, the visual arts may be the noteworthy exception to this pattern. If so, this success is paradoxical since in certain respects the visual arts are the most obscure and least accessible of the various high-art forms. Participation in the world of visual arts discourse requires specialized knowledge and is often not understood even by those with significant training.

However, the visual arts appear better suited to the changing consumption and life styles of American consumers. Their visual character, for example, makes them easily and readily experienced. They require less time commitment than other art forms and their appreciation can be tailored to Americans' patterns of leisure consumption. Museums, the principal centers of visual arts appreciation, are also generally located in central cities, not only making them readily accessible but also allowing consumers to combine their visits with other recreational opportunities. Visiting museums and galleries is generally less expensive than other kinds of cultural pursuits. Finally, changes in the operation of the arts market and in the financial world have led to art, even contemporary art, being accepted as a viable investment option.

But is the current picture as rosy as rising attendance figures and art price indices suggest? And will this success continue into the future? As our analysis has shown, in addition to lines around the block for special exhibits, well-paid superstar artists, flourishing university visual arts programs, and a global expansion of collectors, developments in the visual arts also tell a story of rapid, even seismic change, systemic imbalances, and dislocation. Indeed, the organizational ecology of the visual arts world has changed dramatically.

This change is apparent in each of the three institutions that have shaped the visual arts system. Art museums, for example, appear to be increasingly shifting their primary focus from their collections to public involvement, or as Weil has put it, "from being *about* something to being *for* somebody." The arts market has become more transparent, more efficient, and more globalized. In the process, it has become more like other asset markets. Finally, with the declining importance of the modernist canon, the world of arts discourse has become increasingly pluralistic and less concentrated among a narrow range of experts. In different ways, each of these institutions has a broader conception of who their public is and how they should serve it—in short they reflect the greater pluralism of American society at large. As pointed out in Chapter Two, the visual arts system has historically reflected the broader culture and society from which it emerges.

These changes, however, are not seamless. Instead, they have and will continue to pose a series of challenges for the visual arts and generate tensions between traditional ways of doing business and the need for a new approach. Although the specific form may vary, many of these challenges and the tensions they embody are not entirely new. Instead, they reflect themes that have recurred intermittently over the course of the last 150 or so years in the American visual arts world. At root, they reflect a central issue that is not unique to the visual arts: How can the organizational ecology of the arts adapt to a changing social environment without abandoning the central core of the visual arts experience?

In the rest of this chapter, we first examine the challenges facing each of the four components of the visual arts around which we have structured this analysis: demand, artists, the arts market, and museums. We conclude with a discussion of the role public policy might play in helping the visual arts system respond to these challenges.

The Challenges Facing the Visual Arts

Demand

Despite the absolute increases in museum visitors and art collectors, the growth in demand for the visual arts (both appreciation and collecting) is largely attributable to broader societal trends. Rising levels of museum attendance, for example, have been driven more by population growth and increasing levels of education within the population than by increasing rates of attendance within educational categories. Similarly, the increasing number of collectors in the elite arts market is largely a byproduct of rising levels of affluence and the increasing attraction of art as a form of consumption and investment. However, rising income levels and rates of return are not the only factors driving demand. Consumer tastes, something over which the art sector has considerable influence, are also important. Since demand is central to fu-

ture growth, the key challenge facing the visual arts is how to stimulate an increase in the public's taste for visual arts consumption.

Given existing patterns of consumption, the challenge for increasing demand for arts appreciation, in particular museum attendance, involves two different target populations. The first are those segments of the population who are not inclined to participate, especially those with less education and little familiarity with museums and the visual arts. The second are those segments of the population, particularly the better educated, who occasionally visit museums. Although, as we have noted, there is evidence that museums have had some success increasing the frequency of attendance among current visitors, the stability in participation rates among the better educated overall suggests that more work needs to be done in broadening the attraction among this group. We suspect this need may be particularly true for this population's younger members.

Although the approaches that are appropriate for these two target populations will differ, in both instances a major obstacle will be shifting leisure practices and consumer tastes. On the one hand, these shifts favor a certain type of experience, which increases the importance of ancillary services, such as shopping and dining, as well as an element of excitement at museums. On the other, a growing preference for home-centered leisure activities works against expanding attendance. In addition, the visual and other arts face increasing competition from a variety of other entertainment and recreation options.

Museums have attempted to respond to these challenges by increasing their marketing and outreach efforts (with a particular focus on special exhibits, blockbusters, and upgrading restaurants and retail facilities) and by attempts to make museums centers of social activity and general entertainment. These efforts are predicated on the assumption that in the face of increasing competition, museums need first to draw visitors with special attractions. Subsequently, they can convert them into return visitors, members, supporters, and visual arts *habitués*.

Although these efforts appear to have had some success, as indicated by the increasing frequency of multiple visits, they have also generated fears that an emphasis on ancillary activities and entertainment will detract from the unique qualities of the visual arts experience. Moreover, such efforts are unlikely to attract those who are disinclined to visit museums in the first place. Although attracting this population is no easy task (after all at least some museums have been trying to diversify their audiences for a long time), a more promising approach may be to focus on the museum's role in local communities, especially those where specific target populations are located.

However, in the longer run, the most effective way to reach such populations may be through more early exposure to the visual arts, either in schools or in local communities. The literature on arts participation indicates that early arts exposure, especially arts education, plays a significant and enduring role in later participation

behavior, regardless of the number of years of completed schooling. Indeed, developing familiarity and competence in the arts early in an individual's life is particularly important for those whose families lack what Bourdieu calls "cultural capital."[1]

Although still dwarfed in absolute numbers by the millions who go to museums each year, the number of arts collectors has increased by an order of magnitude. This increase, as we noted above, can largely be attributed to two factors—the increasing affluence of the population, especially at higher income levels, and the increasing view of art as an investment. As we suggested in Chapter Three, continued growth in the number of fine art collectors will partly depend on macroeconomic forces that determine income growth and the relative return to different types of assets. Thus, the key challenge for future growth in this domain will be increasing the taste for fine arts collectibles in the population.

Some might assume that continued escalation in art prices will drive collectors out of the arts market. We think this is unlikely. Instead, we suspect that rising prices in some submarkets will simply shift demand into other, less expensive submarkets—a phenomenon that already seems to be occurring. Assuming then that income levels continue to increase and the investment value of art does not plummet, the key challenge will be the market's ability to supply a wider range of art reliably to an increasingly diverse set of buyers.[2] In particular, we suspect that much of the growth will occur in sectors or submarkets that have not previously been the focus of the primary market intermediaries, including fine art works that did not receive critical attention when they first appeared and works in the commercial and design world. As we suggested above, many of the major intermediaries have already started to move in this direction. Finally, as we will discuss in greater detail below, consumers will need to have confidence in the operation of those markets.

Artists

The distinguishing features of visual artists' employment circumstances have been the uneven distribution of their earnings; their changing career patterns, including the increasing importance of academic training; the more rapid, if more volatile, ascent to commercial success; and an apparent increase in employment options, particularly those in arts-related employment. The major driver behind these changes has been the changing operation of the arts market, in particular the demand for a wider range of artistic styles, the volume of that demand, and the prices paid in the market.

By and large, these market forces are more likely to influence career patterns than the distribution of earnings. Indeed, we believe the uneven distribution of artists' earnings is endemic to the arts—it can be observed in all arts disciplines.

[1] See McCarthy et al., 2004.

[2] Diverse in this context refers to a wider range of tastes, knowledge of the visual arts, and income levels.

Changes in the operation of the market will affect which artists and styles succeed and how much artists are paid for their work, but not the underlying distribution of earnings. Similarly, the speed with which artists progress through the various stages of their careers also appears to have been market driven. A significant number of dealers and collectors seek to identify the "hottest" artists for their potential investment value—a pattern that will depend not on artists but on the market and the demand for collecting.

Correspondingly, we suspect the greatest challenges for artists will be the employment options available to them and the effects that range of options has on the stability of their earnings and benefits. Rapid growth in art schools and teaching positions as well as in more stable career fields such as commercial design and advertising will improve employment conditions for some, but it is unlikely to affect the employment conditions for those who continue to support themselves primarily from the sale of their work. For these artists, the major issues will be benefits (health, pensions, etc.) and rights to a share of the proceeds from the resale of their work. Although there have been some innovative programs with regard to the former,[3] the experience with the latter (at least in this country) has not been particularly successful.

Arts Market

As we discussed at some length, the arts market has undergone dramatic changes over the last 25 years. Whether that metamorphosis will continue or whether the market will revert to the status quo ante will depend primarily on two factors: the supply of art and the demand for that art. We suspect that demand is likely to be the more important of these two factors in influencing the future shape of the market. We noted that a continued escalation of prices will force some collectors (including museums) out of those submarkets with limited supply and high prices—e.g., artists who are no longer alive and whose work is in limited supply, and superstar contemporary artists. But escalating prices will not necessarily drive these collectors out of the market altogether. After all, the supply of collectible art is elastic. Indeed, the run-up in prices during the last decade has led to just such an expansion into new submarkets. Supply can expand with the rediscovery of older and less well-known artists; "outsider" artists; artists and work from other countries, particularly those that have not yet been "discovered"; and, of course, the work of emerging contemporary artists. In addition, those collectors who cannot afford to purchase works in the elite market can purchase much less expensive prints of well-known artists, participate in the general commercial market, and purchase products from the design world.

[3] See, for example, the Artist Pension Trust, www.artistpensiontrust.org (online as of June 8, 2005).

However, barring a major collapse in demand (which we believe is unlikely), we do not envision a return to the traditional value-setting mechanism of the status quo ante. Instead, the changes most likely to occur will be in patterns of collecting—that is, what types of work are collected by which collectors. As we suggested above, the continued growth of the market may well depend on how the market accommodates this growth in terms of new supply channels and procedures. The degree to which potential buyers accept such innovations, however, may depend on their perceptions of its fairness, reliability, and efficiency.

As we indicated in Chapter Five, the arts market is largely unregulated (particularly when compared with other asset markets), despite the price-fixing conviction of Sotheby's former chairman and other practices that are questionable and appear to benefit intermediaries at the expense of purchasers. As competition among intermediaries for a potentially expanding pool of purchasers increases, securing the trust of those consumers in the market may prove to be a major challenge. If the market fails, the result might be closer scrutiny by regulators.

From an artistic perspective, the most significant change in the market has been the way value and prices have been set. Traditionally, the value of artists and their work was determined by a slowly evolving consensus among experts (dealers, critics, and major collectors) who evaluated work based on its relationship to the visual arts canon. This process has largely been displaced by the forces of supply and demand, especially in the market for contemporary art. In a speculative environment, particularly one in which the products or assets are unique and difficult to evaluate, reliable information is particularly important to both buyers and sellers. To the extent that intermediaries appear to be manipulating that information, the pressures for regulation will undoubtedly increase.

Museums

In many ways, museums face the most difficult challenges. While developing programs to deal with the more intense competition they face for audiences, museums are also encountering increasing financial pressures as costs rise but revenues often stabilize or decline. They must also deal with more complex legal, ethical, and operating environments. They need to determine what priorities they should assign to their various missions and address the tension such prioritization inevitably involves. Moreover, they are under increasing pressure to focus more on expanding public involvement at the expense of their missions of collecting, preserving, and interpreting art objects.

Although these pressures are felt by most museums, their ability to respond to them has become increasingly unequal. Their ability to address these various organizational challenges is tied to the quality and size of their collections, their prestige, the size of their endowments, and their access to a large pool of potential donors and visitors. These attributes are largely the purview of older, well-established museums

located in major metropolitan areas whose share of total museum revenues and assets has been steadily increasing.

If museums are to navigate their way successfully in this environment, they need to address some basic issues about their objectives and capabilities. Specifically, museum directors and their boards face three basic strategic challenges: They need to define their institutions' primary focus or objective; they need to monitor and assess their museums' institutional performance in fulfilling these objectives; and they need to maintain their museums' institutional competitiveness.[4] With regard to the first challenge of defining a museum's strategic objective, Weil draws a clear distinction between a museum's outputs and the outcomes it is trying to achieve. Outputs are essentially measures of what the museum produces and as such are basically internal measures, such as the number of exhibits the museum presents, its total attendance, or the size of its collection. In contrast, outcomes refer to the external goals or objectives the museum is designed to achieve. Unlike commercial enterprises whose ultimate goal is making profits, nonprofit organizations, like museums, are established to achieve social objectives, such as maintaining a community's cultural heritage, advancing scholarship, stimulating creativity, or enriching people's lives.

The second challenge, assessing a museum's institutional performance, requires museums to identify measures that reflect the museum's performance in meeting its primary objectives—e.g. the success in achieving the desired outcome. As Anderson (2004) has noted, museums typically measure their success in terms of outputs—e.g., attendance, funds raised, and staying within their budgets. But these types of output measures are not necessarily related to a museum's ability to achieve its desired outcomes nor are they easy to assess. Yet if museums are to assess their success in meeting their ultimate objectives, they need to define and measure their performance.

The third challenge, maintaining a museum's institutional competitiveness, requires museums to assess their capability to meet their ultimate objectives. Making this assessment involves three tests, each focusing on a different set of stakeholders. The first test focuses on the public whose needs the museum's objectives are designed to meet. This test asks, Does a need exists, is it unmet, and does the museum have the capability to meet it? The second relates to the museum's staff (both paid and volunteer) and seeks to determine whether they have the ability and willingness to meet the need identified in the first test. Finally, the last test concerns the museum's patrons (financial supporters) and asks whether they are willing and able to meet the museum's financial needs.

There are, of course, a variety of different objectives that museums may pursue (and correspondingly, ways to measure their performance in achieving them as well as their comparative advantages for doing so). Whatever their ultimate objective, mu-

[4] This discussion borrows heavily on the ideas of Weil (2002b).

seums and other visual arts nonprofits need to address these types of strategic issues. Strategic assessment is not easy, nor are museums (or the nonprofit arts world more generally) accustomed to the process. But given the changes occurring in the visual arts world and the more pluralistic and competitive environment in which museums find themselves, it may be critical for museums' future success. After all, institutions that fail to identify their mission and prioritize their goals risk scattering their resources and failing to do anything very well.

Potential Roles for Public Policy

To this point, we have focused on current trends in the visual arts and the challenges they pose for different components of the visual arts system. Apart from noting that both the visual arts market and museums are largely self-regulating and that government at the federal, state, and local levels have provided funding for the visual arts, we have not specifically focused on the role government policy plays in the visual arts system. In this section, we examine the potential role government policy might play in the future. Because the visual arts system is largely driven by the actions of the multitude of private individuals and institutions that produce, consume, market, and display the visual arts, we focus on these factors. These private actors are motivated by a diverse and complex array of personal and organizational interests and will remain so in the future. The government at the federal, state, and local levels provides some direct funding to the visual arts system. But its primary influence on the operation of that system is largely indirect, via regulations, tax policies, and other government actions that create incentives for private individuals to act in particular ways.

Indeed, although many arts advocates think about government's role in the arts in terms of direct government funding, government can affect the organizational ecology of the arts in at least four different ways. One way is through direct governmental funding to arts organizations, artists, and other arts-related activities. In addition to direct support, government tax policies that treat donated revenues and property as tax-free to the recipients and as tax-deductible to the donor are a second way in which government policy can affect the arts. Indeed, this form of indirect support far exceeds direct government funding for the arts.[5] Third, governmental regulatory policies and enforcement actions can influence behaviors of individuals and organizations in the visual arts world. Finally, various government laws deal with such issues as copyright, cultural patrimony, and international trade. In the discussion below, we focus on the possible role of government policy in each of these four areas.

Direct government funding for the arts has been a principal focus for arts advocates since the founding of the NEA and the establishment of state and local arts agencies. Initially, such funding included support for artists, for arts organizations,

[5] See, for example, Schuster, Feld, and O'Hare, 1983.

and for other arts activities. For political reasons, such funding is now focused almost exclusively on supporting arts organizations.[6] This focus reflects the supply-side orientation of much of government arts funding, which assumes that the best way to assure public access to the arts is to support arts organizations. We suspect that this supply focus, which is essentially based on the notion "if we build it, they will come," is misplaced for two reasons. First, because arts consumers tend to be better educated and wealthier than nonconsumers, supply-side subsidies raise equity questions because this funding in essence subsidizes the consumption of those who least need subsidies. Second, a more effective way to ensure public access might be to stimulate demand. As our previous work has indicated, early exposure to the arts in childhood and adolescence appears to have a long-term effect on adult arts participation. Thus, government funding targeted at programs that seek to build knowledge and competence in the arts, such as school and community arts education, might have high payoff in building future demand.

We recognize, of course, that such demand-side funding does not deal directly with the employment and earnings problems of individual artists. But as we suggested above, the earnings and employment problems facing visual artists are endemic to all the arts, and intervention in private labor markets is not considered an appropriate role for government. Furthermore, the controversies surrounding the "cultural wars" of the early '90s suggest that, at least among a sizeable segment of the population, public funding of artists may invariably be linked with government attempts to control the content of the art that they create.

As we indicated above, indirect government support for the arts through tax policy provides considerably more funding for the arts than does direct funding. Moreover, past experience suggests that changes in the way private donations are appraised for tax purposes as well as the different treatment of the value of donated art (depending on whether the donation is made by the artists or a collector) can have a significant effect on the incentive provided to donors. Similarly, changes in the tax incentives for donating funds to nonprofit visual (and other arts) organizations have been shown to have major effects on contributions. We suspect that the way tax policy evaluates contributions and the taxability of museums' unrelated business income will remain significant issues in the future.

As we indicated in Chapters Five and Six on the arts market and museums, the visual arts are largely self-regulating and self-policing. The basic laws and regulations governing nonprofits, on the one hand, and for-profits, on the other, leave a great

[6] There were two principal political reasons for this shift. One was the political opposition that certain NEA grants to "controversial" artists engendered among some politicians who objected to the government supporting work they found offensive. The second related to a more general philosophy that government funding decisions should be made at the local and state level. Indeed, a large share of the NEA's current appropriation is passed through to state and local arts agencies. These agencies in turn tend to place more emphasis in their funding decisions on the local economic effects of the arts than they do on funding the arts qua arts. See Lowell, 2004.

deal of latitude to individual institutions and the sector as a whole to determine best practices and appropriate codes of conduct. Presumably, this reflects a consensus that this state of affairs is in keeping with the public interest and that no further government policy has been required.

However, a series of high-profile incidents in the arts world involving trade in illegal art, Nazi-looted art, conflicts of interest, and public outrage over artistic content has eaten away at this consensus. Moreover, scandals in the nonprofit sector over executive compensation, financial irregularities, political campaign financing, and other incidents have brought unwelcome scrutiny to the nonprofit sector, including museums.

Whether such incidents will prompt efforts at greater regulation is unclear. We suspect that as long as the museum world, in particular, continues to respond quickly and concertedly to each controversy with public reprimands and new policies and guidelines of practice for all, new regulations of the museum world are unlikely. Although some public attention has been drawn to shady practices in the arts market and to price-fixing charges that were brought against the two major auction houses, these developments have not generated enough public outrage to prompt more government regulation. Calls for regulatory changes will depend on how broad public participation in the arts market becomes and whether additional scandals come to light. Given some combination of these developments, attempts to increase regulation of the arts market could well be a possibility.

No doubt the least explored areas of government policy are in regard to such issues as trade policy, cultural patrimony, and copyright law. The one area of likely attention is copyright law. But the effects of changes to copyright on the visual arts appear at first glance to be less salient than for the performing and media arts. Such laws typically revolve around the rights to reproduce an original artwork, which is much more prevalent in the performing than visual arts.

Our focus in this book has been on the organizational ecology of the visual arts world rather than the nature and quality of the visual art being produced. Much of the debate about the visual arts, particularly as reflected in the comments of visual arts critics, has focused on the challenges the visual arts system faces and the ways the various components of that system are responding to these challenges. In particular, some observers complain that the increasingly commercial orientation of the arts market (and the decline of the modernist canon) has not only produced a more eclectic blend of art but also increasingly trendy art. Critics of museums' efforts to emphasize audiences, marketing, and museums as centers of social and entertainment activity have charged that these approaches undervalue the importance of the art object and the qualities of the museum experience that set it apart from everyday life. Beyond reasserting our belief that the market will not return to pre-boom practices, we simply note that the true test of aesthetic quality continues to be determined by the passage of time. With rare historic exceptions, most eras produce a very limited

number of great artists and artworks. In any case, the quality of arts objects should not be a subject of national arts policy. Similarly, the tensions within the museum world about how museums should respond to a changing environment are, as we have tried to demonstrate, endemic to the art world. While museums need to weigh carefully what their primary objectives are, we believe that the wide variety of approaches have been and will continue to be a strength of the visual arts world.

As this discussion suggests, the direct and indirect levers of government over the visual arts system principally work their effects by influencing the actions of private individuals and institutions. Indeed, the future of the visual arts system will largely be determined by the multitude of nonprofits, commercial intermediaries, artists, and individuals making choices about how to spend their time and money. The decisions and behaviors of these assorted actors are as likely to be influenced by broader developments in American society—in particular the increasing pluralism of society and the pressures it exerts on the visual arts system. As we have indicated, these changes have already increased the demands on the system. The key challenge the system faces is to recognize and respond to these pressures without losing sight of the art itself and how it can enrich individuals' lives.

Bibliography

Adams, Georgina, "Measuring Art as an Asset," *Art Newspaper*, No. 109, December 2000a, p. 69.

———, "Artful Investment," *Art Newspaper*, December 2000b, p. 69.

Adams, Georgina, and Lucian Harris, "Sheikh Saud's Spending Spree," *Art Newspaper*, June 2004, pp. 1, 49.

Alexander, Victoria D., *Museums & Money*, Bloomington and Indianapolis: Indiana University Press, 1996.

Alliance for the Arts, *Who Pays for the Arts? Income for the Nonprofit Cultural Industry in New York City,* New York, 2001.

Alloway, Lawrence, "When Artists Start Their Own Galleries," *New York Times,* April 3, 1983, pp. 29–31.

Alper, Neil O., and Gregory H. Wassall, *More Than Once in a Blue Moon: Multiple Jobholdings by American Artists*, Santa Ana, Calif.: Seven Locks Press, 2000.

Alper Neil O., Gregory H. Wassall, Joan Jeffri, et al., *Artists in the Work Force: Employment and Earnings*, NEA Research Division Report No. 37, Washington D.C.: National Endowment for the Arts, 1996.

"America's Museums," *Daedalus*, Vol. 128, No. 3, American Academy of Arts and Sciences Proceedings, Summer 1999.

Anderson, Maxwell, *Metrics of Success in Art Museums,* Los Angeles: Getty Leadership Institute, 2004.

Ashton, Dore, *The New York School: A Cultural Reckoning,* New York: Penguin, 1975.

Ashworth, John, and Peter Johnson, "Sources of 'Value for Money' for Museum Visitors: Some Survey Evidence," *Journal of Cultural Economics*, No. 20, 1996, pp. 67–83.

Atkins, Robert, "State of the (On-line) Art," *Art in America*, April 1999, pp. 89–95.

Bahrampour, Tara, "Hired Eyes: Advisors Who Fill Walls with Art," *New York Times,* January 9, 2000, p. 4.

Balfe, Judith H., and Monnie Peters, "Public Involvement in the Arts," in Joni M. Cherbo and Margaret J. Wyszomirski, eds., *The Public Life of the Arts in America*, New Brunswick, N.J.: Rutgers University Press, 2000, pp. 81–98.

Barstow, David, "After Furor over Financing, Museum Group Adopts Ethical Guidelines," *New York Times* (online), August 3, 2000.

Baumol, William, "Unnatural Value: Or Art Investment as Floating Crap Game," *American Economic Review*, Papers and Proceedings, May 1986.

Baumol, William J., and William G. Bowen, *Performing Arts—The Economic Dilemma: A Study of Problems Common to Theater, Opera, Music, and Dance*, New York: The Twentieth Century Fund, 1966.

————, "On the Performing Arts: The Anatomy of Their Economic Problems," *American Economic Review*, Vol. 50, No. 2, 1965, pp. 495–502.

Bourdieu, Pierre, *Distinction: A Social Critique of the Judgment of Taste*, translated by Richard Nico, Cambridge, Mass.: Harvard University Press, 1984.

————, "Intellectual Field and Creative Project," *Social Science Information*, Vol. 8, 1969, pp. 106–107.

Brooks, Arthur C., and Roland J. Kushner, "Cultural Districts and Urban Development," *International Journal of Arts Management*, Vol. 3, No. 2, 2001, pp. 4–15.

Brown, Christie, "Art, Stock, & Real Estate" *Art and Auction*, December 1997, pp. 93–97, 123.

Browning, Lynnley, "Donor's Windfall Vexes Museum: Senate Committee Questions Actions by Smithsonian," *New York Times*, June 14, 2004.

BSM, "Aiming at Young Professionals, *Art Newspaper*, September 1998, p. 19.

Budick, Ariella, "We Know What We Like," *Los Angeles Times*, July 5, 2004.

Cocks, Anna Somers, "No Poetry in These Numbers," *Art Newspaper*, Vol. 12, No. 112, March 2001, p. 1.

Collins, Glen, "The Media Business," *New York Times*, July 23, 1997.

Colson, Crocker, "Too Much Too Soon?" *ARTnews*, September 1997.

Cowen, Tyler, "Why I Do Not Believe in the Cost Disease: Comment on Baumol" *Journal of Cultural Economics*, Vol. 20, 1996, pp. 207–214.

Crane, Diana, *The Transformation of the Avante-Garde*, Chicago: University of Chicago Press, 1987.

Cuno, James, "The Object of Art Museums," in James Cuno, ed., *Whose Muse: Art Museums and the Public Trust*, Princeton, N.J.: Princeton University Press, and Cambridge, Mass.: Harvard University Art Museums, 2004a, pp. 49–75.

Cuno, James, ed., *Whose Muse? Art Museums and the Public Trust*, Princeton, N.J.: Princeton University Press, and Cambridge, Mass.: Harvard University Art Museums, 2004b.

Cuno, James, and Malcolm Rogers, "Is Buzz Killing the American Museum?" Interview, *Boston Herald*, December 15, 2000, pp. 1–6.

Danto, Arthur, *Beyond The Brillo Box: The Visual Arts in Post-Historical Perspective,* Berkeley, University of California Press, 1998.

———, *The Philosophical Disenfranchisement of Art*, New York: Columbia University Press, 1986.

D'Arcy, David, "Up From Downsizing," *Arts and Auction*, December 1997, pp. 84–87.

Davidson, Abraham A., *Early American Modernist Painting, 1910–1935,* New York: Da Capo Press, 1994.

Day, Sherri, "Former Sotheby's Head Sentenced to Year in Prison," *New York Times*, April 22, 2002.

Decker, Andrew, "Searing at the Top," *ARTnews*, October 1998a, pp. 116–117.

———, "Smart Money," *ARTnews*, October 1998b, pp. 114–115.

De Montebello, Philippe, "Art Museums, Inspiring Public Trust," in James Cuno, ed., *Whose Muse? Art Museums and the Public Trust*, Princeton, N.J.: Princeton University Press, and Cambridge, Mass.: Harvard University Art Museums, 2004, pp. 151–169.

———, "Address to American Federation of Arts' Curators Forum," quoted in *Art Newspaper*, No. 115, June 1, 2001.

Deveraux, Scott, *Jazz in America: Who's Listening,* Washington, D.C.: National Endowment for the Arts, 1994.

DiMaggio, Paul, "Introduction," *Poetics*, No. 24, 1996, pp. 81–86.

———, "Talk to Association of Art Museum Directors," New Orleans, La.: January 28, 1994.

DiMaggio, Paul J., "Cultural Entrepreneurship in 19th Century Boston" in Paul J. DiMaggio, ed., *Nonprofit Enterprise in the Arts: Studies in Mission and Constraint,* New York: Oxford University Press, 1986.

Dobrzynski, Judith, "Blockbuster Shows Lure Record Crowds into U.S. Museums," *New York Times,* February 3, 2000, p. E5.

———, "A Lull in Art Sales? Well, Not Anymore," *New York Times,* September 7, 1999, pp. E1–E3.

———, "Blockbuster Shows and Prices to Match," *New York Times,* November 10, 1998, pp. E1–E13.

Dore Ashton, *The New York School: A Cultural Reckoning,* New York: Penguin, 1975.

Einreinhofer, Nancy, *Art Museums: Elitism and Democracy,* Leicester, U.K.: Leicester University Press, 1997.

Ellis, Adrian, "How Will American Museums Survive the Financial Crisis?" *Art Newspaper*, April 6, 2004, p. 1.

Falk, John H., and Lynn D. Dierking, *Learning from Museums*, Walnut Creek, Calif.: Alta Mira Press, 2000.

———, *The Museum Experience*, Washington, D.C.: Whalesback Books, 1992.

Fazioli, Roberto, and Massimo Filippini, "Cost Structure and Product Mix of Local Public Theatres." *Journal of Cultural Economics*, Vol. 21, 1997, pp. 77–86.

Feldstein, Martin, ed., *The Economics of Art Museums*, Chicago: University of Chicago Press, 1991.

Fingleton, Eamon, "Portrait of the Artist as Moneyman," *Forbes,* July 1982, pp. 34–37, 86.

Finn Jr., Edwin W., and Hiroko Katayama, "Sheikh Saud's Spending Spree," *Art Newspaper*, June 2004, pp. 1, 49.

———, "Follow the Money," *Forbes*, December 29, 1986.

Foltz, Kim, and Maggie Malone, "Golden Paintbrushes," *Newsweek*, October 15, 1984.

Frey, Bruno S., "Superstar Museums: An Economic Analysis," *Journal of Cultural Economics*, Vol. 22, 1998, pp. 113–125.

Frey, Bruno S., and Werner Pommerehne, *Muses and Markets: Explorations in the Economics of the Arts*, Oxford, U.K.: Basil Blackwell, 1989.

Galenson, David W., "The Careers of Modern Artists: Evidence from Auctions of Contemporary Art," *Journal of Cultural Economics*, Vol. 24, No. 2, May 2000, pp. 87–112.

Getty Center for Education in the Arts, *Insights: Museums, Visitors, Attitudes, Expectations: A Focus Group Experiment,* Los Angeles: Getty Center for Education in the Arts, 1991.

Gimelson, Deborah, "How Corporate Collecting Fell on Hard Times," *New York Times*, October 9, 1994, pp. 34, 42.

Gleadell, Colin, "Records Fall, Contemporary Rises," *ARTnews*, January 2003, pp. 58–60.

Glynn, Mary Ann, C. B. Bhattacharya, and Hayagreeva Rao, "Art Museum Membership and Cultural Distinction: Relating Member's Perceptions of Prestige to Benefit Usage," *Poetics*, Vol. 24, 1996, pp. 259–274.

Graeber, Laural, "Hype and High Prices in the 80s," *New York Times*, October 15, 1989, p. 48.

Gray, Charles, "Art Costs and Subsidies: The Case of Norwegian Performing Arts," in Ruth M. Towse, ed., *Cultural Economics: The Arts, the Heritage and the Media Industries,* Cheltenham, UK, and Lyme, N.H.: Elgar Reference Collection, 1997, pp. 337–343.

Gregg, Gail, "What Are They Teaching Arts Students These Days?" *ARTnews*, April 2003, pp. 106–109.

Guilbaut, Serge, *How New York Stole the Idea of Modern Art: Abstract Expressionism, Freedom, and the Cold War*, Chicago: University of Chicago Press, 1983.

Haden-Guest, Anthony, "The Art of Musical Chairs," *Vanity Fair*, September 1987, pp. 60–72.

Halle, David, *Inside Culture: Art and Class in the American Home,* Chicago: University of Chicago Press, 1993.

Harris, Louis, "Americans and the Arts," *Highlights from a Nationwide Survey of the Attitudes of the American People Towards the Arts,* New York: American Council for the Arts, June 1996.

Harris, Neil, "The Divided House of the American Art Museum," *Daedalus,* Vol. 128, No. 3, American Academy of Arts and Sciences Proceedings, Summer 1999, pp. 33–56.

Heilbrun, James, and Charles M. Gray, *The Economics of Art and Culture,* 2nd edition, Cambridge, UK: Cambridge University Press, 2001.

Herscher, Ellen, "Tarnished Reputations," *Archaeology,* Vol. 51, No. 5, September/October, 1998, pp. 66ff.

Holak, Susan L., William J. Havlena, and Pamela K. Kennedy, "Analyzing Opera Attendance: The Relative Impact of Managerial vs. Environmental Variables," *Empirical Studies of the Arts,* Vol. 4, No. 2, 1986, pp. 175–188.

Horowitz, Harold, "The Status of Artists in the U.S.A.," *Journal of Cultural Economics,* Vol. 17, 1993, pp. 29–48.

"How Museums Can Most Wisely Dispose of Surplus Material," *ARTnews,* July 13, 1992.

"How U.S. Museum Directors Reacted," *Art Newspaper,* No. 145, April 2004.

Hudson, Kenneth, "The Museum Refuses to Stand Still," *Museum International,* Vol. 50, No. 1, 1998, pp. 43–50.

Hughes, Robert, "That's Showbusiness," *The Guardian,* June 30, 2004. Available online at http://www.guardian.co.uk (as of July 6, 2004).

———, "The Great Massacre of 1990," *Time Magazine,* December 3, 1990a, pp. 124–125.

———, "Bumps in the Auction Boom," *Time Magazine,* May 28, 1990b.

———, "Art and Money: Who's Winning and Who's Losing As Prices Go Through the Roof," *Time Magazine,* November 27, 1989a, pp. 60–69.

———, "The Anatomy of a Deal," *Time Magazine,* November 27, 1989b.

———, "On Art and Money," *New York Review of Books,* December 6, 1984.

"Inside the Art Market," Special Edition, *ARTnews,* October 1998.

Ivey, W. J., "Bridging the For-Profit and Not-for Profit Arts," *Journal of Arts Management Law and Society,* Vol. 29, No. 2, 1999, pp. 97–100.

Janson, W. A., *History of Art,* Englewood Cliffs, N.J.: Prentice-Hall, 1964.

Jeffri, Joan, "Philanthropy and the American Artist: A Historical Overview," *Cultural Policy,* Vol. 3, No. 2, 1997, pp. 207–233.

Jeffri, Joan, and David Throsby, "Professionalism and the Visual Arts," *Cultural Policy,* Vol. 1, No. 1, 1994, pp. 99–108.

Jones, Chris, "The Blockbustering of U.S. Museums," *Los Angeles Times,* February 19, 2003, pp. E6–7.

Kaufman, Jason Edward, "Casino Loan Earns Boston Unwelcome Attention," *Art Newspaper,* Vol. 14, July/August 2004a, p. 11.

———, "Guggenheim Cleared," *Art Newspaper,* No. 148, January 2004b.

———, "Retrench as Boom Goes Bust," *Art Newspaper,* January 2003, pp. 1–6.

Keegan, Carol, *Public Participation in Classical Ballet: A Special Analysis of the Ballet Data Collected in the 1982 and 1985 Surveys of Public Participation in the Arts,* Washington, D.C: National Endowment for the Arts, 1987.

Kelly, John R., *Freedom to Be Me: A New Sociology of Leisure,* New York, NY: Macmillan, 1987.

Kelly, John R., and Valeria J. Freysinger, *21st Century Leisure: Current Issues,* Boston, Mass.: Allyn & Bacon, 2000.

Kimmelman, Michael, "Does it Really Matter Who Sponsors a Show?" *New York Times Magazine,* May 19, 1996, p. 33.

Kotler, Neil, "Delivering Experience: Marketing the Museum's Full Range of Assets," *Museum News,* May/June 1999.

Kramer, Hilton, *The Age of the Avant-Garde: An Art Chronicle of 1956–1972,* New York: Farrar, Straus, Giroux, 1973.

Kreidler, John, "Leverage Lost: The Non-profit Arts in the Post-Ford Era," *Journal of Arts Management, Law, and Society,* Vol. 26, No. 2, 1996, pp. 79–100.

Landes, William, "What Has the Visual Artist's Rights of 1990 Accomplished?" *Journal of Cultural Economics,* Vol. 25, 2001, pp. 283–306.

Lange, Mark D., and William A. Luksetich, "The Cost of Producing Symphony Orchestra Services," *Journal of Cultural Economics,* Vol. 17, No. 2, 1993, pp. 1–15.

Lee, Sherman E., ed., *On Understanding Art Museums,* Englewood Cliffs, NJ: Prentice-Hall, Inc., 1975.

Lee, Sherman E., and Edward B. Henning, "Works of Art, Ideas of Art, and Museums of Art" in Sherman E. Lee, ed., *On Understanding Art Museums,* Englewood Cliffs, NJ: Prentice-Hall, Inc., 1975, pp. 5–33.

Lee, Susan, "Greed Is Not Just for Profit," *Forbes,* April 18, 1988, pp. 65–75.

Lemmons, Jack R., *American Dance 1992: Who's Watching, Who's Dancing,* Washington, D.C.: National Endowment for the Arts, 1996.

Levin, Kim, *Beyond Modernism: Essays on Art From the '70s and '80s,* New York: Harper and Row, 1988.

Lowell, Julia F., *State Arts Agencies, 1965–2003: Whose Interests to Serve?* Santa Monica, Calif.: RAND Corporation, MG-121-WF, 2004.

Lowry, Glenn D., "A Deontological Approach to Art Museums and the Public Trust," in James Cuno, ed., *Whose Muse? Art Museums and the Public Trust,* Princeton, N.J.: Princeton University Press, and Cambridge, Mass.: Harvard University Art Museums, 2004, pp. 129–150.

Lunden, Ingrid, "Art Commerce Sites Run into Trouble," *Art Newspaper,* No. 107, October 2000.

Maier, Andrea, "If Art Is Resold, Should Artists Profit?" *New York Times,* February 8, 1992, pp. 11–12.

Mamiya, Christin J., *Pop Art and Consumer Culture: American Super Market,* Austin: University of Texas Press, 1992.

Markusen, Ann, Greg Schrock, and Martina Cameron, *The Artistic Dividend Revisited,* Minneapolis: Project on Regional and Industrial Economics, Humphrey Institute, University of Minnesota, Working Paper #315, July 2004.

Mason, Christopher, *The Art of the Steal: Inside the Sotheby's–Christie's Auction House Scandal,* New York: Putnam, 2004.

———, "A Bid Too Far," *New York*, October 2, 2000, pp. 36–44.

McCarthy, Kevin, Arthur Brooks, Julia Lowell, and Laura Zakaras, *The Performing Arts in a New Era,* Santa Monica, Calif.: RAND Corporation, MR-1367-PCT, 2001.

McCarthy, Kevin F., and Kimberly Jinnett, *A New Framework for Building Participation in the Arts,* Santa Monica, Calif.: RAND Corporation, MR-1323-WRDF, 2001.

McCarthy, Kevin F., and Elizabeth Heneghan Ondaatje, *From Celluloid to Cyberspace: The Media Arts and the Changing Arts World,* Santa Monica, Calif.: RAND Corporation, MR-1552-RF, 2002.

McCarthy, Kevin, F., Elizabeth Heneghan Ondaatje, and Laura Zakaras, *Guide to the Literature on Participation in the Arts,* Santa Monica, Calif.: RAND Corporation, DRU-2308-WRDF, 2001.

McCarthy, Kevin F., Elizabeth H. Ondaatje, Laura Zakaras, and Arthur Brooks, *Gifts of the Muse: Reframing the Debate About the Benefits of the Arts,* Santa Monica, Calif.: RAND Corporation, MG-218-WF, 2004.

McGuigan, Cathleen, "New Art, New Money," *New York Times*, February 10, 1985.

Mei, Jianping, and Michael A. Moses, "Art as Investment and the Underperformance of Masterpieces: Evidence from 1987–2002, *American Economic Review*, No. 92, February 2002, pp. 1656–1668.

Melikian, Souren, "The Demand Drains Market," *International Herald Tribune,* March 23, 2002a.

———, "The Transfiguration of the Auction House," *International Herald Tribune,* January 12, 2002b.

Menger, Pierre–Michel, "Artistic Labor Markets and Careers," *Annual Review of Sociology*, Vol. 25, 1999, pp. 541–574.

Molotsky, Irvin, "Tax Break to Aid Museums," *New York Times*, August 19, 1993.

Montias, J. Michael, "Are Museums Betraying the Public's Trust?" *Journal of Cultural Economics*, Vol. 19, 1995, pp. 71–80.

Morgan, Joyce, "A Fine Line Between Art and Commerce," *Sydney Morning Herald,* March 1, 2000. Available online at http://www.smh.com.au/news.

Moulin, Raymonde, *The French Art Market: A Sociological View,* New Brunswick, N.J.: Rutgers University Press, 1987.

National Endowment for the Arts (NEA), *2002 Survey of Public Participation in the Arts*, NEA Research Division Note 81, Washington, D.C.: National Endowment for the Arts, 2003.

———, *1997 Survey of Public Participation in the Arts*, NEA Research Division Report 39, Washington, DC: National Endowment for the Arts, 1998.

———, *1992 Survey of Public Participation in the Arts*, Washington, D.C.: National Endowment for the Arts, 1993.

———, *1987 Survey of Public Participation in the Arts*, Washington, D.C.: National Endowment for the Arts, 1988.

———, *1982 Survey of Public Participation in the Arts*, Washington, D.C.: National Endowment for the Arts, 1983.

———, *Visual Artists in Houston, Minneapolis, Washington, and San Francisco: Earnings and Exhibition Opportunities,* NEA Research Division Report 18, Washington D.C.: National Endowment for the Arts, 1982.

O'Hagan, John W., "Art Museums: Collections, Deaccessioning and Donations," *Journal of Cultural Economics*, Vol. 22, 1998, pp. 197–207.

Orend, Richard J., and Carol Keegan, *Education and Arts Participation: A Study of Arts Socialization and Current Arts-Related Activities Using 1982 and 1992 SPPA Data,* Washington, D.C.: National Endowment for the Arts, 1996.

"Partial Ban on Loans from Sicily," *Art Newspaper*, July 13, 2004.

Passell, Peter, "Vincent Van Gogh, Meet Adam Smith," *New York Times,* February 4, 1990, pp. 1, 12.

Peters, Monnie, and Joni Maya Cherbo, "The Missing Sector: The Unincorporated Arts," *Journal of Arts Management, Law, and Society*, Vol. 28, No. 2, 1998, pp. 115–128.

Peterson, Thane, "Did You Get that Utrillo on the Web?" *Businessweek Online*, July 3, 2000.

Plagens, Peter, "Bad Times at Mountebank High," unpublished paper, 1999.

Pollock, Barbara, "Distinct Strategies," *ARTnews*, Summer 2000, pp. 109–110.

Pommerehne, Werner W., and Lars P. Feld, "The Impact of Museum Purchases on the Auction Prices of Paintings," *Journal of Cultural Economics*, Vol. 21, 1997, pp. 249–271.

Putnam, Robert, *Bowling Alone: The Collapse and Revival of American Community*, New York: Touchstone, 2000.

Pye, Michael, "Agents of Mercy in a Bare Market," *Independent*, The Sunday Review Page, February 3, 1991.

Robins, Connie, *The Pluralist Era: American Art 1968–1981*, New York: Harper and Row, 1984.

Robinson, John P., and Geoffrey Godbey, *Time for Life: The Surprising Ways Americans Use Their Time*, University Park, Pa.: Pennsylvania State University Press, 1997.

Rosen, Sherwin, "The Economics of Superstars," *American Economic Review*, Vol. 71, No. 5, 1982, pp. 845–858.

Russell, John, "Clapping for Money at Auctions," *New York Times*, May 21, 1989, sec. 2, pp. 1–3.

Sandler, Irving, *Art of the PostModern Era*, New York: Harper Collins, 1996.

————, *The Triumph of American Painting: A History of Abstract Expressionism*, New York: Harper and Row, 1979.

Schor, Juliet, *The Overworked American: The Unexpected Decline of Leisure*, New York: Basic Books, 1991.

"Schultz Conviction Upheld," *Archaeology* (online), June 25, 2003.

Schuster, J. Mark, *The Audience for American Art Museums*, NEA Research Division Report 23, Washington, D.C.: National Endowment for the Arts, 1991.

Schuster, J. Mark, Alan L. Feld, and Michael O'Hare, *Patrons Despite Themselves: Taxpayers and Arts Policy*, New York: New York University Press, 1983.

Schuster, Mark, "Neither Public nor Private: The Hybridization of Museums," *Journal of Cultural Economics*, Vol. 22, 1998, pp. 127–150.

Schwarzer, Marjorie, "Turnover at the Top: Are Directors Burning Out?" *Museum News*, Vol. 81, May/June 2002.

Sennott, Charles M., and Sarah Liebowitz, "They've Lost Their Marbles, and They Want the World to Know," *Boston Globe* (online), July 12, 2004.

Sheer, Lisa, "Art for Pensioners Sake," *Forbes*, December 28, 1987, pp. 64–66.

Simpson, Charles R., *Soho: The Artist and the City*, Chicago: University of Chicago Press, 1981.

Singer, Leslie, and Gary Lynch, "Public Choice in the Tertiary Art Market," *Journal of Cultural Economics*, Vol. 18, 1994, pp. 199–216.

Smith, Dinitia, "Museums Struggle to Recoup with Attendance Down," *New York Times*, October 8, 2001.

————, "Art Fever: The Passion and Frenzy of the Ultimate Rich Man's Sport," *New York Magazine*, April 20, 1987, pp. 34–43.

Smith, Roberta, "For the New Galleries of the 90's, Small and Cheap is Beautiful," *New York Times*, April 22, 1994, pp. C1, C22.

Solomon, Deborah, "Is the Go-Go Guggenheim Going?" *New York Times Magazine*, June 30, 2002, pp. 37–41.

———, "The Collector," *New York Times Magazine*, September 26, 1999a, pp. 44–49.

———, "How to Succeed in Art," *New York Times*, Sunday Magazine, June 27, 1999b.

———, "The Art World Bust," *New York Times*, Sunday Magazine, February 28, 1993, pp. 28–33, 64.

"Special: The Business of Art," *Art and Auction*, December 1997.

Stigler, George J., and Gary S. Becker, "De Gustibus Non Est Disputandum," *American Economic Review*, Vol. 67, No. 2, 1977, pp. 76–90.

Stohs, Joanne M. , "Young Adult Predictors and Middle Outcomes of 'Starving Artists' Careers: A Longitudinal Study of Male Fine Artists, *The Journal of Creative Behavior*, Vol. 25, 1991, pp. 92–105.

Stone, Ann, *Treasures in the Basement? An Analysis of Collection Utilization in Art Museums*, Santa Monica, Calif.: RAND Corporation, RGSD-160, 2002.

Szántó, András, "Hot and Cool: Some Contrasts Between the Visual Arts Worlds of New York and Los Angeles," in David Halle, ed., *New York and Los Angeles: Politics, Society, and Culture: A Comparative View*, Chicago and London: University of Chicago Press, 2003.

———, *Gallery: The Transformation of the New York Art World in the 1980s*, New York: Columbia University, doctoral dissertation, 1997.

Taalas, Mervi, "Generalised Cost Functions for Producers of Performing Arts—Allocative Inefficiencies and Scale Economies in Theatres," *Journal of Cultural Economics*, Vol. 21, 1997, pp. 335–353.

Taylor, Joshua C., " The Art Museum in the United States," in Sherman E. Lee, ed., *On Understanding Art Museums*, Englewood Cliffs, NJ: Prentice-Hall, Inc., 1975, pp. 34–35.

"This Exhibit Is Brought to You by . . .," *Business Week*, November 10, 1997, pp. 91–92.

Thomas, Kelly Divine, "Troubled Indemnity," *ARTnews*, Vol. 102, No. 6, 2003.

Toffler, Alvin, *The Culture Consumers: A Study of Art and Affluence in America*, New York: St. Martin Press, 1964.

Tomkins, Calvin, "The Art Market: Going, Going, Gone," *New Yorker*, December 14, 1992, pp. 136–138.

———, *From Post to Neo: The ArtWorld of the 1980s*, New York: Penguin, 1988.

———, *Off the Wall: Robert Rauschenberg and the Art World of Our Time*, New York: Penguin, 1980.

U.S. Department of Labor, Bureau of Labor Statistics, *2001 National Occupational Employment and Wage Estimates*, 2002. Online at www.bls.gov (as of August 23, 2003).

Varian, Elayne H., "New Dealing," *Art in America*, January–February 1970, pp. 68–73.

Vincent, Steven, "Hidden Assets," *Art and Auction*, December 1997, pp. 90–93.

Vogel, Carol, "A Momentous Ten Years," *Art Business*, January 2002, pp. 32–37.

——, "Taste of the 80s: High Prices Are Back in an Auction of Contemporary Art," *New York Times*, May 18, 2000, p. B4.

——, "Auction Sets Records for 18 Contemporary Artists," *New York Times,* November 17, 1999.

——, "Sotheby's As Bank," *New York Times*, April 17, 1998.

——, "A Night of Records for 8 Contemporary Artists," *New York Times*, November 20, 1997a.

——, "Christie Draws a Line for Modern Art at 1900," *New York Times*, September 6, 1997b, pp. 15–17.

——, "Secret Tips on Art for the Wealthy and Wary," *New York Times,* August 12, 1997c, pp. C11–12.

——, "Museums Speak in Celebrity Voices," *New York Times Magazine*, November 16, 1996a, pp. C1, C15.

——, "Contemporary Art Bounces Back," *New York Times*, May 8, 1996b, pp. C20–21.

——, "Cracks Still Deep in Contemporary Art Market," *New York Times*, May 5, 1994, pp. C15, C21–22.

Walker, Richard, "Plenty of Money—For Big Spenders Only," *ARTnews*, Summer 1987, pp. 29–30.

Watson, Peter, *From Manet to Manhattan: The Rise of the Modern Art Market,* New York: Random House, 1992.

Wechsler, Dana, "A Treacherous Market," *Forbes*, November 27, 1989, p. 292.

Weil, Stephen E., *Making Museums Matter*, Washington, D.C.: Smithsonian Institution, 2002a.

——, "Are You Really Worth What You Cost, or Just Merely Worthwhile? And Who Gets to Say," paper presented at the Museum Trustee Association, October 2002, San Diego, available from the Getty Leadership Institute, Los Angeles, California, 2002b.

——, "From Being About Something to Being for Somebody," *Daedalus*, Summer 1999, pp. 229–258.

Wells, Marcella, "Do Museums Need a Visitor Opportunity Spectrum?" presentation at the American Association of Museums, Washington, D.C., May 26, 1998.

West, Edwin G., "Nonprofit Versus Profit Firms in the Performing Arts," *Journal of Cultural Economics*, Vol. 11, No. 1, 1987, pp. 37–48.

"When Merchants Enter the Temple," *Economist*, April 19, 2001.

White, Harrison C., and Cynthia White, *Canvasses and Careers: Institutional Change in the French Painting World,* Chicago and London: University of Chicago Press, 1965.

Winston, Andrew S., and Gerald C. Cupchink, "The Evaluation of High Art and Popular Art by Naïve and Experienced Viewers," *Visual Arts Research,* Vol. 18, 1992, pp. 1–14.

Wolfe, Tom, *The Painted Word,* New York: Bantam Books, 1976.

"Yesterday's Blooms: A Survey of the World Art Market," *Economist,* December 22, 1990.

Zielbauer, Paul, "Old Auction Rivalry Jumps to Internet," *New York Times,* January 27, 1999.

Zolberg, V. L., "Art-Museums and Cultural Policies—Challenges of Privatization, New Publics, and New Arts," *Journal of Arts Management, Law, and Society,* Vol. 23, No. 4, 1994, pp. 277–290.

Zolberg, Vera, and Joni Cherbo, *Unsettling Sensation: Arts Policy Lessons from the Brooklyn Museum of Art Controversy,* New Brunswick: Rutgers University Press, 2002.

Zukin, Sharon, *Loft Living,* New Brunswick: Rutgers University Press, 1989.